Digital Photography Lighting

FOR

DUMMIES®

by Dirk Fletcher

WILEY

Wiley Publishing, Inc.

Digital Photography Lighting For Dummies®

Published by
Wiley Publishing, Inc.
111 River St.
Hoboken, NJ 07030-5774
www.wiley.com

WILEY

About the Author

St. Louis native and son of a professional photographer, **Dirk Fletcher** began his career as a public relations photographer and a stringer for a small newspaper as soon as he could drive. After several years, he and his high school sweetheart moved to Santa Barbara where he attended Brooks Institute of Photography and earned a degree in Advertising and Illustration Photography.

After graduation, Dirk moved to Chicago where he worked with advertising photographers before taking a full-time job at a full-service photo and design studio shooting advertising, packaging, and catalogs. After several years, he departed for a five-year stint as the sole photographer at the world-famous Museum of Science and Industry in Chicago. He had a variety of subjects, from exhibit interiors to advertising, events, annual reports, and documentation of priceless artifacts.

In 2004, he was chosen to create and develop a digital photography program for Harrington College of Design. The program serves 200 students today and grows each year. As chairman of the photography programs, he teaches regularly and manages the daily and long-term operations of the department. In addition, he has researched and written degree programs in Digital Filmmaking, Digital Photography, and Commercial Photography. Dirk has guest-lectured at colleges, institutions, and professional organizations as well as the flagship Apple Store on Michigan Avenue in 2009.

His 2007 portfolio from the Chinese city of Rizhao in the Shandong province achieved top honors in the 2008 International Photo Imaging Education Association (PIEA) competition. The portfolio crossed the globe for two years in internationally traveling exhibitions.

Believing in a convergence in still and motion disciplines, Dirk completed an MFA in Digital Imaging/Independent Filmmaking in 2009 at Governors State University in the southwestern suburbs of Chicago. His thesis film, *The Digital Dilemma,* a documentary about the pitfalls of using small digital cameras and cellphones to record your family history, was an official selection and was publically premiered at the Washington, D.C., Independent Film Festival in March 2010.

He served for eight years as a board member for the Chicago chapter of American Society of Media Professionals (ASMP) and served on the Alumni Board of Brooks Institute of Photography. He lives in the Chicago suburbs with his wife and two aspiring photographers and filmmakers, ages 7 and 10. His work can be seen at www.dirkfletcher.com and his blog at www.dirk fletcher.blogspot.com.

Dedication

This book is dedicated not only to aspiring photographers and visual artists but to anybody who has ever looked at an image and wondered, "How did they do that?"

Let this book serve as a springboard for that curiosity; may it take you far and reward you well.

Author's Acknowledgments

First and foremost I have to thank my wonderfully supportive wife Kate and boys Sam and John. These three have given me the strength and motivation to take on another major endeavor. I don't know where I'd be without you three; I draw inspiration and creativity from each of you every day!

For the number of times that I reached out at all hours not just now but always, thanks to Mom, Dad, and my brother Eric — you have always been there.

I need to specifically thank my father, a now retired corporate/industrial photographer, who gave me, at an early age, a deep understanding and respect for the tools and techniques of the industry. I dare say he gave me insight to creativity as well, even though he doesn't really use that word.

To Elizabeth Pratt and Ed Meyers from Canon Professional Services, thanks for making sure I had whatever support I needed for testing and creation of the sample images in this book. Thanks also to Helix Photographic for their generosity with loaner equipment.

Thanks to Traci, Erin, Christy, and Alissa, my amazingly talented and remarkably patient editors at Wiley; I truly appreciate your efforts!

Thanks to my literary agent Barb Doyan who brought me this fantastic opportunity.

A huge debt of gratitude needs to be paid to my students, whose energy and enthusiasm make every day at the college feel like a weekend. I thoroughly enjoy and appreciate being able to work around you, with you, and for you each and every day. I especially need to thank a group of young professionals

who were so kind to lend their fantastic imagery to this project. Your images truly make these pages jump! Not necessarily in order of appearance, the students whose images appear are Britton Black, Stephanie Remelius, John Karl Brewick, Nick Provost, Robert Vreeland, Ricky Kluge, and Tyler Lundburg.

Last (but nowhere near least), thanks to the faculty, staff, and administration at Harrington who are too numerous to mention except for my rock-star, full-time faculty and staff in the photo department, Tim Arroyo, Joe Byrnes, Susannah Lancaster, and Ed Wesly. It is truly a pleasure to work alongside you guys each and every day.

Publisher's Acknowledgments

We're proud of this book; please send us your comments at http://dummies.custhelp.com. For other comments, please contact our Customer Care Department within the U.S. at 877-762-2974, outside the U.S. at 317-572-3993, or fax 317-572-4002.

Some of the people who helped bring this book to market include the following:

Acquisitions, Editorial, and Media Development

Senior Project Editor: Alissa Schwipps

Acquisitions Editor: Stacy Kennedy

Copy Editor: Christine Pingleton

Assistant Editor: Erin Calligan Mooney

Technical Editor: Mark D. Sawrie

Editorial Consultant: Alan Hess

Senior Editorial Manager: Jennifer Ehrlich

Senior Editorial Assistant: David Lutton

Editorial Assistants: Rachelle Amick, Jennette ElNaggar

Front Cover Photo: Ricky Kluge (www.rtkphoto.com)

Cartoons: Rich Tennant (www.the5thwave.com)

Composition Services

Project Coordinator: Sheree Montgomery

Layout and Graphics: Claudia Bell, Tim Detrick, Joyce Haughey, Stephanie D. Jumper

Proofreaders: Lauren Mandelbaum, Toni Settle

Indexer: Steve Rath

Publishing and Editorial for Consumer Dummies

 Diane Graves Steele, Vice President and Publisher, Consumer Dummies

 Kristin Ferguson-Wagstaffe, Product Development Director, Consumer Dummies

 Ensley Eikenburg, Associate Publisher, Travel

 Kelly Regan, Editorial Director, Travel

Publishing for Technology Dummies

 Andy Cummings, Vice President and Publisher, Dummies Technology/General User

Composition Services

 Debbie Stailey, Director of Composition Services

Contents at a Glance

Table of Contents

Introduction

*I*f the people in your photos look flat, green, or — worse — like they're nursing black eyes when you photograph them outside, this book can help you. If you're comfortable with your digital camera and are ready to take your photography to the next level, the information you find here is just the thing. Whether your interest is strictly personal or you're considering making photography more than a hobby, becoming adept at lighting brings greater polish, life, and creativity to your photographs.

The light that comes pouring down from the sun at noontime and the scarce light you have to work with during a dinner party require different sets of tools, and light intensity is just one of the aspects you need to consider when you prepare to take photographs. You don't want to miss an opportunity because you're futzing with your equipment and wracking your brain for the methods the moment calls for. Within this book, I give you the information you need to proceed confidently in a wide range of situations, whether you're capturing the motion of a giraffe outside on safari or providing flattering light for a portrait of your mama.

Light makes photography possible. Discovering how best to utilize it is essential for making your photography great.

About This Book

Like a photo album that takes you from prom to wedding photos, the information in this book moves logically from more basic to advanced topics, but you don't have to start here and keep reading in order to make sense of anything you find. This isn't a textbook, so if a particular topic piques your interest, turn right to it; let the table of contents and index be your guides. I also define terms and point you in the direction of any information that may help you within every chapter.

Like all *For Dummies* books, this one is designed to give you everything you need to accomplish what you want — lighting a portrait, say, or getting a decent nighttime shot — without mucking up your experience with details you don't need or fancy-pants terminology that sends you running to the library. You find here, instead, a casual and fun introduction to photographic lighting that I hope answers all your questions and spurs you to create better shots than you dared to hope for.

Conventions Used in This Book

I use the following conventions throughout the text to make things consistent and easy to understand:

✔ Each photo in this book is followed by information in small print that looks something like this: *24mm, 30, f/4, 400.* These numbers provide you with insight into how the photo was taken. The first number indicates the focal length of the lens that was used to take the photo, the second number shows the shutter speed, the third number reveals the aperture, and the fourth number is the ISO. For some of the studio shots I indicate that I was using strobes because that negates the shutter speed. Several of the shots were taken using a smaller camera-mounted flash; I mention if these shots were taken through the lens (TTL), flash metering or not.

✔ You run into two camera settings over and over — shutter speed and aperture. Shutter speeds appear as fractions: 1/125 (pretty fast stuff), 1/60, and so on. Each refers to the fraction of a second that the shutter is open. Aperture (the size of the lens opening) is described using a fraction as well, but many times the numeral "1" on the left side of the equation is replaced with an *f,* for example, f/8 or f/5.6 (the equivalent of 1/8 or 1/5.6). The smaller the opening, the smaller the fraction, so although f/4 looks like it should be smaller than f/8, remember to substitute a 1 for the *f,* and you'll see that 1/4 is larger than 1/8.

F-stop (formatted with a hyphen rather than a slash) indicates a generic reference to aperture rather than a specific fraction or setting.

✔ All Web addresses appear in `monofont`.

When this book was printed, some Web addresses may have needed to break across two lines of text. If that happened, no extra characters like hyphens indicate the break. So, when using one of these Web addresses, just type in exactly what you see in this book, as though the line break doesn't exist.

✔ New terms appear in *italic* and are closely followed by an easy-to-understand definition.

✔ **Bold** highlights the action parts of numbered steps and key words in bulleted lists.

What You're Not to Read

I intended this book to be a pleasant and practical read so that you can quickly find and absorb the techniques you want. However, sometimes I can't help going a little bit deeper or relaying information that expands on the basics. You may find this information interesting, but you don't need it to understand what you came to that section to find.

When you see a "Technical Stuff" icon or a sidebar (a gray-shaded box of text), know that the information next to the icon or in the box is optional. You can lead a full and happy photographic life without giving it a glance. (But aren't you curious? A little?)

Foolish Assumptions

Before I could write this book, I had to make some assumptions about who you, the reader, may be. I assume that you

- ✔ Own or have access to a digital SLR camera
- ✔ Know your way around your camera and are ready to take your skills up a level
- ✔ Would like to expand your photographic tool kit to include lights and light modifiers
- ✔ Want to find out how to better light the scenes you photograph without becoming a certified expert
- ✔ Are curious about practical and creative techniques using lights
- ✔ Enjoy futzing with new techniques and equipment that make your photographs better
- ✔ Crave new information about photography but don't have endless time to devote to the project

How This Book Is Organized

The upcoming sections give you a taste of what you find in this book and a sense of where to look for the morsels of information you most want. You

may notice that the parts of the book follow a natural progression from basic to involved techniques, but don't be shy about diving in to the book at whatever part intrigues you.

Part I: Lighting Basics

Light is all around you, but short of changing bulbs in your lamps, you may never have thought about light. It's a fascinating, multifaceted element that's the foundation of photography. It comes in waves, intensities, and colors that vary according to where you are, what time it is, and what's around you. It's worth getting to know, and this part introduces you to it. I give you an overview of light itself and then take you through the ways your camera deals with it and the tools you can use to change the light that's available.

Part II: Let There Be Light: Measuring and Manipulating Light

Without light, there is no photography, and without adequate or appropriate light, there is only crummy photography. This part of the book shows you one of the most important aspects of photography: measuring light. You find out about metering options to discover how much light you're dealing with (and what to do with that measurement). I tell you how to set up your camera (including how camera settings work together) and show you how to use the gear that adds or amends light.

Part III: Lighting for Different Conditions

Each of the zillion times and locations (and combinations thereof) that you may photograph comes with its own set of pluses and minuses. This part covers the conditions of times when you're likely to photograph regularly, like those golden hours around sunrise and sunset. (If you haven't discovered the warm light that time of day provides, you're in for a delight.) Shooting at night is a little more challenging but can produce amazing shots. Trying to show off a room or building also comes with unique challenges, which I discuss here. (You can't tell a building to move a little to its left, for one.) And you may be ready to set up a studio, which I also tell you about in this part.

This section gets into the techniques involved with all these different situations and describes the best way to handle each one.

Part IV: Making Ordinary Photos Extraordinary with Lighting

Here you find ways to light commonly photographed scenes so that the images look their best and the photograph tells the story you want. A harshly lit photograph of your spouse, for example, doesn't tell a story of romance and adoration. This part of the book saves you from just such a photographic mishap. You find out how to light your subjects for flattering portraits and/or appealing still lifes. I show you how to make up for the low light of a nighttime or indoor event, give you steps for creating "paint with light" images that harness light for fascinating effects, and explain how to make your photos look their best with postproduction software.

Part V: The Part of Tens

This part has a feast of useful information broken up into bite-sized pieces. I give you ideas for taking your photography to the next level, points to consider before any shoot, and ways to avoid rookie mistakes.

Icons Used in This Book

Some points are worth hammering home. When I reference a concept that I've discussed elsewhere or one that's particularly important to your photography practice, I use this icon.

I try to keep the information in this book light, but when I can't resist delving deeply into a technique or piece of equipment, I use this icon to let you know that it's okay to skip this information.

This icon sits next to any information that saves you time, money, or frustration in your quest for better-lit photographs.

Some actions can hurt your shot, your equipment, or you. I mark these with this dangerous-looking icon.

Where to Go From Here

If you're ready to build your camera skills or refresh your memory about your camera-setting options, Chapter 3 is the place for you. If you're heading outside to photograph your friend's '63 Corvette Stingray, you may find the information in Chapter 13 helpful. And if you can't bear the thought of reading page 214 before page 13, I cordially invite you to move on to the next page and read straight through till you hit the back cover.

Enjoy — whatever your approach.

Part I
Lighting Basics

The 5th Wave By Rich Tennant

"Get me three tungsten halogen lights and a 5,000K strobe. I'm trying to do something real natural here."

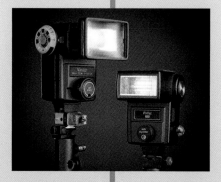

In this part . . .

If light is simply the thing you read or work by, you must be very new to photography. If light is full of color (that you sometimes don't want), causes shadows harsh or soft, and shows viewers where to look in an image, then you're starting to think about light like a photographer. This part of the book explains why and how light does what it does and shows you how to work with it to create the images you want, including setting your camera and using nifty lighting tools.

1

Lighting: An Overview

*L*ight is to photography as breath is to you and me. Without light, photography can't exist. And without well-crafted lighting, great photographs do not emerge from even the most advanced camera or the most breathtaking scene.

If you're new to photography, you probably haven't thought about light much beyond whether you have enough to avoid a fuzzy image. Get ready to open your eyes to the breadth of light and lighting possibilities. Light isn't just the thing that lets you know when to get out of bed or enables you to read a book; it's a wildly complex and thrilling tool that comes in endless varieties. And you — yes, *you* — can bend it to your will to get the photos you want.

Light versus Lighting: Transforming Pictures into Photographs

Light is everywhere, but not all light is created equal. When a photograph catches your eye, the subject usually is what draws you to the image. What you don't always realize is that lighting and the way the photographer used the lighting are what make that photo look as great as it does.

When you start taking pictures, you're happy just to have enough light to get everything lit. After you master taking photos, you need to master *lighting* the photos. When you start lighting your photos, you begin to shape the light and control where you want it to go. You can change the color of the light and control what is lit and what stays hidden; in doing so, you determine the feel and mood of the image.

Recognizing the way light behaves

Fortunately for your photographic purposes, light behaves in an organized and logical way that enables you to use light to your benefit. First and foremost, light moves in a straight line. If you send light out at a certain angle, it keeps going at that angle until it runs out of power or strikes an object.

When light hits an object, the fun really begins because light always does the same thing when it strikes a given type of surface. When light strikes a reflective surface, it bounces off that surface, and it does so at predictable angles. Not only can you direct the light where you want it by reflecting the light into the scene, but you can also reduce unwanted reflections by knowing the angle at which they're coming toward the camera and changing the camera's angle.

When a reflective surface is textured rather than smooth, it reflects light at multiple angles. This scattering of the light actually diffuses the light and is really useful when photographing because the light becomes softer and more pleasing.

Chapter 2 tells you much more about how light works.

Making hard light soft (or vice versa)

As far as photographers are concerned, hard and soft are the primary flavors of light, and flavor is the most important factor in distinguishing light. To begin controlling light, you need to understand the difference between the two:

 ✔ **Hard light** is produced by a small, bright light source, creating hard-edged shadows and high contrast. It's the kind of light you get on a cloudless, sunny day at noon. This type of light is not very flattering, especially when you're photographing people. The first photo in Figure 1-1 is lit with a single camera-mounted flash — and it looks like it. It's properly exposed and illuminates the subject well, but the photo isn't flattering at all.

✔ **Soft light** produces fewer shadows, and the shadows it does produce have a gradual change between dark and light instead of a sharp line. Soft light is very flattering, especially for shooting portraits; the soft shadows fill in any imperfections on the skin and create a smoother look. An overcast day gives you soft light, and you can use light-modifying tools in the studio to achieve soft light. The only difference between the two photos in Figure 1-1 is that the flash is moved slightly and bounced into an umbrella, which seems to wrap the light around the model and makes her skin glow.

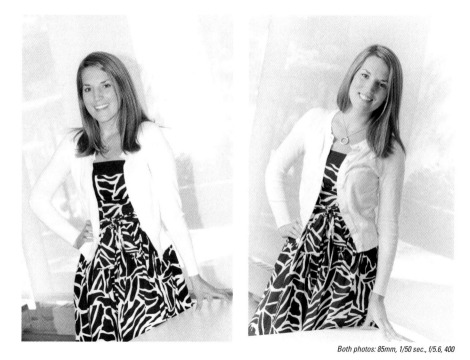

Both photos: 85mm, 1/50 sec., f/5.6, 400

Figure 1-1: A so-so portrait (left) improved with quick and simple lighting changes (right).

A bigger light source is a softer light source. But distance plays an important role: A very large light source that is very far away becomes a very small light source, and a very small light source used close to your subject becomes a big light source. The sun is a great example — although it's an enormous light source, it's so far away that it becomes a small, hard light source (as evidenced by the hard shadows it produces).

When you photograph something that needs a softer touch, move the light closer to your subject or add a diffusion device like a soft box or umbrella. (See Chapter 4 to get the skinny on light-modifying tools.) When you want a harder shadow, move the light farther away, creating a small, hard light source.

Lighting: Past and present

The lighting choices for photographers have come a long way since the days of flash powder. Photographers started out using the sun as their main light source (and many photographers still use it this way), but the invention of electricity changed all that. Photographers started to use electric lights instead of sunlight to take photos, although these lights still weren't bright enough to freeze subjects. The subjects needed to sit still while having their portraits taken, but no longer were photographers reliant on the sun as their main source of light.

Then came flash powder made from highly combustible magnesium, which, when ignited, created a very bright light. The real problem with this was that magnesium was expensive, and because there was no way to sync the flash with the camera, the photographer had to open the shutter, ignite the flash powder, and then close the shutter. Another problem was that the magnesium was very dangerous to work with and could set things on fire if the photographer wasn't careful.

The next big step forward was the invention of the flash bulb, which was a one bulb/one use deal. Each bulb was activated when the shutter release button was pressed. Some bulbs were coated in a blue plastic to change the color temperature of the light and protect the photographer and model in case the bulb exploded. In the 1960s, Kodak released the flash cube for its instamatic camera. The flash cube, which combined four flash bulbs into a single cube, fired when the shutter release was pressed and then rotated 90 degrees when the film was advanced to the next frame. This allowed photographers to shoot four images in a row without having to change the flash bulb.

Modern flashes produce a very bright flash of light for a very short period of time, but from the smallest built-in flash to the biggest studio strobe, they really do it in the same way — by discharging electricity into a gas-filled tube. These flashes can be used over and over again in very quick succession without having to replace the actual flash tube.

Things really have come full circle in some respects. Photographers started by using the sun as a main light, and many working photographers today still swear that it's the best light available. Those photographers who wanted more started with electric lights and now have electric flashes that are powerful enough to light up a building, yet small enough to put in a pocket (albeit a large pocket).

Utilizing the color of light

As anyone who has mixed different kinds of light bulbs in one chandelier or bathroom light fixture knows, light has color. The source of light (a bulb or the sun) determines the light's color, but any surface that light bounces off or passes through before illuminating your subject changes that light's color. So, if you change the lampshade on your living room lamp from white to brown, you get much different light — even a different mood in the room as a result of that differently colored light. Change the bulb from a basic incandescent to a full-spectrum or compact fluorescent, for example, and you get an even wider range of color through those same two shades.

The color of light is measured using the Kelvin scale, which describes the color of light in degrees and is commonly referred to as color temperature. The lower the temperature, the warmer (or redder) the light is, and the higher the temperature, the colder (or bluer) the light is. The warm glow of candlelight and the sunlight at dawn or dusk have a low temperature, whereas a clear blue sky and daylight fluorescent bulbs have a high color temperature.

On the corner of Wacker and Madison Streets in Chicago, where I took Figure1-2, the color looked as normal as can be to the human eye. But after snapping a photo and looking at my camera's LCD screen, I was pleased to find that the sidewalk looks yellow, the building to the left looks green, and the street is an icky blend of the two.

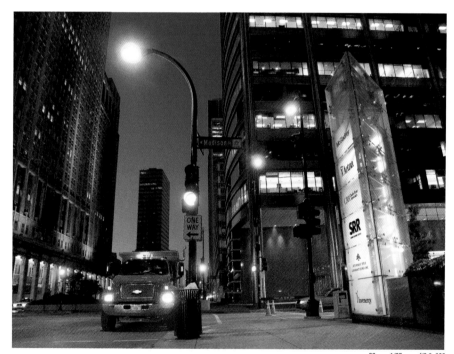

28mm, 1/25 sec., f/2.8, 800

Figure 1-2: A simple street corner is a vast collection of colors and shades.

Knowing the temperature of the light enables you to control what the light looks like to the camera. Digital cameras use a setting called *white balance* to deal with fluctuations in light sources, something your eyes and brain do automatically. When you tell the camera what white balance to use, the sensor accurately records the colors of objects no matter what the color of the light is. In other words, a subject that you shoot under fluorescent bulbs looks the same when shot under studio strobes as long as you set the white

balance correctly. For those times when the color of the light is difficult to know, many cameras also allow you to set a custom white balance. You find out about white balance and the color of light in Chapter 5.

Anything that light passes through can add color to the light, just like the previously noted lampshade, which means that you have a lot of options for changing light's color. If you want to change the color of a flash or studio strobe, you can just put a colored gel in front of it. (Chapter 4 tells you more about gels.) You can't put a gel over the sun, but when you understand the color of light, you can set the white balance in your camera so that the sunlight shows up in your image as the color you want.

You can also change the color of light by bouncing it off something that has the color you want. If, for example you take a flashlight and shine it at a red wall, the light that comes off the wall is red. Reflecting light is a major part of controlling light and using it to effectively illuminate your subject. Because light picks up the color of any surface it's reflected off of, you can change the color of the light to serve your purpose.

Why Effective Lighting Is Important

The light you use in a photograph needs to draw the eye to the subject without becoming the subject itself. Whether you use one light or ten, the subject of the image still needs to take center stage. The best lighting is lighting that the viewers of your images don't notice; instead, they see the play of light and shadow across your subject. The light in your photographs not only illuminates the subject but can also convey a feeling or mood. The way the light illuminates the subject and the mood it evokes are up to you, as the photographer, to control.

Illuminating your subject

Strictly speaking, light's primary job in a photograph is to light up the subject so the sensor in your camera can capture it. The concept is simple at first glance, but when you start to take it apart, it gets really fun and interesting. From this very simple idea, you can start to craft images by selectively revealing and hiding features through light and shadow.

Not every subject needs to be, or should be, illuminated the same way. (What fun would that be, anyway?) You wouldn't want to use the hard light and extreme contrast that you'd use to shoot a horror-movie villain for a politician's headshot. The headshot calls for a softer, more flattering light.

Conveying mood or message

You can control how the viewer responds to your subject by controlling the positioning and color of the light to create the mood you want. Just the way you position your lights goes a long way toward determining how viewers feel about your subject. (Feeling powerful? You should.) Here's a taste of how lighting the same subject in different ways produces three very different moods:

✔ Place your lights in front of and a little bit above your subject to create a nice, open lighting that makes your subject look flat with little texture, which can be very flattering.

✔ Move that same light off to the side, and the shadows start to fill the opposite side of the face. This lighting shows much more texture and starts to add character and mystery to the face.

✔ Place the light on the floor and aim it upward at the subject. Suddenly, you've created a monster-movie poster.

Chapter 12 tells you more about positioning lights for portraiture.

The color of light can also affect the mood of the image. (Chapter 2 tells you about light's many colors.) When you photograph people using warmer light, like a candle, a sunset or sunrise, or even a studio light with a little warming gel, they look healthier than people photographed under a cold light. You can control the mood by controlling the color of the light.

Manipulating Light: The Starter Package

Discovering how to make light work for your images is the beginning of great photography. You do it by learning to see like a photographer and by using your camera and lighting tools to better assess and control the light you work with. You're never going to find one right answer, even for a particular type of image or lighting. So the best you can do is to find out everything you can about how light works and then to practice, practice, practice, taking shots in different situations, modifying various kinds of lights, and creating a range of moods in your images.

Evaluating the light in your scene

Any light that's at the scene when you get there is commonly known as *available light.* It includes the sun, street lamps, building lights — basically any light that's in the scene without you putting it there.

The type, color, and brightness of the available light in your scene determine what you do to amend or supplement that light. Controlling available light is more difficult than controlling the light you bring to a scene, but that doesn't mean you can't do anything with it. You can manipulate the light with diffusers and reflectors or simply add more light. The photos in Figure 1-3 share an awful lot: They were shot from approximately the same location (okay, within a couple feet of each other), they were shot with the same camera, and they were shot with the same 24mm lens. But there's one important difference: about seven hours. I took the first figure at high noon and the second figure a much more pleasing 6 hours and 50 minutes later.

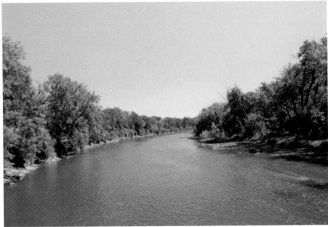

24mm, 1/250 sec., f/8, 100

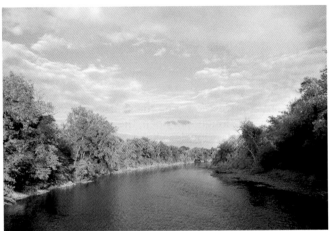

24mm, 1/160 sec., f/6.3, 100

Figure 1-3: A simple landscape image made at high noon (top) compared to the same image made during golden hour just before sunset (bottom).

Before you address any changes, you need to find out how bright the available light really is. That's where *light metering* comes in. Light meters (one is built right in to your camera) either measure the light directly (this type of meter is called an *incident light meter*) or measure the light that bounces off your subject (via a *reflected light meter*). Chapter 5 tells you more about using a light meter.

Your camera's light meter measures the amount of light reflecting off a subject and tries to make it 18-percent or middle gray. This technique works for a lot of situations, but not all of them. I show you when the meter can be trusted and when a handheld, incident meter is a better choice.

Bringing lighting tools into the equation

One of the most important things you can do for your photography is to learn all you can about your camera — especially the controls that control the *exposure,* or the amount of light that's allowed to reach the digital sensor.

The tools you use to manipulate light extend far past the settings on your camera, however. At your disposal (if you care to pay for them or have a buddy generous enough to lend them to you) are scads of tools that soften, direct, or otherwise amend light.

Camera settings that let you control light

Your camera's one and only job is to capture the light reflected off your subject. That sucker may have a slew of complicated controls, buttons, levers, and dials, but don't panic: A measly three controls really matter when it comes to capturing the light and producing an image:

- ✔ **Aperture** controls the size of the opening in the lens that lets the light into your camera. The bigger the opening, the more light is allowed in during a given time. Aperture also controls the depth of field, which determines how much of your image is in acceptable focus.

- ✔ **Shutter speed** controls how long the shutter in front of the camera's sensor is open. The longer it's open, the more light is allowed through. Faster shutter speeds allow less light through. Shutter speed also controls the motion of the subjects in your image and the movement of the camera: Faster shutter speeds freeze action, and slower shutter speeds allow blurring that shows action.

- ✔ **ISO** determines how much the signal from the camera's sensor is amplified when it captures the light. The more the signal is amplified, or the higher the ISO, the less light you need.

Chapter 3 tells you more about how to use these settings.

Light and the equipment that modifies it

You have a great many lighting choices at your disposal, from the built-in, "pop-up" flash on a great many cameras to a full, studio strobe lighting setup. Here's a quick overview of the lights available to photographers today:

- **The sun:** No discussion of lighting can be complete without the big one, the sun. It gives you illumination all day and reflects off the moon to illuminate the night, as well. Photographers use sunlight as a main light, a fill light, or even an accent light. Sunlight streaming through a window or door is some of the easiest light to use to create great photographs. Chapters 8 and 12 tell you about shooting in sunlight; Chapter 15 shows you a cool nighttime technique.

- **Small flashes:** The battery-powered flashes you attach to the hot shoe in your camera can put out a fair amount of light and save a lot of situations by bringing light into an otherwise dark place. They actually work best when not aimed directly at the subject. Chapter 4 introduces flashes, and you find ways to use them throughout this book, especially in Chapter 14, which discusses event photography.

- **Studio strobes:** These large, powerful lights require separate power supplies, stands, and light modifiers. They can put out a really large amount of light, but only during the instant that you shoot. These come in a huge variety of sizes, powers, and costs, and you find out about them in Chapter 4. Chapter 10 tells you about setting them up in the studio.

- **Continuous lighting:** These types of lights started off in the world of movies and video because they put out a constant light. What makes them great for photography is that you don't need anything extra to make them work, and you don't have to figure out how to set your camera. You can just point your camera, have the built-in light meter read the light in the scene, and shoot away.

- **Diffusers:** These are the tools that take small, bright light sources and turn them into big, soft light sources. The most common diffusers are soft boxes and umbrellas that are usually used on strobes and diffusion panels. They can turn the small, bright sun into a large, soft light source. I introduce diffusers in Chapter 4, and you find ways to utilize them throughout the book.

- **Reflectors:** You can buy reflectors made just for photographers, but anything that bounces light back into a scene also does nicely when you need to add light to your photo. Reflectors come in a great many types, colors, and styles.

Chapter 4 goes into much more detail about light-modifying tools.

Using Light for Fabulous Results

The basics of light and lighting stay the same. The light modifiers and techniques you use are what vary, and that depends largely on the situation. The same light that you work with in the studio to photograph portraits doesn't work for shooting action, and it certainly doesn't work when shooting by moonlight, or even at sunsets and sunrises. Each situation requires a different approach. But not to worry — this book has you covered.

You have to use light, light-shaping tools, and your camera in concert to make a photo successful. Along the way, you overcome challenges like mixed lighting sources, low light, and major differences in contrast. And then you do what you set out to do in the first place — light your subject with the most flattering light possible.

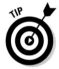

You can use light to direct the viewer's eye into any area of the photo you want to. Here's a simple secret that goes a long way toward telling the story you want to tell: A viewer's eye goes to the brightest part of the image. That doesn't mean you always have to make the subject the brightest points; it's just one of those little things you need to know to make sure that the viewer's eye goes where you want it to.

Don't think for a minute that the wealth of technical information about lighting means that creativity isn't in the, ahem, picture. You can do all kinds of great wonky, funky things with light to make a picture say something completely different from what viewers expect (or you expected yourself). You can paint with light, add different colors, and even tweak your images in postproduction.

Of course, the best way to do this is to understand the way light works and how to control it. Work with the tried-and-true methods you find in this book until you can consistently achieve the results you want. Then get out there, experiment, and build up an arsenal of your own techniques!

2

Defining Light in a Photographic Capacity

In This Chapter
▶ Looking closely at the light around you
▶ Discovering the qualities of light
▶ Taking advantage of natural light

*L*ight is all around you, telling you when to wake up in the morning and when to pack it in for the day. It shows and hides everything you see. When you're taking photos, light is truly more important than the camera itself. On second thought, that may be a bit of a chicken and egg conundrum, but my point remains: You can't take a good picture without the right light.

Whether it's streaming down from the sun, coming out of a ceiling lamp, or placed with care by you, light makes the difference between simply taking a picture and creating a photograph. You can use your understanding of light and shadow to complement or wreak havoc on your subjects. In this chapter, you find out about the ways in which light helps or harms your photographs and get basic information about harnessing its impressive power.

Noticing the Light You Live With

A big part of your job as a photographer is utilizing and manipulating light. But before you even begin to think about how to use lighting in your photography, you need to develop a deep acquaintance with light. Get to know it like your spouse, partner, or college roommate.

Study how early morning and late afternoon light are different from that of high noon. If you work in an office, observe how the overhead fluorescent light differs from the light that comes through a large window. Turn off the overheads while watching whatever is lit by the windows. Keep an eye on how your desk, plant, or carpet changes when the light changes. For that matter, how does that light differ depending on which way the window faces? Even a gloomy and rainy day holds some qualities of light that can be quite peaceful and beautiful. Pay attention to how the light bounces off the walls and other reflective surfaces, causing areas that aren't directly lit to still be softly illuminated. What happens to the light when it has to pass through the leaves on the tree outside or though the semitransparent window coverings?

Check out the two images in Figure 2-1. They couldn't be more diverse, yet photographically the only difference is 12 hours! The top image makes the office look stuffy and uncomfortable, mostly due to the bleak and depressing overhead fluorescent lighting. With the overhead lights off and the wonderful sunlight streaming into the room in the bottom image, the same office looks like a warm and inviting place to work.

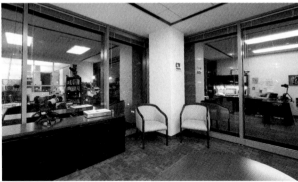

14mm, 5 sec., f/14, 100

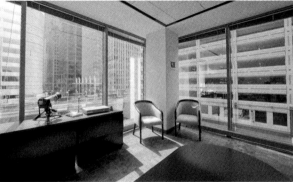

14mm, 1/2 sec., f/14, 100

Figure 2-1: An office scene gets a complete makeover simply due to the light.

As you survey the way light falls on everything around you, look just as carefully at the shadows. Only when you mix light and shadow in perfect harmony do you truly reveal the shape and texture of your subject.

Take your light study a step further and look closely at the lighting found in magazines, on TV, and in movies. The flat, shadowless light found in soap operas and the evening news looks lifeless. The lighting you see in most movies, TV shows, and magazines looks more dramatic, believable, and complementary to the subjects because it mixes shadows and light. Doing the same in your photographs builds realism.

Begin to look carefully at the *transition line* — the point where light meets shadow (see Figure 2-2). Sometimes the transition line is hard and sharp as in the photo on the left; other times the transition is much softer and smoother as in the photo on the right. When the transition line is soft and smooth, you're not as aware of the lighting as you are when a shadow makes a very hard or sharp line in a photograph. Whether the transition line should be hard or soft is a matter of individual taste.

 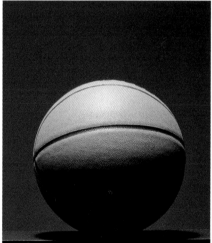

Both photos: 120mm, 1/60 sec., f/22, 50

Figure 2-2: Comparing transition lines. The basketball on the left was shot using a large light source for a soft line, while the one on the right was shot using a small light overhead for a harder line.

Portraiture is a perfect example where the transition line can drastically change the image. Nowadays we use larger light sources that give you a soft and pleasing transition from light to shadow; it's more complementary to your subject, and the photographer does not have to pay as close attention to the subject's facial structure. If you take a look at older portraits, especially the

historic Hollywood glamour portraits, you see they have sharp transitions from highlight to shadow, which sculpts the facial features, meticulously revealing the bone structure of the subject. This sharp definition is missing from modern portraiture.

Describing Light

The various qualities of light can be described as being either comparative or formative. The *comparative* qualities of light — brightness, color, and contrast — can be measured and adjusted in very specific and exacting fashion, whereas *formative* qualities are based on the photographer's own unique interpretation. You control the comparative qualities of brightness and contrast upfront by adjusting the shutter and aperture settings on your camera. With a digital camera, you can control color by setting the proper white balance either upfront, when you take a picture, or after the picture has been taken, using software in postproduction.

Although you can change the comparative qualities of light after you take a picture, your photographic vision should drive all your lighting decisions, and you should control and create lighting conditions while you're shooting. Even though you can make adjustments to these qualities after the fact, working in this manner (with an "I'll just fix it in Photoshop" mindset) is a sloppy practice that will come back to bite you in the long run. Take the time to get it right when you're shooting.

The *formative qualities of light* — size, proximity, and direction — are three qualities of light that you manipulate each time you set up your lights or reflectors. These qualities are exciting because the photographer must actively control them while shooting. You can't change them in postproduction, so it's important to get them right in the camera from the get-go. Understanding these qualities gets straight to the core of how a photographer creates and executes his vision.

The following sections give you the lowdown on each of the aforementioned qualities of light — both comparative and formative.

Brightness

Brightness refers to how light or dark the overall scene is (see Figure 2-3). You know your overall brightness is off when your first reaction is "Yikes, that's too light!" or "Aaagh! Why is it so dark?" Brightness is different from having a single part of the scene very light or dark. If the sun is shining through the window in the background but the faces of your cats are perfectly illuminated in the foreground, then the overall brightness of your scene is appropriate.

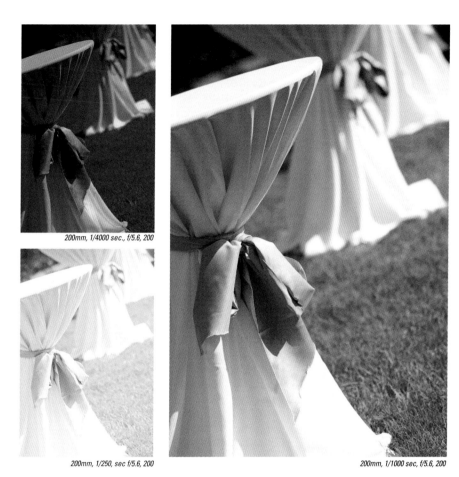

200mm, 1/4000 sec., f/5.6, 200

200mm, 1/250, sec f/5.6, 200

200mm, 1/1000 sec, f/5.6, 200

Figure 2-3: In this three-part series, the overall brightness of the scene shifts dramatically: too dark, too light, and just right.

Separate from how contrasty or flat your lighting is and how colorful or dull your scene may be, brightness is the overall measure of the amount of light in your image.

Color

Light is made of various colors that we're used to seeing all around us. You see color in the warm morning light that wraps around everything and in the cool blue evening light coming through a window in an architectural scene. Color is what makes a blushing bride warm and beautiful.

Color is measured in degrees on the Kelvin scale, which you see in Figure 2-4. The visible spectrum is marked where the human eye can begin to see light. On either side of the visible scale are the infrared and ultraviolet frequencies, which are outside a human's ability to see. Within the scale that humans can see and photograph is the color temperature of things you're already familiar with. You can see how far down a candle is compared to the light of a normal sunlit day. You can also see how shade gets so much bluer in color because it receives light not from the sun, but from the blue sky instead.

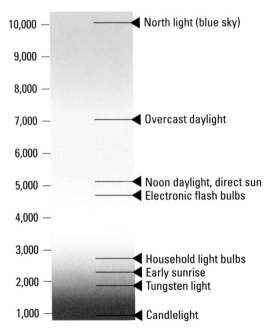

Figure 2-4: The Kelvin scale shows the complete color scale, including that which is outside of human vision.

You can see a perfect example of how tricky photographic color can be by shooting pictures under fluorescent lights, which emit mostly blue and green light (refer to Figure 2-1). Your brain neutralizes this light for you, but the camera doesn't. If you take a picture in an office or other area that's lit with fluorescent lights, your images will turn out green because the lights don't contain red — its wavelength is literally missing from the spectrum of

colors it puts out. If you're shooting under fluorescents with film, you need a magenta filter; if you're using a digital camera, you can correct by either using a custom white balance or selecting the fluorescent color setting on the camera's color dial.

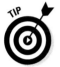

Color balance varies widely among fluorescent lights, so it's best to do a custom white balance (see Chapter 5) before you shoot in fluorescent lighting. The color balance setting on your camera can only come close.

Contrast

Contrast refers to the difference between the brightest bright and the darkest dark parts of your photograph. You can enhance and reduce your contrast in postproduction, but controlling contrast when you shoot your images makes you a better photographer.

Think about how horror movies use high contrast to build suspense and conceal scary people in the shadows. While horror movies usually combine hard light with high contrast for added scariness, you can also achieve high contrast with soft lighting. The easiest way to control contrast in a scene is by using two lights — one that lights your scene and another that fills in the shadows. Your second light source generally is a large one, like an umbrella or soft box that allows you to add as much or as little light as you want. Adding no or very little fill light makes the scene quite contrasty; adding too much fill light creates flat, even lighting on your subject. Experiment with high and low contrast.

Figure 2-5 shows an example of how fill light can affect a photo. The first shot has too much fill, in my opinion; the intricate detail that defines the cake has been lost or simply washed out. The second shot is much more pleasing with almost no fill whatsoever, giving Patty and Neil's cake more detail. However, there's no right or wrong here — the amount of contrast to use is a personal choice.

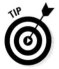

In some cases, like shooting the Grand Canyon, using a reflector or another light to fill in the shadows isn't an option. But with a knowledge of photography — and, more specifically, light — you can make decisions when you're shooting that will help you capture what you see. Changing the time of day can reduce or enhance the contrast of a scene, as can using some simple metering techniques to ensure that you're exposing your shots properly so they're the very best they can be.

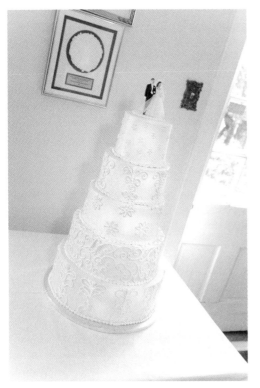 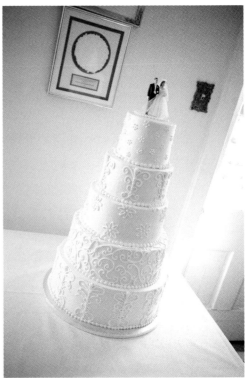

Both photos: 50mm, 1/80 sec., f/5.6, 640

Figure 2-5: The shot with less fill light (right) is more appetizing.

Size

Some shadows have razor-sharp edges, whereas others are soft and smooth. The way you control this variation in your own work determines the look and feel of your photos. How do you create a sharp or soft line between shadow and light? The answer is simple: Size matters. The size of your light source is the single most important factor in determining how hard or soft a shadow is (and vice-versa).

Lighting with small, specular light sources

Specular light is hard light that comes from a small source, such as the built-in flash on your camera. Its hard shadows give it away. Specular light tends to be unflattering in most cases. Hard shadows, especially on a person's face, tend to make a picture look dated.

Don't mistake hard light for contrasty light (light that increases contrast in a photo). Check out Figure 2-6. The shadows are quite sharp and defined, but the image isn't that contrasty. Contrast is also determined by the image's tonality. If the paper in Figure 2-6 was dark in tone, then the image would be contrastier. This image was lit with a single strobe light with a 7-inch reflector.

As a student of photography — and specifically, photographic lighting — try to get in the habit of studying the shadows on all the photographs you see. Look carefully at shadows to determine exactly where the light came from and how large it was. It's a great way to learn lighting.

24mm, 1/125 sec., f/11, 400, with strobe

Figure 2-6: Hard light creates sharp shadows but doesn't necessarily increase contrast in a photo.

A very common specular source is an unmodified electronic flash or strobe unit. When I say unmodified, I mean just the raw flash head — no umbrella or soft box. A small camera flash unit with its 1-x-3-inch flash head will put a hard shadow on just about anything you point it at.

Specular lights cast a *specular highlight,* or little round hot spot, on glass, metal, and other reflective objects when you hit the incident angle just right. The incident angle is identical to playing pool here: It's the angle at which the camera lens can see a light reflected in a shiny object. The angle of incidence is always equal to the angle of reflectance. So to recap, the angle of incidence is the angle at which the light strikes the surface of an object, and the angle of reflectance is the angle at which the light bounces or is reflected off of that object. These two angles are the same. If the light strikes the object at 45 degrees, then it will bounce off at 45 degrees.

Lighting with large, diffuse light sources

Diffuse or *diffused* light is light that is very large in size. The larger the light, the softer it is because of the way it can actually wrap around its subject. Figure 2-7 shows the difference between small and large light sources in photographing a subject. You can see how the light in the photo taken with the large light source (on the bottom) actually wraps around the vase of flowers because the light is so soft and broad.

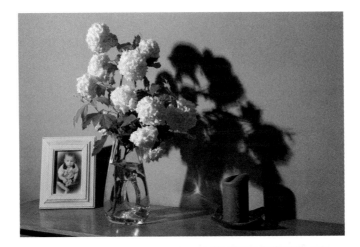

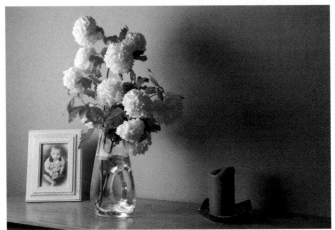

Both photos: 50mm, 1/2 sec., f/16, 100

Figure 2-7: Two identical shots with the only difference being the size of the light source.

Diffuse light is nowhere as direct as that from a specular source — the nature of diffuse light is to spread out from its source. This is what helps it wrap around its subject.

Diffuse light is the same as the north light that all artists want for their studio. Most portraits are shot with diffuse light because it creates soft and pleasing highlights on skin as well as smooth shadow transitions. The line between the highlight (lit) and shadow areas of a shot is much softer and smoother, and draws much less attention. Imagine that you're shooting a photograph of your grandma and want to give her all the help that Barbara Walters receives on a regular basis. Barbara always looks soft and radiant, in part because of the way she's lit — no harsh shadows appear because the light wraps around and fills every nook and cranny on her face.

You want the light to be broad and even before it graces your nana's face. You can accomplish this by bouncing your main light into a white photo umbrella to increase its size from merely a few inches to a couple feet across. Shining your light into a soft box (see Chapter 4) softens the light more evenly than an umbrella, due to the very nature of its design. Figure 2-8 shows both an umbrella and a soft box set up and ready for action.

The portrait on the left of Figure 2-9 is almost identical to the one on the right; the only difference is that the main light source is now a diffused light instead of a specular one. Ahhh, isn't that better?

If, instead, you use just the light of a studio flash or the light of a small flash unit, you're using a much smaller light than you'd get from an umbrella or a soft box. The result is sharp and often harsh-looking, because the light can't wrap around your subject at all. It doesn't fill any lines in the face and, without careful positioning, can give your subject raccoon eyes. This is also the light you get if you photograph someone outside on a bright, sunny summer day.

Lastly, don't forget about window light — it's nature's diffusion panel. Simply find a window that doesn't have direct light shining through, and place your subject at the far edge so the soft light can bathe the person's face. Keep the actual window out of the shot, and shoot away. Photographers have used this technique for years.

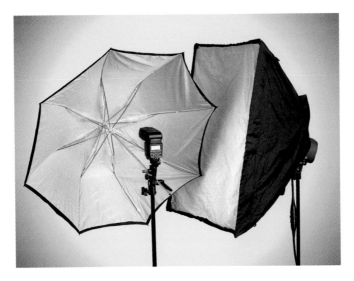

Figure 2-8: Using an umbrella (left) or soft box (right) gives you broad, even light.

Both photos: 50mm, 1/125 sec., f/5.6, 400, with strobe

Figure 2-9: The simple (and goofy) portrait on the left was shot with a small specular light source, whereas the portrait on the right (still goofy) was made with a large diffused light source.

Lastly (and I mean it this time), think about the soft light of a cloudy day. Nothing is softer than the giant diffusion panel in the sky, wrapping everything in sight with soft, shadowless light.

Proximity

The size and proximity of your light source are interrelated (for more on why size matters, see the preceding section). The *proximity* (or nearness) of your light source to your subject affects the size of the light hitting your subject. A large light close to your subject gives you a nice, softly lit image. Move that same light away from the subject, and you get the same flat, unflattering qualities of a smaller light.

If you place an umbrella or soft box 2 or 3 feet away from nana, the light hitting her face will be incredibly soft on her skin. Her age lines and wrinkles will be filled in softly and gently by your large light source. If you move that very same light across the room, it loses its size in relationship to her face. When it's 2 or 3 feet away, the light is more than twice as large as her face, whereas from across the room, it's quite small in comparison. You lose all the softening qualities you get with a large light source close to your subject. Nana instantly looks older because her wrinkles have shadows in them instead of being lit by your large, soft light source.

This same phenomenon is true of sunlight and moonlight. Anybody who has seen a night lit by a full moon knows that the moon's light produces sharp shadows. The moon is a specular — or small, sharp — light source. (See the preceding section for more on specular light sources.) But how can something with a circumference of more than 2,100 miles be considered a small light source? Even a huge, monstrous source is small when it's well over 200,000 miles away. You get the same effect when you move your large (diffused) light source far away from your subject. Now think about the sun for a minute. It's the biggest thing in the galaxy but because of its distance from us, the light source is actually very small, producing a very hard light. Just look at the shadows produced on a cloudless day — sharp-edged and clearly defined, the characteristics of a hard, small light source.

Direction and angle

The direction of the light as it shines on your subject affects pretty much everything about your shot. If you're making a portrait of a friend, for example, you can make his face look skinny or fat by how you place the light. If you're shooting your significant other, you better know which is which!

Take great care when you set up your lights; you can't change the direction and angle of light in postproduction. Your lighting setup becomes even more critical when you're using specular lights, because the shadows are so sharply defined. Diffused light, with its softer shadows, is a bit more forgiving.

Your orientation to the sun can make or break an image quicker than you know it. Next time you shoot pictures outside, try this simple test:

1. **Shoot a portrait of a friend with the sun shining directly in her face.**

 Fill the frame with her head and shoulders. Don't let her wear a hat or sunglasses.

2. **Turn (and turn your model) 180 degrees so the sun is behind your subject, and shoot the picture again.**

3. **Compare the two images.**

Step 1 produces a shot in which the model is wincing from the sun in her eyes, and flat light makes her blend into the background. The image from Step 2 looks better in comparison: The model's face is evenly lit by the open shade (shooting from a shady spot on a bright, sunny day; see the section "Ambient Light: The Light That's Available — Or Not" for more on open shade). She isn't squinting, and she just pops off the background because of the backlight.

The only thing that changed between Step 1 and Step 2 was that you used your rock-star knowledge of the angle and direction of light! Well done; take a bow! To take this to the next level, try changing the angles to 90 degrees and 45 degrees to see what happens when the sun travels across the surface you're shooting and, more importantly, what happens to the shadows.

Shooting shiny: An introduction to reflective surfaces

Just as the size and proximity of your light source have everything to do with just how soft your lighting is, the surface of your subject also has a considerable effect on the outcome of your pictures. Say that you finally agree to shoot Aunt Edna's collection of toasters so she can sell them all on eBay and move to Branson. The challenge is this: Aunt Edna has a thing for chrome, and half of her collection is as bright and shiny as the bumper of a 1951 Studebaker.

You know you want your shadows to be soft, so you show up with your photo umbrella, ready to go. After you knock out all the painted and rusty toasters, you get to the chrome ones — and you're stuck. Regardless of where you place your light, all you see is the rest of Aunt Edna's dining room reflected in the side of the dang toaster. Your pictures of the rusty ones look so good that you're planning to pop for a print for your own portfolio. Yet the chrome ones have you ready to pack it in.

You've just hit a common obstacle that all photographers face sooner or later. And you don't encounter it only when you're shooting a chrome toaster for a friend — it may be cousin Louie's pride-and-joy, 1972 convertible Karmann Ghia or really, anything that's shiny. An even bigger challenge is something that's both shiny and dull at the same time. In Chapter 10, I give

the example of comparing a basketball to one of those gazing balls that people put in their garden. Both are the same size and available in similar colors, but they couldn't be more different when you set out to photograph them.

All your shiny surfaces need to be lit with a large, diffused light source (see the earlier section "Lighting with large, diffuse light sources" for more details). This will generally be a soft box or a 3-foot frame that you can make out of PVC pipe from the hardware store. You can then cover it in any number of materials, ranging from official photo diffusion material to a clean white bed sheet, a shower curtain, or my personal favorite, rice paper. Regardless of what you use for diffusion material, the idea is for the shiny object to only reflect the smooth, wrinkle-free material that you have evenly lit. Don't forget the discussion about keeping the light close to nana (see the "Proximity" section) — the exact same things apply here too.

There are also specialized items called *light tents* or *light cubes* that are made for shooting shiny tabletop objects. These light tents or cubes are designed to surround an object and, when lit from the outside, they create an even, flat lighting with no hard shadows or reflections. They're available in different sizes, from small tabletop boxes all the way up to portrait-sized.

Ambient Light: The Light That's Available — Or Not

Ambient light is light that is all around you — the light that was there when you got there and will be there when you leave. It's the light that comes from the ceiling, through the window, or from that giant orb in the sky. If you're

clever, you can use it for fill when you shoot on location. Photojournalists' standard operating procedure is to use ambient — also known as existing — light for all their images. Nothing makes an image look more realistic then just using what's already there.

This is a very valid way to approach your craft, and being aware of how artificial light works, as described in the previous sections, will only make you a better natural light photographer.

When you're working with ambient light, keep the following considerations in mind:

✔ **Color temperature:** Because ambient light comes from such a variety of light sources, you need to be ready for a very wide selection of color temperatures. Evaluate the light to determine where it falls on the warm–cold continuum. A normal light bulb comes in around 1,900 degrees Kelvin, for example — warm as toast. See Figure 2-10.

Figure 2-10: Tungsten light bulbs (left) create a warm light often equated with homes. Fluorescent lights (right), with their green overtones, feel more like office and workplace lighting.

✔ **Environmental influences:** Imagine two lights in a room, one that hangs from a white ceiling and a floor lamp in a corner. The wall is green and so is the couch. Guess what color will be reflected into the scene? Depending on where you're shooting in the room, you'll have some green in your shot. That's because light picks up the color of any surface it bounces off of.

✔ **Open shade:** Outside, you'll encounter a blue cast when you're shooting in open shade conditions. *Open shade* refers to shooting into a shady spot on a bright, sunny day. In effect, what's lighting you is the blue sky, which is where the blue cast comes from. This happens under trees, in the shade of buildings — anywhere you have shady conditions on a sunny day. Photographing people with this blue cast may cause them to look a little sickly. To avoid this, most cameras offer a setting for open shade. It's usually a little house that looks like it's being held up by a bunch of wooden beams, as shown in Figure 2-11. When the white balance is set to this, the blue color cast will be neutralized.

Figure 2-11: The open shade symbol on a Canon camera.

✔ **Atmospheric haze and pollution:** Ever wonder why all the really big telescopes are on hilltops in obscure places away from the city? Atmospheric haze is a factor to some degree no matter where you are, but in major cities, pollution plays a bigger role. Shooting from a back yard in the western burbs of Chicago is a lot different from shooting in a field in Peoria or Springfield, Illinois. The haze can affect the color and intensity of the light. If it's really bad, a custom white balance may have to be used, but in most cases, the auto setting will take care of the problem. (See the sidebar "Using the moon as a light" for more on the effects of pollution.)

Using the moon as a light

Making use of the moon's ambient light in the thick of the night produces unique images. If you just want to let the moonlight illuminate a landscape, you need some coffee, a tripod, and a flashlight. Theoretically, with the moon in the sky on a clear night, you should be able to shoot in daylight white balance with your camera set at the same exposure you use when shooting in sunlight. The figure in this sidebar was shot from my back yard with the amazing (and $12,000) Canon 800mm lens using the camera's daylight white balance setting. The final image (the one you see in the figure) had a good amount of yellow removed from it. This is partially due to the amount of atmospheric haze we were trying to shoot through, but more so due to the amount of pollution in the air. The best strategy is to get away from any and all light pollution.

800mm, 1/80 sec., f/8, 250

In Chapter 15 you can see Eric Fletcher's use of a painting-with-light technique in a car shot, which was made in the middle of the desert. Off in the distance you see the light pollution on the horizon from sin city (Las Vegas). When you're in a city and accustomed to its light pollution, you really don't notice it, but if you want to take a shot lit only by the moon, you soon realize how far you have to go to get away from it.

After you drag the kids to the middle of a field to shoot a creepy, abandoned barn, you need to set up your tripod. Don't wait till total darkness falls — you may want to capture some of the last bits of blue color in the sky in your shot. A half hour or so after sunset is usually a good time to start shooting if you want to shoot with some color in the sky.

When you set the shutter speed, know that you'll need a long exposure, but also know that if your exposure is longer than 15 seconds and you have the moon and stars in the shot, they'll blur because of the earth's rotation. If your camera has a noise reduction feature, flip it on to help reduce the amount of digital noise that finds its way into your shadows. Keeping the ISO or camera speed under 800 also helps reduce the amount of noise. Set the camera's color balance to daylight, and start banging away like a drummer. I generally begin by taking a look at the camera's exposure and then *bracket,* or make exposures that are brighter or darker on each side of the camera's first reading. Start at 15 seconds at f/8 and see what you get. After you see your first exposures, you can make adjustments from there. Refer to Chapter 5 for more detailed information on metering tricky situations like this one.

3

Getting Familiar with the Camera Settings that Control Light

*T*he camera can be a source of frustration for photographers making the jump from a 100-percent-automatic, "let the camera do everything for me" mode to full manual control where nothing is set until you set it. I assure you that after you get a handle on how these controls work, setting your camera will be as comfortable as wearing your favorite pair of jeans.

As you discover each control, I encourage you to think about its place in the big picture. The three main controls work together in harmony, so making a change to one may require you to change another. And each change you make affects your image. When you master the controls I talk about in this chapter, you gain creative control over your work.

Discovering Your Camera's Basic Settings

The same three factors that have been around since the beginning of photography are the ones that cameras use today to record an image. Whether you let the camera make all the decisions for you or you make all the decisions for the camera, understanding these three basic controls and how they work are paramount to applying lighting techniques to your photography.

Lens aperture

The *aperture* is an adjustable opening inside your lens that opens or closes to let an exact amount of light through to the shutter and, ultimately, the film or sensor. Made up of tiny metal blades, it functions just as the iris of a human eye does, getting small, or *stopping down,* outside in bright sun and opening up wide in darkened rooms.

Aperture is measured in f-stops, which are fractions describing the size of the lens opening in relation to the focal length. F-stops are usually described as "f/number." The f-stops that a lens has are determined by the manufacturer when the lens is made. Lenses can have a range of apertures that can go from f/1 through f/22 and beyond (a little more on aperture ranges and lenses in a minute). Because these are fractions, the smaller the number, the bigger the opening in the lens, and the more light is let through. Figure 3-1 shows you several apertures and their corresponding f-stops. Notice that the lower the f-stop number, the wider the opening in the lens.

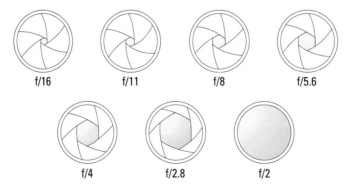

f/16 f/11 f/8 f/5.6

f/4 f/2.8 f/2

Figure 3-1: With a smaller f-stop comes a larger aperture.

If you buy a lens with a maximum aperture of f/2.8, when you set the lens to f/2.8, the aperture is open as wide as possible and not blocking any light whatsoever. As you stop the lens down by adjusting from f/2.8 to f/4, the blades of the aperture begin to close down, blocking exactly half of the light from getting through the back of the lens. When you stop down to f/5.6, the aperture's blades block another half of the light passing through the lens. When you get all the way to f/22, very little light passes through the lens because the opening is very small.

As a rule of thumb, lenses with very wide maximum apertures — those that range from f/1.2 to f/2.8 — are more expensive than lenses that have a maximum aperture of f/4 or smaller.

There are also two different types of zoom lenses: those that have a constant maximum aperture and those that have a variable maximum aperture:

- ✔ **Constant maximum aperture:** With these zoom lenses, the maximum aperture doesn't change when you change the focal length. For example, a professional 70–200mm f/2.8 zoom lens has a range of focal lengths from 700mm to 200mm, and no matter which one you use, the maximum aperture is f/2.8.

- ✔ **Variable aperture lenses:** These zoom lens are made such that as the lens zooms out, the maximum aperture changes. So if you have a 24–120mm, f/3.5–5.6 lens, when the focal length is set at 24mm the maximum aperture is f/3.5, but when you zoom out to 120mm, the maximum aperture changes to f/5.6.

The finder of your camera doesn't get dark as you stop down because the aperture only stops down or engages as you take a picture. If you want to see this process in action, set your shutter speed to 1/30 second or a similar slow shutter speed, stop the lens down to f/11 or so, and look into the end of the lens as you release the shutter. Voilá! It looks like the beginning of a James Bond movie, doesn't it?

Aperture also affects the depth of field in a photograph. *Depth of field* refers to just how much of your scene is in focus in front of and behind your focus point. Say you're photographing your kids playing in the yard and you want everything possible to be in focus. Stop the lens down to f/11, f/16, or even f/22 if it's bright enough outside. Doing so gives you the greatest amount of focus, or the greatest depth of field. If, on the other hand, you're taking a portrait of a friend, you probably want as few distractions as possible so that the emphasis of the picture is on your friend. After you select a nice, nondistracting background, shoot with the lens opened up to a smaller number so that the background goes out of focus. Set your aperture to around f/4 or f/5.6 to get started.

Shutter speed

The *shutter* in your camera is a physical stop in front of your camera's digital sensor. You set the shutter's speed to control how long it remains open when you press the shutter release button. Modern cameras generally have settings that range from 30 seconds all the way to 1/4000 second.

The smaller the number (faster the shutter speed), the less time the shutter is allowed to stay open and the shorter the exposure time — and the more action-stopping ability you gain. A photo of grandma sitting by the window doesn't involve much action, but a shot of runners and bikers requires a shutter speed of at least 1/250 second; 1/1000 second is ideal to ensure the runners and riders will be frozen in the image.

Shooting in the evening, at night, and indoors all require slower shutter speeds that could easily be a full second or longer. A good rule of thumb is to set your camera on a tripod when you're shooting at 1/60 second or longer.

There's a rule of thumb that many photographers use to get the sharpest photos when hand-holding their camera (not using a tripod): You want to use a shutter speed that's faster than the focal length used. This means that for a 200mm lens, you want to shoot at 1/200 second or faster and at 50mm, you want to shoot at 1/50 second or faster.

With practice, it's possible to hand-hold a camera and shoot at slower shutter speeds, but it's more difficult. Remember that the preceding rule doesn't take into account the movement of your subject, so if you have a car race where your subject is moving really fast, you still need to use a high enough shutter speed to freeze the action.

When using flash equipment, you need to be aware of the *sync speed* — the fastest shutter speed that lets you use a flash — of the camera you're using. Check your owner's manual to find the sync speed. When you use the faster shutter speeds on your camera, the entire digital sensor may not be exposed at the same time. If your camera has a flash sync speed of 1/250, you can shoot at 1/250 or any speed slower, and the entire shutter will be exposed at the same time.

As the shutter travels across the opening — particularly with the faster speeds — the shutter actually begins closing on one side while the other side is still opening up to expose the film or digital sensor. The flash fires when the entire sensor is exposed. You can shoot at any speed slower than your camera's sync speed with your flash, but if you shoot at a faster speed than your sync speed, your flash lights only a portion of your photograph. Say you're stopping a speeding race car in turn four and you set your shutter speed to 1/1000 second. Then you decide to use your flash, but you forget to change your shutter speed to your camera's sync speed. If your camera's sync speed

is 1/250 and you shoot at 1/1000, only a quarter or so of your picture will be lit by the flash. You'll see this when you're shooting digitally — make the correction quickly.

Film speed and ISO

A film's speed or camera's *ISO* refers to its sensitivity to light. ISO stands for International Organization for Standardization (test question, write it down) and is simply the measurement system for your camera sensor's sensitivity to light. The higher the ISO, the more the signal from the sensor is amplified, meaning it can do with less light and is effectively more sensitive to light. The higher the ISO is set, the less light you need, enabling you to shoot in a darker environment. If you're shooting at 200 and switch the camera's ISO to 400, it becomes exactly twice as sensitive as before. If you go the other way and set the speed to 100, the sensor in your camera becomes half as sensitive.

Back in the good old film days, you bought whatever speed you wanted. So a photographer carried film in several different speeds: 100 for outside in bright light, 400 for indoors with a flash, and up to 1600 for nighttime and sports shooting. The higher the ISO number of the film, the more sensitive the film is to light. The trade-off is that faster film means more grain shows up in your image, and you lose sharpness, color brilliance, and contrast.

Similar things happen in the digital world when you set your camera's ISO increasingly higher, but instead of the larger grain you get with film, you get increased digital noise. *Digital noise* adds discolored pixels that are especially noticeable in the dark areas and those with a smooth tone, like a blue sky. Software can reduce these somewhat, but lowering the amount of noise by shooting at the lowest possible ISO is always best.

Try to shoot using the camera's *native speed* — the lowest possible ISO setting, which results in the least amount of digital noise. On most cameras, the lowest speed is either ISO 100 or ISO 200.

To find your camera's native speed, you need to locate the ISO setting; most cameras have a button marked "ISO" or "ISO Sensitivity." When you hold the button down, a screen pops up with the current ISO setting, and you can use one of the camera's dials or knobs to set the speed you want. The native speed is the lowest setting available. With some cameras, you have to go through menus to get to the ISO — a little slower but worth it. Your images look much sharper, have better contrast, and have less noise when you shoot with a lower speed.

Figure 3-2 shows the difference between a shot made at ISO 80 (the Canon G11's native speed) and the very same shot at ISO 1600. Here you can see the negative effects of the added noise in the picture.

12.1mm, 1/200 sec., f/4, 80

12.1mm, 1/1000 sec., f/8, 1600

Figure 3-2: The shot on the top shows more digital noise than the one on the bottom.

Deciding How Much to Decide: Picking the Right Mode

Letting the camera choose combinations of aperture, shutter speed, and ISO is great if you're just shooting snapshots to record your vacation. But as you make the journey from taking pictures to making photographs, you'll want more and more control over your photography.

Don't get me wrong — all camera modes have their place; my favorite is the green mode Canon and Nikon put on their cameras. I call it "grandma mode." If you need to hand the camera to someone who doesn't have a clue and just wants to see something — anything — green mode is your answer. The mode

is actually masquerading as full program mode with some added automation. This mode takes care of the aperture and shutter speed as the other modes do. It can also take of your ISO, and even your color balance — which can be a bad thing. It's hard to get a handle on your lighting if the camera is doing everything for you.

Modes you can make the most of

Look at the standard modes on your camera and get acquainted with these basic modes:

- ✔ **Program (P) mode:** Program mode sets the lens aperture and the shutter speed for you, based on its meter readings. It uses whatever color balance and ISO you set into the camera. This mode is a good, all-around shooting mode to use if you don't want to worry about aperture or shutter speed all the time. The difference between this and a full Auto mode is that you can adjust the shutter speed or aperture settings and the camera will automatically adjust the rest of the settings to still get the proper exposure.

- ✔ **Time value (Tv) mode or Shutter Speed Priority mode:** This mode lets you set your shutter speed, and the camera uses its meter to determine and set the proper aperture for the photograph. This is a great mode for sports or other photography where you know you want to stop the action. The camera selects the aperture it needs for the ISO and shutter speed you select.

- ✔ **Aperture value (Av) mode or Aperture Priority mode:** In Av mode, you select which f-stop you want to use, and then the camera meter decides which shutter speed to use for the shot. This is the best mode for shots where you want to control your depth of field. For scenic and architectural shots where you want a large depth of field, stop the lens down or use a small aperture (f/11-, f/16-ish). Wedding photographers often use this mode for the opposite reason, to ensure the aperture stays open (f/2.8-, f/4-ish) so that the backgrounds are as out of focus as possible. Reducing background clutter makes a blushing bride pop off the page.

- ✔ **Full manual mode:** Full manual mode means that all the decisions are up to you. Some situations cry out for full manual, and this mode is the best one for experimenting and learning about photography. From setting your ISO to a low, noise-free setting to setting a custom white balance that prevents the camera from being tricked by your lighting, manual settings are truly key to your success as a photographer. Not all modern cameras offer full manual control. Only the most expensive of the pocket-size, happy-snappy cameras offer this feature, and the entry level dSLRs don't allow full manual control.

Auto modes to avoid

As you're figuring out how to maximize your camera setting for the optimum results, make sure the following auto features are *not* set:

- ✔ **Auto ISO mode:** Some cameras have an auto ISO mode that can get you in trouble faster than a kid in a candy store. This mode usually is represented on your camera by just the letter A. When you use auto mode, the camera selects the ISO it thinks is appropriate for the shot. It works to keep the shutter speed above 1/60 second to prevent any blurring you may get if you're holding your camera while shooting, and it keeps the lens stopped down about two stops from wide open, which is generally the ideal f-stop for maximum sharpness.

 To achieve this middle ground of exposure, the camera uses the ISO to speed up or slow down as necessary to keep the exposure in the safe zone. So if you're outside on a sunny day, it shoots around ISO 100 or ISO 200; if you go into the basement, it quickly shoots up to ISO 800 or ISO 1600 in an effort to keep the aperture and shutter speed out of extreme areas. These higher ISOs produce a large amount of digital grain or noise in your images. Refer to Figure 3-2 to get a sense of digital noise.

- ✔ **Picture modes:** Several camera modes are indicated by pictures instead of names. I've always been amused by these modes because they rarely match up with what I want to shoot. The concept behind the pictures is to remove the need for a technical understanding of photography and make it easier to use the camera's technology to capture what you want to shoot. You select the picture that closely matches what you want to photograph, and the camera sets the color balance and the ISO, and makes aperture and shutter speed decisions for you. The camera adjusts contrast settings based on the little picture you select. Portraits have a smoother, less contrasty setting, while sport and scenic shots may be a bit contrasty, making the images pop a little more.

P (or Program mode — see the preceding section) used properly is about as far as you should travel down the "camera-does-everything-for-you" highway. Setting color and ISO are too important to your end results to leave up to a running stick figure.

Choosing a File Format

All of the DSLRs and many of the compact digital cameras sold today come with the ability to shoot using the Raw file type. Each camera maker has its

own proprietary version, but the result is the same: The Raw file type saves all the information captured by the camera's sensor without doing anything to it — no color correction, no sharpening, no adjustments at all.

When you shoot Raw, you have to do some sort of postprocessing using image-editing software before you can share or use the images. The Raw file type makes a lot more information available to you for use in postproduction, and you can apply adjustments without damaging the file (see Chapter 16 for more on working with photos in postproduction).

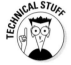

The Canon Raw file saves 14 bits of information for each color, which is a staggering 16,384 potential colors. But when you take 16,384 levels for each of the RGB colors, you get more than 281 trillion colors. That's right — *trillion.*

The disadvantage of Raw files is that they're bigger, so they take up more space on your memory card and are slower to upload to your computer. When you save your images using the JPEG file type, on the other hand, all the data from the sensor gets processed and saved as a smaller file but with less of the original data. JPEG is the way to go if you don't have the time, energy, or skill to postprocess all your images.

I believe that you should photograph using Raw files all the time. Doing so gives you better image quality overall and allows for better editing in post-production. Some camera manufacturers allow you to shoot in both Raw and JPEG at the same time for the best of both worlds. Shooting in both formats at once takes up more space on your memory cards and can slow down the camera a bit, but memory cards are inexpensive, and having the option to either use an image right away or to most effectively correct it is no small thing.

To shoot in both Raw and JPEG at the same time or to just shoot all Raw all the time, you need to access your camera's menu. File format usually is in the first setup screen when you activate your menu; look under the Quality tab. There you find choices for how large you'd like your JPEGs and Raw files to be. With cameras providing larger and larger files, you may find the choice of Raw, smallRaw1 and even smallRaw2. Just like selecting a JPEG file size, you can save Raw files that are smaller than the full resolution files the camera is capable of producing.

With the memory cards getting faster, larger, and cheaper and hard drives doing the same, I recommend shooting the largest possible Raw file that your camera is capable of shooting. You never know what the future brings; perhaps your photo will end up on a billboard or printed large for a gallery show down the road. Large Raw files will serve you well.

Surveying a Few Other Settings

The camera's built-in white balance control is quite remarkable: With a few flicks of your fingers, you always have the perfect film with you. George Eastman probably would have wet himself to have this kind of power at his fingertips. Knowing when to use each white balance preset instantly improves your images.

- ✔ **White balance:** Most cameras have a series of white balance modes that set the camera to approximately the right color balance for the lighting conditions you're shooting pictures in. These conditions include

 - **Daylight:** Represented by a sprocket-like symbol (it's actually supposed to be the sun)

 - **Tungsten:** Represented by a lightbulb symbol

 - **Overcast day:** Represented by a cloud

 - **Shade:** Represented by a symbol that looks like either a tree with wood holding it up or a small, one-room house with 2x4s holding it up.

 These modes are great, and I use the sunlight mode whenever I'm outside. It sets the camera to approximately 5,500 degrees Kelvin. (See Chapter 2 for an explanation of the color spectrum.) For interiors and other situations that are a little trickier, you should always perform a custom white balance (see next bullet).

- ✔ **Custom white balance:** One look at all the color balance presets, and you know that color can really run the gamut. Digital photography enables you to get a perfect color under almost any lighting known to man (or woman). While you should consult your owner's manual for the exact procedure, it goes something like this: When you're under the lighting conditions that you'll be shooting in, take a picture of something that's neutral in color, usually a commercially produced gray or white card that's designed specifically for this purpose. Then tell the camera to use this particular photo for a *custom white balance*. The camera makes the image completely void of colors and tints, so that all the images you shoot after setting this white balance are perfectly neutral in color.

 Performing a custom white balance is one of the very best habits you can develop. Your images will begin to look better immediately once you incorporate this practice into your workflow. Figure 3-3 shows two examples of badly discolored gray cards before a custom white balance on the left, and the exact same shots after a custom white balance on the right. Chapter 5 goes in depth into this process, along with how to trick it for creative purposes.

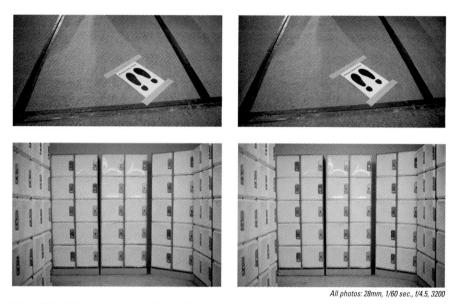

All photos: 28mm, 1/60 sec., f/4.5, 3200

Figure 3-3: Before-and-after effects of a custom white balance.

Using Flash Settings

Flashes come in a couple flavors nowadays with a majority being *TTL,* or "through the lens" systems. The way the system works is both simple and kind of cool at the same time. Light from the strobe shines onto your subject when you first start taking the picture, and the camera literally shuts off the light when the subject receives enough light. How does it do this? In one of two ways, the first of which is falling by the wayside:

- ✔ The camera has a little sensor that literally watches the film plane and measures the amount of light bouncing off it.
- ✔ The digital sensor sees the amount of light it's taking in from the flash and ensures that the right amount is falling on the subject.

Full auto

An auto flash works in a pretty straightforward manner. Mount the strobe unit on top of the camera, and you're set; the camera trips the flash, and the flash illuminates your scene. It does this completely separate from the mode that the camera is in. A little optical sensor that's built in to the strobe

watches the amount of light bouncing off the subject and shuts off once the proper amount of light hits the subject.

The one time it's important for you to refrain from using full auto is when there are objects in the frame closer to the camera than your subject. These will be overexposed because they'll be hit with too much light.

Fill flash (or slow sync)

A *fill flash* is any small light that you use to fill in the shadows of your subject. Fill flash has become a wildly popular feature in cameras ranging from a little happy-snappy that can fit into your pocket to a larger, single-lens, reflex camera system. You use a fill flash when you have a lot of contrast that you want to reduce. A brightly lit day and subjects in the dappled light under a tree are ideal situations for fill flash. You use it to fill in the shadows on your subject, not to add light to the main image. If you do it well, viewers don't notice the flash in your shot. Instead, they see more detail in the shadowy portion of the photo. Figure 3-4 shows two before-and-after examples of fill flash. You can see how the filled versions don't look like normal full-flash photos.

Some cameras call this feature *slow sync* because the flash is barely firing during a longer (or slower) exposure, usually putting 1½ to 2 times less light on the subject than a full flash. Fill flash can be used both inside and outside with equally good results. In both situations, the camera bases the exposure on the natural light in the scene and then uses the flash to fill in the shadows. It can even be used during very long interior shots and night shots with a tripod.

Lighting for Wide Angle and Telephoto Lenses

The lens you choose can either make your job easier or be a thorn in your side when you set out to light a photograph. A typical portrait lens is 85mm on a full-frame digital camera, but if you're using a digital camera with a partial chip, a 50mm lens offers the same slight telephoto effects that the 85mm lens offers on a full-frame camera. The 85mm and 105mm lenses are called portrait lenses because they're slight telephoto lenses that make the backgrounds go a little fuzzy or soft in comparison to normal or wide angle lenses. They give you nice head-and-shoulders shots without having to get too close to your subject. Figure 3-5 shows you a portrait taken with a normal lens on the top and with a portrait lens on the bottom.

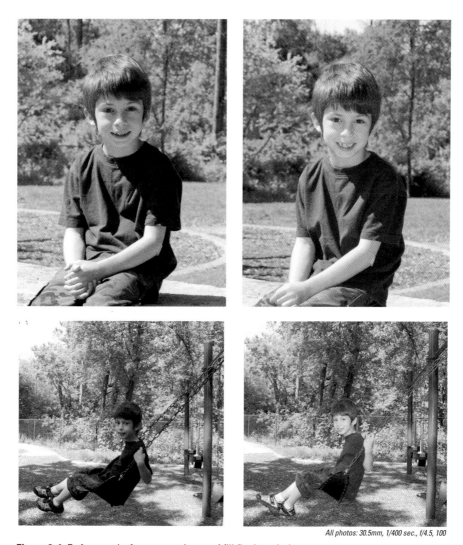

All photos: 30.5mm, 1/400 sec., f/4.5, 100

Figure 3-4: Before-and-after comparisons of fill flash technique.

I tell you about this slight telephoto lens in detail in Chapter 12 but in the context of lighting, a short telephoto lens for portraits offers a couple benefits over wide-angle lenses. When you light people and take tighter head shots, the short telephoto lens lets you work with your lights and reflectors close to your subject, giving you the ability to really see not only the big changes but also the effects of the smaller adjustments and tweaks you make along the way.

50mm, 1/15 sec., f/5.6, 160

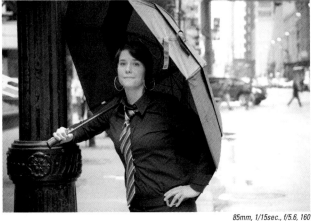

85mm, 1/15sec., f/5.6, 160

Figure 3-5: A simple portrait made with a normal 50mm lens (top) and a more pleasing head-and-shoulders shot made with a portrait lens (bottom).

The challenge that you find yourself up against when you're lighting anything is where to put the lights or reflectors to get maximum results for your pictures. Before you even look through the camera, you have an idea of what you want the shot to look like. In some cases, lighting with a longer telephoto lens may be easier. The larger challenge is to get the same quality of light on your subject in a wide-angle shot as you would in a normal or telephoto shot, and the reason is right there in front of you. Put the wide-angle lens on your camera, and suddenly you see your light, the light stand it's on, maybe a reflector or two, a mirror — the whole shebang is right there, in your shot.

If you've seen a motion picture being filmed, chances are you've seen the massive 12- and 24-foot reflectors and other light-control devices that are part of making movies look good. Using such large reflectors isn't necessarily better than using small ones, but larger reflectors can cover a much larger space and remain far out of the shot. They have the same effect as a medium reflector sized for still photography when it's close to your subject.

Think back to high school geometry class (if you're currently in high school geometry class, you know better than the rest of us): If you put a 5-foot panel right next to your subject and then move it back 12 or 15 feet, the effective width is now the size of a small flash unit, and all your efforts to use a soft reflector to bounce light on your subject have been stifled.

 When you set up shots, keep subjects close to you so you can get decent light on them. If they end up in the back of your composition, it's not the end of the world by any stretch — you just don't get a super-smooth transition from highlight to shadow when your subjects are 20 feet from a light.

How sensor size affects everything

The chip in the majority of digital cameras is smaller than the 35mm frame. So if a camera says it has a 1.5x magnification factor, you need to multiply the focal length of the lens by that factor to get the actual focal length of the lens. Imagine the chip of a partial sensor (also referred to as a cropped chip) camera fitting inside the chip of a full-frame camera. The smaller chip, or sensor, is more affordable to manufacture, so camera makers use them to keep the price of cameras down. The following figure shows how the crop factor affects an image. The center color portion represents what the smaller chip or sensor will give you with a wide-angle lens, about a 35mm lens in this case. The outside black-and-white portion represents what the same super wide-angle 20mm lens gives you on a full-frame camera. Wide-angle lenses are closer to a normal lens in terms of angle of view. A 35mm lens, which is normally a short wide angle, is now a normal

lens with a partial chip camera. If you often photograph people, this generally works in your favor because you tend to shoot with normal and telephoto lenses. If you shoot a good deal of interiors or other subjects that require a wide-angle lens, this can be problematic because you now need to use more expensive, extreme wide-angle lenses to get a normal wide-angle view. On the telephoto side, your lenses now have some extra push, which is generally a benefit to people and sports shooters.

An advantage of shooting with a camera with a full-size sensor is that you automatically get less noise. In most cases, the actual pixels on the chip are larger, so they give more detail and less noise. The pixels themselves are being magnified less because the original pixels themselves are larger. Imagine 100 post-its making up a square that has a picture drawn on them;

(continued)

(continued)

this is your full-frame 17–24 megapixel camera. Another 100 post-its have a picture drawn on them and have been folded up and compressed into a smaller square; this is a partial chip 17–24 megapixel camera. Both will unfold to yield the same image, but the one that isn't folded up will yield a cleaner image. This is exactly why a 22 megapixel medium format back will yield a file with much more detail than a full-frame 22 or 24 megapixel Nikon or Canon counterpart.

1.5x crop

35mm full frame

Tooling Up: A Rundown of Lights, Gadgets, and Gewgaws

In This Chapter

▷ Finding out about flashes and strobes

▷ Honing in on hot lights

▷ Accessories to get your light just so

*A*s much as it takes cameras and lenses to take pictures, the sooner you take control of your lighting, the sooner you begin to *make* pictures. You need to know how different lights and modifiers work and just what kind of results to expect from each one. Then you can make the right decisions and select the right tools for the job. I think the best part of photography is the ability to transform the mundane into the fabulous through lighting. Understanding how common lighting tools work helps you get to fabulous.

Read on and carefully consider all the cool stuff in this chapter, but don't think you need to mortgage your house to make a good picture. You don't need to buy everything I discuss in this chapter. Most photographers I know own only the equipment they need for the specific kind of images they create. I also give you some down-to-earth home remedies that give your images the exact same results as their more costly commercial counterparts.

Non-Continuous Light Sources: Flashes and Strobes

The words *flash* and *strobe* generally refer to the same thing. The small light that mounts to the top of your camera on the hot shoe is referred to as both a flash and a strobe. Easy enough, but here's where it gets tricky: The larger lights that are generally mounted to a light stand in a studio and plug in to a larger power pack are generally known as strobes. The smaller flash units that mount on your camera can also be used off-camera as small alternatives or additions to studio strobes. There's really no rhyme or reason for this nomenclature.

Although you see overlap in the terms flash and strobe, for the purposes of this book, *flash* always means a light you attach to your camera, and *strobe* refers to a free-standing light unit.

Fixating on flashes

A *flash* is a small, battery-powered unit that mounts to the top of your camera and puts out a flash of light to illuminate your scene when you press the shutter. Many of today's cameras offer a built-in or pop-up flash that pops up when it's being used and can be closed flat when you aren't using it. However, because you have the option of attaching a flash that's separate from the camera (most cameras have a hot shoe that allows you to use an external flash), you need to know about the features and types of flashes available in order to choose wisely.

Some units are very straightforward and offer few to no features outside of just putting out light, whereas other units are complex and offer a variety of features, especially when combined with a full-featured, digital SLR camera. These small flash units are also available in a pretty wide variety of power ratings and corresponding price ranges.

These small flash units are becoming more powerful and more functional every day. Since I've embraced the functionality of these units, they have become my first choice over larger studio strobe units in many situations.

Controlling flash output

Because all a flash does is send out a brief flash of light to help illuminate your scene, it's important to be able to control the amount of light that is output. The three most common ways to set the flash unit to control the amount of light it puts out are:

✔ **Through the lens (TTL):** The camera monitors the amount of light through the lens, and when it sees that exactly enough light has reflected off of the subject, it shuts the flash off. TTL is a great all-purpose flash mode that yields pretty consistent results and excels in circumstances where you're mixing the flash with the ambient exposure.

✔ **Auto flash:** Unlike TTL, which puts the camera in charge, an auto flash monitors its own output and shuts it off when it has put out enough light to make the perfect exposure. A lot of event photographers prefer using an auto flash when they're using only the light from the flash unit (and not any ambient light) to expose a scene.

✔ **Manual output:** This is a key setting when it comes to having complete creative control over your flash. The ability it gives you to add a little bit of light or a lot of light independently of what the camera's built-in light meter thinks is right is a key feature in allowing you to use these small units off the camera in a role that was traditionally held by studio strobes. Most manual units allow you to control the power from full 100-percent output (1/1), where you get the maximum amount of light possible from the unit, all the way down to about 1 percent (1/128), where the output is just a tiny wink of light. The exposure level remains constant from shot to shot, so the output is extremely consistent from shot to shot.

Checking out the pros and cons

On-camera flash units have both pros and cons. On the downside, when you mount these small units atop your camera, you generally get flat, frontal lighting that isn't flattering. This is fine for crime scene photos, ID pictures, and other areas of photography where the need for maximum detail outweighs the need for style and overall complimentary lighting, but it's not so suitable in other situations.

Another con you're probably familiar with is the flash's propensity to give subjects red eye. *Red eye* is caused by light shining through the eye and illuminating the red blood vessels on the inside back of the eyeball. When photographing people with a flash unit mounted on the camera or, worse yet, a pop-up flash, the proximity of the light to the lens often proves problematic. Turn to Chapter 14 to find out how to avoid red eye.

On the plus side, modern flash units have a much faster recycle time than ever before, making them infinitely more useful. The *recycle time* is the period a flash unit takes to power itself back up after it has been fired. A flash unit with a very fast recycle time allows you to shoot several pictures in close succession. On the other hand, the recycle time may not be as important to photographers who shoot still-life scenes, because waiting a couple extra seconds doesn't mean missing a shot.

The flash manufacturers publish recycle times for their products, but these numbers aren't gospel. Battery life, battery type, and the amount of light the unit is putting out affect the results greatly, so test the recycle time yourself for the most accurate information.

Knowing what to consider while shopping

When you shop for a camera-mounted flash system, you'll find that the manufacturer advertises the unit's power potential as a *guide number* (sometimes referred to as a *G.N.*). The guide number is essentially a rating for how much light the flash puts out in a given circumstance. While it can be computed for any distance and ISO setting, the standard is 10 feet with an ISO setting of 100. This number equals the distance multiplied by the f-stop or aperture of the lens. For example, a guide number of 80 gives you an aperture of f/8 at 10 feet. A more powerful flash unit may boast a guide number of 160, which gives you an aperture setting of f/16 at 10 feet.

A few very important factors affect this number:

- The actual power of the unit.
- The kind of reflector or lens that's on the front of the flash. (If the reflector is a zooming reflector, where it's set makes a difference.)
- The color of the walls and ceiling of the room in which the power is tested. An all-black room yields different results than an all-white room, because light bounces and will travel farther when bouncing off white surfaces.
- Whether the unit is fully charged.

Manufacturers know that the better the power rating, the more units they'll sell — which makes me wonder whether flashes are tested in small rooms with low ceilings and white walls. This setting would help to bounce the light around and increase the power rating of the flash unit. I would assume a fudge factor of at least 10 percent plus or minus when looking at the advertised outputs of these units.

Don't get carried away when comparing guide numbers. With the increased low-light capability of digital cameras, the amount of light you need is greatly reduced. You can routinely shoot with ISO ratings between 320 and 640 and still get fantastic results.

Along with guide numbers, a couple other considerations come into play when you're shopping for a flash unit. Following is a brief rundown on these:

✔ **Tilt and swivel capability:** Consider looking for a flash with a head that can tilt and swivel. Some of the very small units may not do either, and the midsize to large units may not always do both. Most larger flashes have a head that tilts vertically so you can bounce the light into the ceiling for softer, more even light. Fewer units have a head that swivels, though. If you get a unit that doesn't swivel, you won't be able to bounce the light into the ceiling when you're doing a vertical shot. Additionally, some aftermarket flash diffusers (see Chapter 14) won't work with flash units that don't swivel.

Non-swiveling units are often ideal for use as secondary or auxiliary flash units because you're less likely to need to bounce or swivel an auxiliary flash than an on-camera flash.

✔ **Zooming capability:** Adjustability or zooming capability is another feature that's especially useful. When you plug in the lens you're using, the zooming head adjusts the width of the beam of light it puts out to match the angle of view of the lens.

You can also use this zooming feature for special effects or secondary purposes. Say you're making a portrait, and you want to add a small beam of light to make the subject's hair shine. By using a second or third strobe light, you can zoom the head all the way down to 105mm, which will put out only a small beam of light — a perfect little accent light.

Lingering between flashes and strobes

Just as a black-and-white photograph includes many shades of gray, some light sources don't fit precisely into either the "flash" or "strobe" category; instead, they occupy the middle range of the light-source spectrum. These external, battery-powered units serve as a bridge between shoe-mount flash units and large professional studio strobes. They're intended to be used as studio units with soft boxes, umbrellas, and other modifiers that usually suck up a lot of power, but they have the added functionality of not having to be plugged in to the wall. These units vary greatly in price and functionally based on how powerful the unit is and, more importantly, how robust the battery is.

Battery size presents a rather fine line for manufacturers to tread, though, because if a unit's battery is too big, the unit is hard to carry and use on location, which is its intended use. On the flip side, if the battery is too small, it doesn't have enough power for the flash unit or it runs out of power too quickly, making the unit unattractive.

On the smaller side of these units are Quantum flashes, which actually look like giant shoe mount flashes on steroids (see Figure 4-1). Quantum has been in business for some time and has perfected its offerings, which, although

pricy, are very popular with wedding and other event photographers. Following are a few features of Quantum flashes:

- They can be controlled through the camera's TTL circuitry, which can be beneficial in rapidly changing environments like weddings.
- The use of smaller soft boxes and umbrellas is popular with these units, as is using a larger, bare-bulb reflector.
- The batteries are usually small enough to be clipped to a belt.

There are several older units that lack the Quantum units' sophisticated circuitry but provide a substantial amount of power. These are made by Norman and Lumedyne, among others. For many years prior to the sophistication and technological advancements of today's digital systems, these units were the workhorses of wedding photographers. The battery packs are large and bulky, and generally are worn on a guitar strap over the photographer's shoulder. The actual flash head is very small — just a mounting platform for the flash tube and the reflector. The flash head mounts to a bracket that, in turn, mounts to the camera. While these aren't getting much use anymore as a wedding light source, they're often utilized by photographers who need a more powerful but affordable alternative to a shoe mount flash.

Figure 4-1: A Quantum portable flash system with a mounted soft box; the battery that powers the unit is hanging from the stand.

The last category or variety of battery units consists of modern, professional units. These are the larger, more robust battery-powered units that professional wedding photographers depend on. The batteries include a strap, but it's only intended use is for moving the unit from one place to another. The thought of shooting an 8-hour wedding with this type of unit on your shoulder is appealing only to your physical therapist. These large units offer long-life batteries and modeling lights (see the nearby sidebar for more on the use of modeling lights). The pick of the litter in this high-end category can easily cost more than $8,000 with accessories. One of my personal favorites is the Elinchrom Ranger kit, which offers a great mix of battery longevity, durability, and affordability — Elinchrome sells lighting kits (one light, one battery) for around $1,500 to $2000.

Getting the scoop on strobes

Strobes refers to the large, less portable, non-continuous light systems that you usually find in a studio. They either plug directly into the wall or have a large *power pack* that sits on the floor and has cables that run to the various strobe heads. One power pack can power up three or four strobe heads — enough to run an entire studio setup — and most power packs allow you to control the amount of power going to each strobe.

The power pack, in turn, is plugged in to a wall outlet and powered by 120-volt wall power, so you never have to worry about batteries running out in the middle of a shoot. In Figure 4-2 you can see two power packs, each powering its own soft box.

Some of the large, older units draw enough power that if you plug one into a lower-wattage circuit, you could pop the breaker. However, most of these higher-wattage units have what's called a *slow charge switch* that purposely makes the power pack charge slower so it won't pop the circuit it's plugged in to.

If you plan to shoot tabletops or portraits in a studio and don't plan on venturing too far, strobes provide the most bang for your buck. They generally provide more than enough power to cover even a large scene with light. They're easy to find new or used, and many accessories are available for them.

Strobes provide an advantage over their smaller counterparts in that each strobe head has a second light called a *modeling light* — a continuous light source that can be turned on or off and dimmed up or down to match the relative amount of light put out by the main strobe. See the sidebar "More on modeling lights" to get the full scoop.

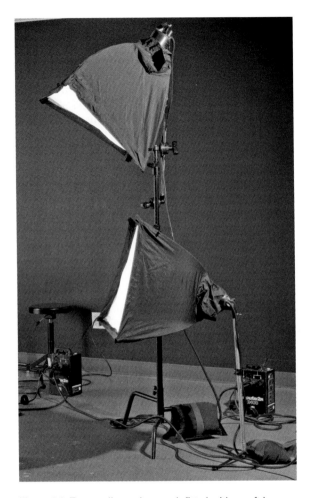

Figure 4-2: Two studio strobes each fitted with a soft box and powered by its own power pack.

Buying considerations

You're making a long-term investment when you buy a strobe, so you want to be sure you're getting the most for your money. Things to factor into your buying decision include the following:

✔ **Watt seconds:** Strobes are measured in *watt seconds,* which refer to the amount of energy the capacitor of the power pack can store, rather than guide numbers, which refer to the amount of light output by smaller, shoe-mount flashes. Think of the capacitor as a balloon that fills up with water

until you let it go and it sprays water all over. The energy comes in from the wall and fills up the capacitor until a light blinks telling you that it's full of power and ready to flash. The greater the watt seconds, the more energy the strobe can store, and the brighter the light will be at full power.

✔ **Recharge time:** Part of the cost of the pack is not only how much light it can put out but also how long it takes to recharge for the next shot. The faster the charger, the more money it costs. This factor will weigh more heavily in your decision if you need to take shots in quick succession. If you don't mind waiting for the pack to recharge between shots, it may be better to invest your money elsewhere.

✔ **Strobe duration:** Another factor that's increasingly being advertised is *strobe duration* — the amount of time that the strobe's light is actually on or flashing. The shorter the duration, the more action-stopping ability the strobe has. This factor is particularly important for fashion photographers and advertising photographers who need to capture the pours and splashes of liquids. A short strobe duration allows you to "freeze" your subject.

✔ **Ability to add modifiers and diffusers:** When working in the studio, it's common practice to use diffusers and modifiers in front of your lights, and you need a way to attach them properly. Check to see that the lights can be used with the diffusers of your choice.

Studio strobes are absolutely timeless. I've been in studios where a 25-year-old power pack is working in perfect unison alongside a modern strobe pack. Regardless of the format you're shooting or the particular brand of camera you like, strobes provide the light you need for your photography. So choose wisely and don't skimp; you can use these for many years to come.

More on modeling lights

Strobes fire a very short burst of light at your subject, only illuminating it for a fraction of a second. This short duration makes it difficult to see where the light is actually striking and what will be in shadows versus what will be in light. This dilemma is where modeling lights come into the action. A modeling light is a second light source in the head of the studio strobe that puts out a continuous light, allowing you to see where the light will fall. Many modeling lights are adjustable so that they put out the same relative light as the strobe does when it fires. Because it's not as powerful as the strobe, the light is not the same, but the relative brightness is. For example, if the main light is set to 50-percent power, then the modeling light will beat 50-percent power. This adjustability allows you to use multiple lights and see how each will be affected when you change one.

A side effect of modeling lights is that they allow you to see in the studio, which can be quite dark otherwise. Your camera needs light to focus, and they really help with that. Because modeling lights are on continuously, they can get hot — take caution accordingly.

Monoblocks

If you can imagine a studio flash system that's made up of a strobe head and the power pack together sitting atop a light stand, what you're picturing is a monoblock.

A *monoblock* is basically a miniature, all-in-one strobe system. A good number of photographers mix studio systems with a monoblock or two or just use monoblocks alone. This is a smart practice for a couple reasons:

- ✔ **Monoblocks are powerful.** Many monoblocks are just as powerful as the traditional studio strobes but at a lower cost.
- ✔ **Monoblocks are versatile.** Just as many light-shaping tools are available for monoblocks as for studio strobe systems.
- ✔ **Monoblocks make good back-up systems.** If your power pack breaks and you don't have a back-up, you can't finish your job, which could be devastating. If you have a monoblock or two mixed into your system, you still have another strobe and power pack ready to press into service.
- ✔ **Monoblocks make your shooting area cable-free.** Monoblocks are good for background lighting. Not only does using a monoblock in this capacity allow you to control the power separately but also, more importantly, it keeps you from having to use a heavy cable to connect the light and the power pack. This is a particular concern if you're a school photographer taking pictures of hundreds of subjects in a day — in this scenario, you want to keep your shooting space as cable-free as possible.

Continuous Light Sources: Hot Lights and More

Because of the surge in popularity of digital video, manufacturers are falling over themselves to get new continuous lights to the marketplace. This is great news for photographers, coming at a time when traditional hot light research and development seemed to have come to a standstill. In addition to traditional quartz lights that have been made for photographers for years, these new lights include LED and fluorescent lighting fixtures.

Traditional hot lights

Tungsten lights or traditional quartz photo lamps are also referred to as *hot lights* and are just that — bright lights that stay on for the entire duration of

your shoot. Before the flash became the mainstay of photography, hot lights were the only choice for photographers. Although new LED lights are becoming commonplace, these hot lights are far from obsolete.

Traditional tungsten hot lights still have a place in photography today. In fact, I use them to teach my students about studio lighting before turning them loose with strobes. Hot lights help the students actually see the light and shadows that they're creating in the studio. Only after they see the light for a couple semesters are they free to use the strobe system of their choice.

These bright sources come in a couple of styles: open-faced broad lights or floodlights. They generally range from 350 to 700 watts and are made by several manufacturers.

My favorite tungsten sources are focusable units that have what's called a *Fresnel lens* in front of the light bulb. You can use this glass lens to focus the unit into either a tight or a wide light source. Additionally, the glass front causes the light to create a sharp or hard edge on your subject. This is the kind of light source that gave the photos of famous Hollywood glamour photographer George Hurrell their amazing quality. These focusable units are still a mainstay for television and movie lighting, with units available from 150 watts clear up to 5,000 watts! Figure 4-3 shows a focusable 1,000-watt Mole Richardson studio lamp.

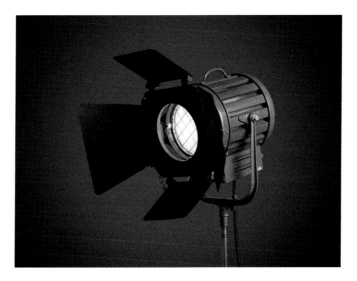

Figure 4-3: A 1,000-watt Mole Richardson focusable Fresnel.

Lastly, we can't forget good old photo floodlights. These are color-corrected, high-wattage bulbs that look like regular household light bulbs. They can be screwed into a wide range of available photo reflectors and used as broad light sources.

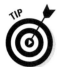

My favorite use for these bulbs comes into play when lighting interiors. If an interior architectural scene contains a floor light or wall-mounted sconce, I often replace the low-wattage light bulb with a photo floodlight to get brighter, more even lighting.

The cost per unit of hot lights is much less than that of their strobe counterparts, and while strobes put out much more power, if you're a still-life photographer, you have the advantage of being able to shoot with long exposures to make up for the difference. (In Chapter 10, I cover a couple techniques you can use for shooting tabletop photos with hot lights.)

You can use tungsten lights for a portrait shoot, too, but tungsten lights are hot, and any session lasting more than a couple minutes can make your subject uncomfortably warm, resulting in a reddish face and even sweat — neither of which lends itself to positive portrait photography.

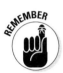

If you're photographing subjects that the heat won't affect, dollar for dollar tungsten hot lights simply can't be beat.

In Chapter 10, I show you how to use the different color balances of strobes and tungsten lights for creative purposes. The color balance of tungsten lights is 3,200 degrees Kelvin, so you need to set your digital camera to the little light bulb setting in the color balance menu.

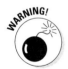

Hot lights can get hot enough to start a fire, so caution should be used. Keep them a couple feet from anything that's flammable or may melt (curtains, rugs, wood paneling, makeshift diffusers and reflectors, ceilings, and so on). You'll need oven-gloves or something similar to adjust the lights after they've been on for awhile. Also, when changing the bulb, don't touch it with bare skin because oils from the skin can cause the bulb to break on first use.

LEDs, HMIs, and fluorescents

LED lighting units have become quite popular and are available in a wide selection of sizes and price ranges. *LED* stands for *light emitting diode,* and while LEDs have been around for some time, taking a large number of them and creating a panel used in photographic lighting is relatively new.

Although the amount of light an LED puts out has recently increased almost tenfold, it's still relatively low. However, LEDs are useful as fill lights or for augmenting an existing lighting scenario. They're just the thing when you need to get a light into a small area or you need a continuous light source that you don't have to plug in. For example, an LED is the perfect choice if you want to simulate the light coming from a computer monitor, hide a light in the dashboard or sun visor of a car, or jam a light into the corner of a phone booth.

I've carried a MicroPro in my bag since it came out a year or so ago, and it has proved to be a perfect little pop-out light on several occasions. Check out Figure 4-4 for a shot of my MicroPro with (bottom) and without (top) the tungsten gel to change the light from daylight to tungsten.

Figure 4-4: A LitePanel MicroPro adjustable LED, for shooting with daylight (top) and with the tungsten gel on for shooting indoors (bottom).

LEDs are available in both 5,500-degree daylight and 3,200-degree tungsten varieties. Both LitePanel and Lowel are making units that can provide either daylight or tungsten at the twist of a knob. You can also blend the color temperature to match the color balance of the environment you are shooting. The thing I really like about LEDs is the fact that you can dim them up or down with the built-in rheostat without changing the daylight (5,500-degree) color temperature of the light.

LEDs are becoming more affordable every day. When they first came out, they were quite pricy. But as their popularity has soared in the digital video arena, these units can now be found for a couple hundred dollars.

At the other end of the spectrum in terms of affordability and power output are HMI lights. *HMI* is short for *hydrargyrum medium-arc iodide* (glad you asked, aren't you?). These lights are the mainstay of the motion picture and video industry. The mercury vapor lights burn incredibly efficiently and are capable of putting out approximately four times as much light as similarly sized tungsten lights. Making them even more useful is the 5,500-degree daylight color balance, which allows them to be used during the day without a color shift. The drawback is that they're very expensive and draw a good amount of power.

The fluorescent fixtures that are becoming available offer a decent amount of output in a low-wattage package that folds up and rolls into a very small package. Again, these units were made popular in the video world and are slowly migrating to the still world. Fluorescent lights are particularly useful for shooting environmental portraits, because a variety of color-balanced tubes are available, allowing the photographer to match the existing color balance with his or her lighting.

Accessories You Don't Want to Miss

At the core of most any photographer is a never-ending pile of accessories. I'm thoroughly convinced that part of the attraction to photography is the yearning to be around cool little gadgets. (Ever see a group of photographers crowded together comparing iPhone apps?)

The accessories you carry really do help you do the kinds of things you want to do. At the end of the day, the camera is just a box. But if you could just mount it (insert cool place here) and get a light to shine down from (insert angle) . . . now, that would be a great shot!

There's no excuse for sloppy lighting. Students of lighting are often intimidated by it early on but soon realize it's just waiting to be bounced, bent, blocked, and otherwise manipulated into becoming a unique vision.

Light stands: The belts of the photography world

After you figure out what kind of lights are perfect for you, the next thing you need is something to hold them up. Enter the light stand. Its only job is to hold up your lights and reflectors. If you pick up a photographic catalog or take a peek online, you'll find the selection to be quite expansive and somewhat overwhelming.

Don't buy any light stand before you know what kind of lights you'll be using. Stands vary quite a bit in height and the amount of weight they can support. If you'll be working only in a studio with larger studio strobes, a larger, heavy stand will suit you perfectly. If you plan on shooting primarily on location, look at some of the smaller stands that collapse for easier carrying.

The last thing to consider is what's at the very top of the light stand. Some stands have a screw thread on top that allows easy attachment of accessories, whereas other stands have a metal stud that you slide your accessories over and then clamp down with a screw. Also notice that the threads come in two sizes: The larger is a ⅜-inch thread, and the smaller is a ¼ 20 thread. The ¼ 20 thread is the same size your tripod and camera use. Figure 4-5 shows a non-threaded stand top, a ¼ 20-threaded stand top, a ⅜-inch threaded stand top, and an umbrella adapter mounted on a stand. One isn't really better than another, so any of the tops should work for you. The non-threaded ones sometimes run a couple dollars cheaper.

Light stands can also come in different finishes, with black and silver being the most common. Black ones can be hidden in dark shadow areas of your scene and won't reflect in other shiny surfaces. Silver ones are less likely to be run into or tripped over in dark or busy sets.

Figure 4-5: From left, a non-threaded stand top, a ¼-inch 20-threaded stand top, a ⅜-inch threaded stand top, and an umbrella adapter mounted on a stand.

Reflecting on reflectors

One decision you may be faced with when you set out to light something — especially when you're on location — is how to provide your subject with some fill light. Fill light lowers the contrast on your subject, fills in any dark shadows, and generally makes the image more appealing. (Chapter 10 tells you more about fill light.) If you use fill light properly, the viewer won't even realize you've done it, which is the true goal.

The easiest thing to do is use the flip-up flash on your camera or mount a flash on the hot shoe and bang away. Unfortunately, this is the worst thing you can do. It's a very effective way to provide some fill light to your subject, but it's also flat, mundane, and not much different from what amateur photographers do.

A reflector is the better way to go. A *reflector* is any item that you can use to reflect or bounce the light back into your scene. Reflectors come in all different sizes, shapes, and even colors, but they all serve the same purpose: bouncing light back into the scene.

There's no limit to how big or small a reflector can be; you could use a tiny reflector that's no bigger than the hole made by a hole punch to shoot

super tiny macro jewelry shots, or you could use something bigger than an 18-wheeler to shoot cars.

Among the commercially available reflectors, the cool little flip-up ones are very popular and convenient for location shooters, but a simple piece of foam core or poster board can do almost the exact same thing — it just won't fit into your camera bag as easily. Most studio photographers have a stash of foam core somewhere near their set. At times it's easier to cut, fold, and otherwise mangle and wrangle a piece of foam core to get it into the perfect position to bounce light into a shadow than it is to get a store-bought reflector to do the same thing.

Foam core has long been a staple in the professional photographer's tool kit. It's cheap, effective, and available just about everywhere. Even my local grocery store stocks it in several different colors. You use the foam core like any reflector by angling it so that the light bounces back into the scene, adding light where it's needed.

More reflectors are sold on the market today than you can shake a stick at. Some have real value while others don't. Keep a keen eye out for natural colored reflectors and use them. Often the dappling effect of reflected light will make an otherwise just okay photograph really interesting, as it did in my 2009 photograph titled "Space Alien" (see Figure 4-6). After seeing the sticker magically appear on the street, I visited several times until the glass windows in the building across the street created a pleasant background for the whimsical image.

50mm, 1/500 sec., f/4, 100

Figure 4-6: A street photograph lit entirely with natural light that was reflected from local buildings.

Another favorite example of mine are the shots of my two biggest helpers on the first day of school, shown in Figure 4-7. Morning light makes the yard glow and backlights the boys perfectly. The white siding on the back of the house that I'm standing in front of gives their faces the soft, shadowless light. For an hour or so each sunny morning, the house with the white siding creates a perfect fill light for anything standing in front of it. I could have not done any better with a flash or reflector. Seeing and using what was already there turned a simple snapshot into a photograph.

50mm, 1/160 sec., f/5, 100

Figure 4-7: Using the natural bounce light from white siding to fill in the morning light.

A reflector adds a softer and more pleasing light, but using one isn't always easy. If you're working alone, holding a reflector perfectly in place while composing your shot can be a challenge. Heck, this can be a challenge even if you have an assistant working with you — working alone only compounds the situation. The solution? A lot of different holders and light-stand combinations are available to help you get your reflectors angled just right and locked in place.

Be aware that you may need something to hold your holder, too. Even the lightest breeze can often turn a 32-inch reflector into a kite. If your camera store sells reflector holders, it will most likely stock sandbags as well — picking up one can't hurt.

Alternatively, you can fill a couple of quart or gallon containers with sand (water is not such a good idea . . . think about it) and tie them together with some rope. Leave about 12 inches of rope out so you can hang it on, over, or through your light stand to keep the stand anchored down.

If it's just too windy and you're having trouble getting your reflector to do exactly what you need, then a strobe may be a better solution. I encourage you to use a small, clip-on diffuser at the minimum to soften your fill light. This strategy will help to camouflage the light as being from the flash and keep it from being too obvious in your final image. If you have the cables to get the flash off the camera, then by all means do so. Even getting the fill off the camera will help your final images.

Tripping systems: Getting your strobes and flashes to fire together

Using multiple strobes can lead to headaches if everything doesn't fire together. The shutter is open for only a fraction of a second, so you have to make sure all your lights trip together.

Several commercial remedies are available for this very situation. Each method is perfect for some situations but not for others. So consider what you shoot and what you need before pulling out your checkbook.

Simple (and affordable) line-of-sight tools

The original solution is as valid today as it was in the olden days. Called an *optical slave* or sometimes just a *slave unit,* this device mounts your auxiliary flash via the hot shoe and fires your auxiliary flash when it sees the light from another flash.

An optical slave is ideal when you aren't around other people shooting with a flash; any flash will fire the unit.

Optical slaves come with a few limitations you need to be aware of:

- ✔ They operate via line of sight; the unit needs to see the primary flash in order to trip your unit.
- ✔ If you're in a place where a lot of people are shooting with flashes, your flash will fire with every flash it sees. Your batteries may be dead sooner than you know it.
- ✔ Some modern flash units emit a preflash to check the exposure before firing the main light. This preflash is 20 percent or so of the main light and lets the camera determine how much or how little it needs to make a proper exposure. The preflash can trip your auxiliary flash before the camera is ready for the main exposure. Several manufacturers make slave units that will fire on the second of two flashes that are in short succession.

These units don't communicate with your camera whatsoever. So you need to either be using the manual output control or the auto setting of your flash. None of the more advanced TTL features will be available.

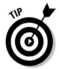

The greatest flashes to use as auxiliary lights in this capacity are the Vivitar 283 and 285. I'm partial to the simpler 283 flash unit that has a simple auto setting — it's powerful, affordable, and crazy reliable. Wein makes something called a *peanut slave* that allows the flash to be triggered off-camera (see Figure 4-8) and is designed to work perfectly with the 283 and 285 flashes.

Another popular slave unit, also pictured in Figure 4-8, is the Wein Hot Shoe Ultra Slave XL. This unit boasts a 600-foot range (your mileage will vary) and has a ¼ 20 thread on the bottom, which is convenient because that's the standard size screw thread for photographic tripods, monopods, unipods, and mounting hardware, so you can mount it anywhere.

Advanced radio tripping systems

There are two different types of radio triggers: The first type just sends a signal for the strobes to fire, while the second type actually sends the TTL (through the lens) lighting information.

The first type is quite simple to use because all it does is trigger remote lights when the shutter release button is pressed. The amount of light is controlled by adjusting the output on the actual lights themselves. These units usually attach to the camera's hot shoe where an external flash would go or via a cable to the camera's PC terminal. One of the best examples of this type of radio trigger is the PocketWizard, which I've been using for over ten years with excellent results (see Figure 4-9).

Figure 4-8: A Wein hot shoe slave (left) and a peanut slave (right).

 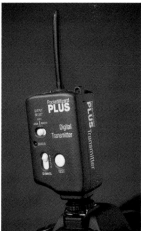

Figure 4-9: A Canon infrared tripper (left) and a PocketWizard Plus digital transmitter (right).

The second type of radio trigger is newer and more expensive, but it sends out lighting information from the scene as seen through the lens by your camera to the external lights. When the shutter release button is pressed, the lights are fired, but their output is controlled by what the camera sees in the scene.

With the ability to transmit your full TTL signals through walls, around corners — just about anywhere you want to stick a light — you can now control the amount of output right from the camera. The light works exactly as it would if it were attached to your hot shoe. Not a bad way to approach things, and, depending on the kind of shooting you do, it could be worth the price tag.

Wireless systems from Canon and Nikon

Canon and Nikon have wireless TTL systems that have been around longer than the PocketWizard system. The Canon and Nikon systems work on a different premise. The camera communicates with your auxiliary strobes wirelessly via a series of preflashes and infrared flashes.

The Canon and Nikon systems use a flash mounted on the camera as a master unit that can not only trigger multiple external flash units but can also change the power output of those external units automatically, depending on what the camera sees through the lens (TTL).

In terms of drawbacks, the largest one is the range and the need for the slave flashes to be in the line of sight of the master or commander flash.

In both the Nikon and Canon systems, some cameras can use the on-camera flash as a flash in your scene, whereas others only use it as the control unit for your other flash units. Check your camera's manual to see whether this is available on your camera. If you never use an on-camera flash but want to take advantage of the wireless control that's available to you, both Canon and Nikon make TTL transmitters whose only purpose is to control your auxiliary lights. These control units need to be in line of sight with the slave flashes for the system to function. The Canon unit is called an ST-E2 transmitter, and the Nikon unit is called an SU-800.

Mirrors

Plexiglass mirrors are a perfect addition to any photographer's lighting kit. These can be purchased at any number of art or hobby stores. A 12-inch square can be used to highlight hair by angling it to catch and bounce back the main light source, illuminating your subject. A little device called an umbrella adapter is a must-have — it lets you attach both a strobe and an umbrella to a light stand. Instead of mounting a flash to the shoe, you can mount a mirror instead by using a ¼ 20 wing nut through a hole that you drill in the mirror. Take a look at Figure 4-10 to see a light stand being used with an umbrella adapter and as a holder for a plexiglass mirror.

Taking advantage of any opportunity to see and use the light that's already there will improve your images.

I stuck the plexiglass mirror shown in Figure 4-11 to the back of a piece of self-adhesive linoleum tile and completely taped over it with clear packing

tape. After the clear tape covered the entire surface of the mirror, I took a hammer (ball bean is the best, but a hearty framer will work too) and pounded the mirror until it was broken to pieces. Now when I use it, it provides an instantly dappled light that is quite pleasing if used properly. I've used this as a main light and a background light. Because of the flexibility of the mirror and linoleum, you can bend it to and fro to change the pattern of the reflection.

Figure 4-10: A light stand and umbrella adapter being used to hold a plexiglass mirror.

Figure 4-11: A broken mirror to provide a dappled, reflected light.

Soft boxes and umbrellas

The easiest way to give your light a more polished or finished look is to increase its size and proximity to the subject. A *soft box* is a light, tight nylon enclosure with a large piece of white diffusion material across the front. The diffusion material makes the light that passes through it smooth and lessens the potential for shadows. Although it cuts the power of your light approximately in half, the results are well worth it. Soft boxes are available in sizes ranging from 5-x-7 inches all the way up to 6-x-8 feet. The size to use depends on what you're shooting and how much power you have. Several unique shapes are available as well. *Strip boxes,* a long, thin type of soft boxes, are available in a couple of different sizes, from 6-x-36 inches to 1-x-6 feet. These are great for product shots where you just want to add a highlight to something, or you have a small space to fit the lights in.

Otabanks or octagon soft boxes are those where the shape of the front has eight sides. They're quite popular for shooting portraits because they leave a more naturally shaped highlight reflected in the eye of the subject.

Umbrellas are probably the most widely sold light modifier ever made. They provide a soft, broad light in collapsible packaging that's very small and portable. *Shoot through* umbrellas are also available: These let the flash shoot through an umbrella made from diffusion material instead of reflecting off the white or silver umbrella lining.

Both umbrellas and soft boxes have their time and place. The light an umbrella provides isn't as smooth and even as the light a soft box gives you, but you can keep a small umbrella in a side pouch of your camera bag for emergencies. Figure 4-12 shows both a shoot-through umbrella and a bounce umbrella.

Figure 4-13 shows a soft box being used to light a small camera flash. An advantage of using soft boxes for product photography is the ability to get a smooth light across a smooth surface. Here the smooth plastic of the flash looks just as smooth in the image as it is in real life. The bright white plastic lens on the flash also is lit smoothly and evenly without being blown out. The photo on the right shows the final image that was made.

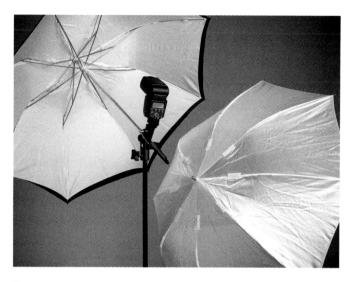

Figure 4-12: A bounce umbrella (left) and a shoot-through umbrella (right) mounted to stands.

Figure 4-13: A large soft box close to the subject (left) wraps lights around a small camera flash to produce one of the many images in this book (right).

Flags, gobos, and body parts

If your goal while shooting a particular photo is to block light, you have a few options. Flags, gobos, and your own body parts can all fill the bill:

- ✔ **Flags:** A flag can be any material whose purpose is to block light. While a flag generally blocks a specific spot of light from hitting your set, a flag can also block any light from shining into the lens. Official photographic flags made especially for use in the studio consist of a wire frame that's covered in a flame-retardant, black material that blocks almost any light you put in its way (see Figure 4-14).

Figure 4-14: Small, medium, and collapsible black flags from a RoadRags kit made by Matthews, and a piece of black foam core that works as a gobo in a pinch (bottom right).

You can make your own flag by using the black side of a piece of foam core, cardboard, or just about any material that blocks light. Depending on how you're lighting your set, you can sometimes get away with using your reflector as both a reflector and a flag to shield the lens.

- **Gobos:** *Gobo* is a term for a flag or a card that "goes between" either a light and the subject or a light and the lens of the camera. You can use a gobo to deliberately place a shadow on something in your scene. You can also use a gobo to shade the lens from light that may be shining into the lens and flaring your picture. There are several different ones available on the market; some are rigid for studio use whereas others are collapsible for location work. Foam core also makes a suitable gobo, but caution must be exercised to avoid using it too close to a light.

- **Body parts:** In the absence of a flag or gobo, you can use your hand or body as a substitute. I'm always shading the lens from the sun with my hand. Often in the studio, I'll stand at the front of the camera and look at the front of the lens right before I take a picture to make sure that no light is shining on any part of the front of the lens. Sometimes I'll purposely place my body between the light and the lens, using my body as the gobo or a flag.

The prospect of using your body to block light is one good reason to dress in dark clothes when you're shooting in a studio.

A super-handy product that's worth buying is called *black wrap, black foil,* or *cine foil.* It's made by both Roscoe and Lee and can be described as "Three-Mile-Island" aluminum foil. It's very thick and has a flat black finish on both sides. You can tear it off in sheets and bend or mold it around anything you want. You can wrap the end of the lens in it if you're getting glare from your lighting, or you can use it as a flag to block light. Because it's foil, you can just wrap part of it around a light stand and move the rest into position to block the light as needed.

As an alternative to buying a professionally produced lighting modifier, you can use something you probably already have for free. Say you're lighting a subject and you like the way the light is falling on the subject, but it's too bright. You don't want to move the lights because you like where they're falling. If you're using hot lights, dimming them can cause the color balance to drop, making your picture warmer than you expect. So what can you do? You have a couple of options. The fastest and easiest way to reduce the amount of light without changing the quality of the light is to place a metal screen in front of the subject. Ironically, you can pull the screen window from your front door or a window and get the exact same light-reducing quality you'd get from a purchased photographic screen.

Using a screen doesn't change the quality of the light, whereas using a piece of diffusion material makes the light much softer and changes the look and demeanor of your lighting.

If you're shooting a person or product on a very flat and overcast day, you can create some contrast and add some shape to the face by placing a black card close to the face. It will literally stop the light from wrapping around the subject and give it some direction. You aren't using it to shade the face; you just want to reflect some black onto one side of the face. If you plan on using the black side of foam core, you may want to spray it with some dulling spray. The reflective nature of foam core, even the black side, won't give you the full effect because the glossy finish of the board may bounce in some unwanted light. A black flag, with its flat, felt-like finish, is ideal negative filler.

Grids and snoots

Opposite soft boxes and umbrellas, whose sole job is to spread light and keep it even and broad, are *grids* and *snoots,* whose job is to funnel light into small patches. Grids and snoots go in front of the light and reduce the spread. They also reduce the overall brightness of a light source. They can be directed at fill cards when a broader fill isn't appropriate. They're also useful for adding a small detail or highlight to something, such as a subject's hair in a portrait setup.

Grids and snoots can add drama, theatrics, special effects, and mystery, especially when they're used as the only light or the primary light. Grids are available in sizes to fit everything from large studio lights to small, camera-mountable flashes.

Both grids and snoots are commercially available, but you can also make your own. For small flashes, a popular technique is to make a grid from a bunch of black drinking straws that have been cut into very short pieces, less than an inch long, and taped together with some black cloth gaffers tape or athletic tape. Snoots can be quickly made from rolled paper or, even better, from cine foil.

Grids and snoots can become very hot, so adjust and remove them carefully or wear protective gloves. Makeshift snoots and grids should be made from nonflammable materials.

Figure 4-15 shows a snoot on a Dynalite flash head and a Honl grid on a Canon flash. This figure also shows the effects of both of these tools as they're being shined on a wall.

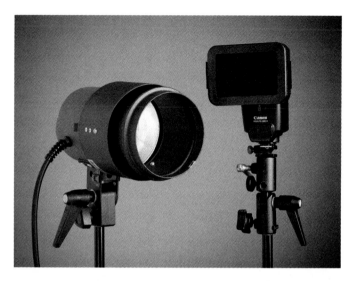

Figure 4-15: A grid and a snoot mounted to a strobe (top) and in action (bottom) mounted to identical strobes for comparison.

Part II

Let There Be Light: Measuring and Manipulating Light

The 5th Wave — By Rich Tennant

"I know I don't need a flash in this light, but it stuns them into inactivity long enough for me to compose subsequent shots."

In this part . . .

Figuring out how much light you have is Step 1 toward improving your photography. Your camera can help, and in some cases you rely on handheld light meters to get the job done. When you know what you're starting with, you can figure out how to amend that light until you have your scene looking just like you want it to. The chapters in this part take you from measuring light to changing it to adjusting your camera so that you get the shot you want in the light you have.

5

Measuring Light: It's All about Metering

In This Chapter

▶ Grasping how different meters work

▶ Tallying the light that falls on and reflects off a subject

▶ Working with white balance during and after your shoot

*T*he decisions you make when you're shooting a garden in blazing sunlight are very different from those that arise from an indoor shot in a living room. The way your camera reacts to these different situations isn't a guessing game. This chapter tells you how to use a variety of tools to measure the way light is affecting your shots so you can make the most informed decisions for your photographs.

Measuring How Much Light Falls On or Reflects Off the Subject

Photography has always been about finding and capturing the ever-elusive "perfect light." This perfection comes in many different shapes and forms — it's the early morning light that skims across your garden and wraps around the back yard; it's the evening light that makes your subject's skin glow; it's even the single shaft of light that sneaks its way through the downtown skyscrapers to illuminate a single person on a street corner waiting for the light to change.

Regardless of where you are and what you like to photograph, a solid understanding of how to measure the amount of light falling on and being reflected off your subject is the foundation of your photographic knowledge. You have more measuring tools than ever at your disposal, including tools that are built in to your camera. Knowing how these tools work and when to use them not only builds your confidence but also saves countless hours sitting at the computer trying to fix something that could have been done right when you were shooting.

As you read about and understand how metering works, keep in mind all light meters are colorblind. The light meter just records the intensity of the light present. As Figure 5-1 shows, your entire photograph can be broken into seven categories or tonalities:

- ✔ Black without detail
- ✔ Black with detail
- ✔ Dark gray
- ✔ Middle gray (also known as 18-percent gray)
- ✔ Light gray
- ✔ White with detail
- ✔ White with no detail

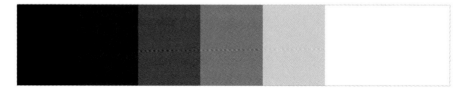

Figure 5-1: The photographic grayscale.

Using an incident meter

At the core of photography is the *incident meter* (also called a *hand meter*), which measures the amount of light falling on your subject (not the amount of light reflected off your subject, as an in-camera meter does). This method of measuring light ensures that your light readings aren't affected by the color of your subject. Figure 5-2 shows a modern incident meter.

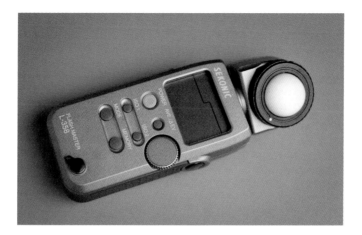

Figure 5-2: An incident meter measures only the light falling on your subject.

The heart of the meter is a bulb, which looks more like a ping-pong ball that has been cut in half. Under this white half-dome, a sensor collects and measures the amount of light hitting it. To use the meter, you place it in the scene and point the bulb directly back at the camera. This procedure lets the same light that is falling on your subject fall on the meter.

Before you use the meter, set your ISO and either the shutter speed or aperture (f-stop). Then take a reading by hitting the button on the side of the meter. *Voilà* — your completed exposure. Set the camera to the shutter and aperture the meter gives you, and your scene should be perfectly exposed.

The advantage of using an incident meter instead of a reflected meter is that it isn't tricked by the color or tonality of your scene the way a reflected meter can be. Reflected meters are influenced by the color of the subject: A white wall and a black wall reflect different amounts of light, even when you hit them with the exact same light source.

Say you're shooting a polar bear eating a vanilla ice cream cone while sitting on the hood of a white BMW in the middle of a blizzard. If you use an incident meter, the scene will be recorded as white with detail — just as it appears in real life — because the incident meter reads only the amount of light that is falling on the scene and doesn't get tricked by all the white in the scene.

The same would hold true if you photographed a black bear eating chocolate ice cream while leaning against a black BMW at night. A quick reading with your incident meter is all it would take to record your scene with all the tonality that it has in real life.

If you were to use your in-camera (reflective) meter for each of these scenes, they'd both turn out middle gray, because that's all the meter would think it was seeing.

Using reflective and spot meters

Reflective metering measures the light that your subject reflects. This is the kind of meter that's built in to your camera. You point your camera at your subject, and it reads the light that is reflected off your subject and back into the lens. *Spot metering* works the same way but reads a very small part of the scene, usually 1 or 5 percent of the total scene. Spot metering is particularly useful if you're reading a face that's in a shadow or exposing for that single person lit by that one bright shaft that sneaks between the buildings.

The challenge with using just reflective metering is that even if your subject is white or black, your reflective meter puts the exposure right in the middle, making it gray. Figure 5-3 shows a modern Seconic L758dr combination incident/spot meter and an example of an incident meter fitted with a spot attachment. Some incident meters can be fitted with a spot attachment so that the meter will only read a small portion of the scene — 1, 5, or 10 degrees. These spot attachments are still available, but the current combination incident/spot meters like the L758dr deliver more functionality.

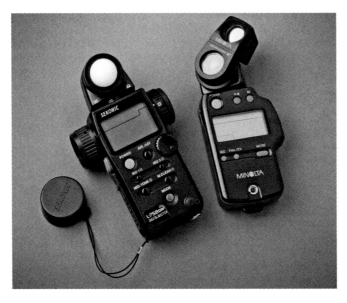

Figure 5-3: A Seconic L758dr combination incident/spot meter and an older Minolta meter fitted with a spot attachment.

Reflective meters are colorblind. No matter what color you point the meter at, it gives you the exposure exactly in the middle of the grayscale, or middle gray, smack dab between the brightest and darkest ends of the grayscale.

If you were to use a reflective or spot meter instead of the incident meter to measure the all-white polar bear scene I describe in the preceding "Using an incident meter" section, the meter would give you an exposure for only middle gray. Shooting at the exposure it gives you without making any changes would render your shot a little muddy, because it goes toward middle gray instead of white with detail, as it is in real life.

The meter doesn't understand that the tonality of the polar bear is white with detail. You, as the photographer, have to realize that the bear is going to turn out muddy (or middle gray) in the photograph, and open up the aperture a stop or two. If the meter tells you to shoot at f/11, opening up the aperture to f/8 turns the bear's coat from middle gray to light gray. But the bear is clearly white with detail, right? So open up another stop to f/5.6 to get a perfect exposure.

Using a spot meter or a spot attachment on an incident meter is a great way to ensure proper exposures. The meter is calibrated to give a perfect exposure when it's reading an 18-percent or middle gray card. You place the gray card in the scene smack dab in front of your subject, and take a reading. You plug in the ISO and either shutter speed or aperture, just like you do with an incident meter, and the meter completes the exposure for you. After you get the reading, all you have to do is remove the card and shoot, and your exposures will be fantastic! See "Using gray and white cards and color checker charts" for more on gray cards.

Using your camera as the meter

You camera's meter works like a spot meter, reading the amount of light bouncing off your subject and being focused through your lens. This method seems to make a lot of sense, but the meter relies on middle gray, and not enough photographers carry gray cards with them everywhere to give the camera a nice neutral gray to get its meter reading from.

Most dSLRs have a metering mode that lets you read only the center 20 percent of the frame; some are even capable of reading like a spot meter and using only the center 5 or 1 percent of the frame. Day in and day out, the 20-percent center spot reading provides the most consistent exposures.

Ideally, you have a gray card with you that you can use in conjunction with your camera's meter. In this case, place your gray card in the shot, making

sure it fills up the entire space of either the 20-percent or 5-percent spot metering pattern. Take your meter reading, and manually set the exposure. I advise you to shoot a frame with the gray card in the shot just to have before removing the gray card. This shot makes it easier to do any exposure and color correction in postproduction. Then pull the gray card and shoot away; you should have perfect exposures.

How your camera can be tricked, and how to trick it back

Your camera meter can perform very well after you understand how it works and ask of it what it can provide. Understanding its limitations and shortfalls helps you get the most out of your in-camera meter.

The biggest limitation is that no matter how many metering modes your camera has, it's still essentially colorblind. If you're taking a picture of a gray wall, the results will be perfect; your wall will be perfectly gray. Unfortunately, shooting a white wall or a black wall will also give you a gray wall. Several techniques help you overcome this limitation.

The camera doesn't have a clue about what you want to photograph, but it makes a decision for you anyway. Say you're shooting the sun going down over your kids playing in the back yard: The sun is shining right into the lens, and the kids have their backs to the sun and their faces to the camera. The difference in exposure from the sky to the children's faces is huge, and the camera has no idea that you want to capture the excited expressions on your little ones' faces. The bright sky complicates matters because, in most cases, the camera tries not to let any part of the frame blow out, or be overexposed.

Depending on the season and your location, the kids' faces may be the darkest things in the photo. If your back yard consists of a thick smattering of mud and you're looking down from the deck, filling the frame with gooey mud, you might be okay because the meter will see a lot of darkness and set the exposure accordingly. On the other hand, if a light snowfall covers your muddy back yard, all the meter will see is white and a bright sun that it will expose for — unless you trick it into exposing for just what you want.

You have a few options for correcting your camera's confusion:

- **Gray card:** Using a gray card is the absolute best thing you can do. Place the gray card in the shot, in this case next to one of your children's faces, and zoom in to get it as big as possible while you take the meter reading. Then zoom out and take your shot. There's just one drawback: Although the gray card works great, using it ruins the spontaneity.

- **Grass:** Grass is remarkably close in tonality to a gray card and works very well in place of one. Of course, it's an option only if you happen to

be shooting near grass — if you're in a snow-filled landscape, you're out of luck.

✔ **Skin:** The palm of your hand can substitute for a gray card with pretty consistent results. Extend your arm as far as you can, zoom in to fill the frame with your palm, and take your meter reading.

When you use one of these techniques, make sure that you set the camera in manual mode so the exposure doesn't go back when you reframe your shot.

The exposure compensation dial

The *exposure compensation dial* enables you to adjust your overall metering based on the tonality of your subject. Figure 5-4 shows you the dial on the Canon G11; if your dial isn't on your camera body, you can access it through a menu on your camera.

Figure 5-4: The exposure compensation dial on a Canon G11.

The exposure compensation dial's scale goes from +2 (stops) to –2 (stops) usually in ⅓-stop increments. The little knob was the sole reason I bought a Canon G11 when it came out — its predecessor, the G10, required you to use the menu on the back of the camera, which is much slower than using a knob.

The exposure compensation dial enables you to shoot with the camera in one of its auto modes but purposely make the meter read darker or lighter. If you're shooting in the snow and want to keep the snow perfectly white rather than gray, one way to do this is to make a gray card reading and manually set your exposure. You know that the snow is two stops brighter than middle gray, because the snow is white with detail. You can let the meter read normally, but use the exposure compensation knob to tell the camera to under-expose by two stops to compensate (hence the name).

Using the histogram as your light meter

Next to light meters, a *histogram* — a graphical representation of the pixels your camera records — is probably your biggest help when you're shooting and processing your pictures. Although I feel the best possible results require both an incident meter and a histogram, I also realize that you won't always carry a meter with you, especially if, like me, you never leave the house without a camera.

Figure 5-5 shows you a simple photograph on the top and the histogram of that scene on the bottom. The X-axis, or vertical axis, shows how many pixels of a given tonality have been recorded. Across the bottom of the graph is the Y-axis, which shows the grayscale or, more specifically, where the tones in your image are. The far right is the shadow area, the middle shows middle gray, and the far left is the highlight portion of the scene.

35mm, 1/80 sec., f/8, 100

Figure 5-5: A photograph and its corresponding histogram.

If you shoot a scene that contains mostly whites and light grays like the photo in Figure 5-6 , you'll see the majority of the pixels concentrated on the left side of the graph because that's where the actual colors and tones that are in the picture fall. You can also see the bump on the left side of the graph behind the tones that were off the scale where the subject's skin is represented.

50mm, 1/40 sec., f/5.6, 400

Figure 5-6: A portrait containing a majority of lighter tones and its corresponding histogram.

Figure 5-7 shows the scene reversed such that a majority of the shot contains dark tones or pixels showing up on the right side of the graph. The model's lighter skin tones show up in the middle of the graph.

20mm, 1/80 sec., f/8, 100

Figure 5-7: A portrait containing a majority of darker tones and its corresponding histogram.

If you use a histogram without a meter, keep in mind that it won't help you determine the exact exposure of your subject, although it can ensure that all your tones will have detail. By watching where the peaks are, you can avoid overexposing or underexposing your images.

Let the tonality of the subject inform your decisions. If you're shooting dark scenes, look for pixels to the right side of your histogram. If they're showing up on the right side of the histogram, your subject will be brighter in the photograph than in real life. Also keep an eye out for highlights and shadows that go off the scale. These are represented by lines on the graph that go off the far left for highlights and far right for shadows. If any data is represented

in these two extremes, it means that solid white or black is being recorded in your image, and there will be no detail in these areas. A highlight will print as white without any detail whatsoever. Shadows that are off the other end of the scale end up being completely black with no detail whatsoever. This is where viewing the histogram while lighting can be so powerful.

Metering to Achieve Color-Neutral Images

Color can affect your metering greatly. Meters don't know the color of whatever they're being pointed at. That's not a problem if you're shooting things that fall on the grayscale, but the world is filled with color, and you probably want to take advantage of the vibrant colors around you.

To understand how color affects a reflective meter, convert some of your images to black and white and compare the colors to the grayscale. Red is a fantastic color to use for a reflective meter, because once it's turned into a black-and-white image, a rich red will be an almost perfect middle gray — the same tonality the camera meter, or reflective meter, is looking for. Yellows fall farther up the scale, in the light gray areas, whereas dark blues and greens range from dark gray to black with detail, depending on how dark the tonality is. Green grass is a wonderful color subject that reacts like 18-percent gray.

You can also use this knowledge about converting color to black and white to your benefit if you're producing black-and-white photographs. A subject who's wearing red will appear to be wearing middle gray. If you want your subject to appear to be wearing a white shirt — in a business head shot, for example — a yellow oxford is a better choice than a white shirt because it holds detail and is less likely to blow out in a black-and-white image.

Using gray and white cards and color checker charts

Regardless of the kind of metering you do or the kind of subjects you photograph, using a white or gray card to achieve perfectly neutral images increases the control you have over your photography and, ultimately, its quality. Achieving neutral color in a wide variety of situations, including those with mixed lighting, is one of the true game-changing benefits that digital photography has made possible, and it's easier than anyone would have predicted.

Shooting digitally gives you two ways to achieve perfectly neutral color: the sloppy way (by using the computer after you shoot) and the preferred method (by using a custom white balance while you're on location or in the studio).

My first choice is always to perform a custom white balance on location, because I want to make my images as good as I can in-camera and reduce the amount of time I have to spend sitting in front of a computer after the fact. All dSLR systems allow for a custom white balance and a surprising amount of small, happy-snappy cameras offer this feature too. If your particular happy snappy doesn't let you perform a custom white balance while shooting, you can do so on the computer after your shoot.

Getting white balance right on location

The best way to ensure accurate color with the least amount of effort is to perform a color balance before you shoot. It requires a gray or white card of some sort (commercially available or otherwise) and between 30 and 90 seconds of your time.

Color balance cards are available in a variety of shapes and sizes, but they all share one characteristic: They're perfectly void of color. They are perfectly white or gray, or a combination of those two. (I'm a fan of the 12-inch Lastolite flip-up style, which has a white side and a 12-percent-gray side, and the Macbeth gray card.) In many cases, the printing process uses multiple colors to make up gray or black on a printed page. Remember making "mud" out of all the colors in grade-school art class? Using a gray with colors, some of which may even be undetectable to the human eye, skews your final color balance and leaves you with an image that's not perfectly neutral.

After metering to get the proper exposure, simply fill at least half of the frame with your white or gray card and shoot an exposure. The camera you use determines the exact procedure for using this as the reference frame, but essentially you're telling the camera to make the card in the shot neutral and apply the same settings to future exposures. It's very straightforward and about as effective as it gets. It's important to make sure the light hitting your subject and the gray card is the same. There shouldn't be any shadows on the card, and it should be relatively parallel to the sensor plane.

The kind of gray/white card or system you use is entirely up to you. I recommend a gray card, because this is the same card you use with your spot meter. The white cards work perfectly for a custom white balance but not with a reflected light meter. Among the gray cards that are available, I recommend either the Xrite Color Checker 18-percent gray balance (the cool, small one that fits into your bag easily) or the Lastolite EZ Balancing Disk. The nice thing with the Lastolite is that the edge offers a black-and-white strip, so as

you use the card for your gray balance, you can also see where the highlight and shadow areas will fall on your histogram. The Xrite doesn't fold down, but I think this helps the gray stay perfectly gray longer. Figure 5-8 shows both cards.

Figure 5-8: Two Lastolite EZ Balancing Disks (in gray) and a GretagMacbeth ColorChecker chart.

Correcting color in postproduction

The second way to ensure perfect color is to photograph a gray card at the beginning of your shoot and then remove it for the duration of your shoot. When you get back to your computer, you can balance and neutralize the color by using either the "Levels" section of Photoshop (click on the gray card) or the "White Balance Selector" in Lightroom (click on your gray or white card).

After you make your adjustment, you can apply it to the entire shoot, and you're done. If you didn't use a gray card, you can still color correct in postproduction by just selecting something in your photograph that's white, gray, or black and using that as a reference.

Color checker charts have long been a part of photography, providing a set of closely controlled colors in a chart that you photograph for adjustment in postproduction. The colors are meant to closely reflect known colors such as those of skin, foliage, and sky. These cards are most useful for creating imagery that will be separated and printed in a four-color environment, such as product catalogs, where very precise color is needed throughout the entire process. The cards are widely available, and the colors on them have been

standardized. So in theory, you could include one in a photograph and someone on the other side of the country could compare the colors. Figure 5-8 shows you an example.

When not to use cards or color charts

You actually may run into a couple of applications in which you don't want to use a gray card and custom white balance. If you wake up early to get that perfect shaft of morning light shining down Main Street or are sitting on the deck of the Del Coronado shooting one of its perfect sunsets, you definitely want to keep the gray card in the camera bag. The last thing in the world you want to do is neutralize the warm light that will make your photograph shine.

The best thing to do in any situation where you're capturing the warmth and saturation of sunrises or sunsets is to use the camera's "sun" preset, the one that looks like a sprocket. This setting adjusts the color temperature to regular high-noon daylight, which is around 5,500 degrees Kelvin. This warm light is much lower in color temperature, or warmer, so it shows up just as warm, saturated, and wonderful in your image as it does in real life. Should you forget and pull out your gray card and do a custom white balance, the image will be correct in color and tonality, but lack every bit of warmth, the reason you wanted to shoot the photo in the first place.

6

Using Exposure Principles and Techniques to Manipulate Light

In This Chapter

▶ Becoming acquainted with the all-important stop

▶ Controlling light and depth of field with aperture

▶ Taking charge of shutter speed

▶ Getting a sense of sensitivity: ISO

*P*hotography is all about capturing light — pretty simple, right? Just let the light come through the lens, pass the shutter, be recorded by the sensor in the back of the camera, and you have a photograph.

But you have to control the amount of light that reaches the sensor, because too much light makes everything too bright, and too little light makes everything dark. You control the light by adjusting the opening in the lens (the aperture) and the length of time the sensor is exposed to the light (the shutter speed). You can also adjust the sensitivity (ISO) of the sensor that captures light. You use these controls to fine-tune the amount of light captured, giving you control over your images.

This chapter gives you the goods on how the adjustments you make to your camera affect the images you get. Changing the aperture changes not only how much light gets into the lens but also the depth of field, for example, and changing the shutter speed can capture a sense of motion. The ways you combine your settings affect not only how light works in your images but also the message you send through those images.

The Stop: Measuring Aperture, Shutter Speed, and ISO

Aperture, shutter speed, and ISO form a close relationship when it comes to exposure: Change one, and you usually have to change one of the others to maintain proper exposure. Fittingly, one measurement describes the adjustments in the shutter speed, aperture, and ISO.

Stop is the term that photographers use to describe the change from one shutter speed to another, one aperture to another, and one ISO to another. A stop means the same thing for all three.

When you change a setting by a stop, you let in either exactly twice as much light as the previous setting or exactly half as much light. Here's how it works:

- **Aperture:** When you change aperture a full stop, you let through twice as much light or half as much light. If you change the f-stop (aperture setting) a full stop from f/5.6 to f/8, you halve the amount of light that makes it through the aperture. If you change the aperture a full stop in the opposite direction to f/4, you let in twice as much light.

- **Shutter speed:** If your shutter speed is set at 1/60 second and you change the opening a full stop to 1/30 second, you let in twice as much light. If, instead of 1/60 second, you go a full stop the other way to 1/120 second, you let in half as much light.

- **ISO:** The difference between ISO 400 and 800 is a full stop of light and makes the camera's sensor twice as sensitive to light. If you go from ISO 400 to ISO 200, the camera becomes half as sensitive to light.

This uniformity of measurement makes adjustments easier and frees you up to get creative. Imagine that you have a scene that's correctly exposed at 1/30 second at f/11 using ISO 200, but you want a shallow depth of field, so you'd rather use f/4. The difference between f/11 and f/4 is three full stops, so when you change the aperture to let in three more stops of light, you also need to change the shutter speed and ISO a total of three full stops to keep the exposure the same. One solution is to change the ISO from 200 to 100, which is a full stop, and then change the shutter speed from 1/30 to 1/120, which is two stops. Doing so creates an equivalent exposure and enables you to use the f/stop that gives you the effect you want.

Adjusting Aperture

Look at the inside of your lens, and you probably see a series of little blades about midway through the lens. When you take a picture, the blades control the size of the opening, allowing a precise amount of light to reach the sensor.

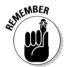

The opening, or *aperture,* is described as a fraction: An opening of 1/1 means the aperture is all the way open, whereas 1/64 means that it's open only a tiny bit. As the f-stop number increases, the size of the opening gets smaller. Each full f-stop change allows in exactly half as much light as the previous f-stop. Most cameras allow you to adjust the f-stops in 1/3 or 1/2 stops.

Chapter 3 introduces aperture and shows you aperture openings and their corresponding f-stops. You see how the lens is stopped down and lets in less and less light as the number increases.

Controlling depth of field

When you change the aperture, you change the amount of light allowed through the lens, but that's not all that happens. When you change the aperture, you also change the depth of field.

Depth of field refers to the actual amount of your scene that's in acceptable focus. Imagine that you're taking a picture of a bride standing outside under a tree. You look through your camera, and the autofocus brings her face into sharp focus, just as you would expect. As you look through the finder, you notice a trash can off in the distance behind her, but it's so far out of focus that you can't tell what it is. You also notice some trash in the foreground but, looking through your finder, you see that it's completely out of focus too. The only thing in sharp, crisp focus is the blushing bride.

You take the picture, and a quick peek at the back of the camera shows you that things look pretty good. You move on and enjoy the rest of the day. When you later pull up the photographs from the wedding, a terrible truth emerges: The trash can is in focus and standing out in the background. What happened? You got stung by a deep depth of field.

Because of the way lenses work and the physics of light, as you use smaller openings in the lens, the amount of area in acceptable focus increases in front of and behind the subject. Under normal circumstances, the area of acceptable focus increases about a third in front of where you place the focus and about two thirds behind where you focus. Because you used a small opening when shooting the bride, the trash can that shouldn't have been in focus was. Some cameras have a depth-of-field preview button, which, when pressed, shows the actual depth of field in the image before taking the shot.

The other thing to keep in mind about depth of field and aperture is that the longer the lens you use, the less depth of field you have when compared to a wide-angle lens. If you take two lenses, a wide-angle and a telephoto, and set them both to f/11 for increased depth of field, the wide-angle lens gives you substantially more depth of field than the telephoto lens. To get soft and pleasing backgrounds for portraits, use an 85mm portrait lens or a 70mm–200mm zoom lens, and set the aperture to f/4 or f/5.6.

The picture of the trash can and the bride would have been completely different (and better) if the trash can behind her and the trash in front of her hadn't been there in the first place. The next best thing would have been to throw these out of focus by controlling the depth of field correctly and using an aperture that would have kept the focus on the bride and let the objects in the foreground and background fall out of focus. Out-of-focus backgrounds make the subject pop right out of the image, keeping the viewer's eye where you want it — on the subject.

Figure 6-1 shows an image with deep depth of field along with a much more pleasing version with shallow depth of field.

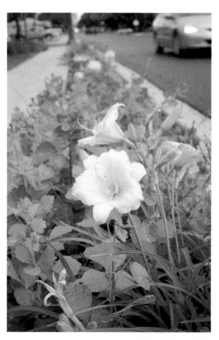

50mm, 1/25 sec., f/13, 200 *50mm, 1/1000 sec., f/2, 200*

Figure 6-1: Stopping down the lens to f/13 gives a lot of unwanted detail in the background. Opening up the lens all the way to f/2 throws the background out of focus nicely.

How about a second example? Check out Figure 6-2.

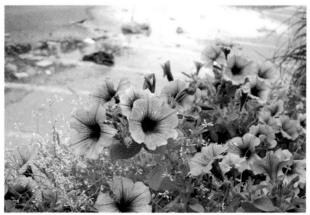

50mm, 1/30 sec., f/16, 500

50mm, 1/3200 sec., f/1.4, 320

Figure 6-2: Garbage be gone! Ahh, that's better.

Aperture and your flash or strobe

Because the burst of light from a strobe or flash is very — and I mean *very* — short, the amount of time the shutter is open doesn't change how much of the flash or strobe light the sensor captures. As long as the sync speed (see Chapter 3) allows for the flash to be triggered properly, the shutter speed's role in the flash or strobe exposure is done. The aperture alone controls the exposure created with the light from a flash or a strobe as long as the ambient light is lower than the flash light.

If you're using a flash or strobe, you can control the exposure in two ways:

✔ **On the camera:** If the image seems too dark, you need to open the aperture (use a smaller f-number). If the image seems too light, you need to close down the aperture (use a larger f-number).

✔ **On the flash or strobe:** If you want to use a particular aperture, you can control the exposure on the flash or strobe. Just set your light and take a test shot at the aperture you want to use. If the scene is too bright, lower the power of the light; if the scene is too dark, raise it.

Using Shutter Speed to Get Light Right

Shutter speed is the amount of time that the shutter is open, allowing light to reach the sensor of your camera. The longer the shutter is open, the more light is allowed to reach the sensor. When it comes to photographing using flashes or strobes, the duration of the light is very, very quick, so the shutter doesn't have to be open very long for all the light to be recorded. The shutter speed is used to control how much of the ambient light is captured. Shorter shutter speeds mean that less ambient light is recorded whereas longer shutter speeds mean that more of the ambient light is recorded, but in both cases, the same amount of light from the flash or strobe is recorded.

Combining shutter speed and aperture

Imagine you have two glasses, both half full (or half empty). One represents aperture, and the other represents shutter speed. The water represents the amount of light you let into your camera. The way the water is distributed between the two makes up the exposure. You can have one glass full of water and the other empty, both half full, or one ¼ full and the other ¾ full. Any combination of the two gives you a perfect exposure as long as you use all the water. Thirsty for more? Good, keep reading.

When you're shooting with a flash and want to utilize ambient light, you use a shutter speed that allows the ambient light into your image, while the aperture controls how much of the flash is present in your image. By setting a slower shutter speed, you allow more ambient light to illuminate the scene, whereas a faster shutter speed means that more of the flash lights the scene.

This concept comes in handy when you're shooting people or an event in a large room, and you don't want the room to go dark behind your subjects. Leaving the shutter open for 1/30 or 1/15 second lets the ambient light illuminate the room, while the short flash burst freezes people in the foreground. You can also use this technique to purposely underexpose a scene when shooting outdoors, so that the background is slightly darker and the flash

properly exposes your subject. Doing so makes the subject stand out against the background. See Chapter 14 for more on this technique.

Using shutter speeds to create lighting effects

Using your shutter speed, you can create a thin black line, or shadow, that actually surrounds your subject and separates her from the background. This technique adds drama and a sense of motion to a portrait. It's perfect when you want to give someone a distinctive, unique, and powerful look. Figure 6-3 shows a powerful portrait made stronger with this effect. The black line is especially noticeable on Nick's cheek and neck. Also note how by using a shortened loop pattern, I was able to keep the umbrella from reflecting in Nick's glasses. No postproduction was done to this image.

70–200 f/2.8 set to approximately 160mm, 2 sec., f/9, 160

Figure 6-3: A thin black line adds cool dimension and drama to a portrait.

By using the same trick in backwards fashion, you can actually pull light from the background and wrap it around the subject in a dreamlike fashion. Figure 6-4 shows this softer and dreamier look, which is great for portraits. Note the cool, fluffy light under the chair. Again, this image was created with zero post-production.

70–200 f/2.8 set to approximately 105mm, 1.6 sec., f/10, 160

Figure 6-4: Pulling light from the background gives a soft, feminine image.

To use this technique, light your background with continuous lights and your subject with a strobe unit. Put your camera on a tripod, and you have everything you need to make this work.

Imagine you're shooting a portrait of a high school senior with his guitar and leather jacket in front of a weathered brick wall. A funky, gritty black outline would add the oomph that both of you are looking for. Here's what you do:

1. **Position a strobe with a soft box or umbrella as the main light on your subject.**

2. **Position continuous lights to illuminate your background.**

3. **Get your rocker dude far enough from the background so that the light from your soft box or umbrella hits him but doesn't reach the wall.**

 Your subject must be in a darkened area for this technique to work. You don't want any ambient light on him.

4. **Using your incident flash meter, get the exposure for your strobe.**

 Make sure the background light in Step 2 is set to give the same exposure. Don't forget to turn off any modeling light.

5. **Meter the background that is lit by the continuous lights.**

6. **Set your shutter speed to match your aperture.**

 Imagine your aperture is f/11. Your shutter speed will be slow; a full second lights the whole scene evenly. Your settings can be different, just as long as the exposure is the same for the background and subject.

7. **Set up your camera on a sturdy tripod and tell your subject to smile (or grimace).**

8. **Take your shot and twist the focus ring on your lens to infinity.**

To create a soft effect instead of a black outline, just twist the focus ring in the opposite direction (starting with your subject in sharp focus) after you press the shutter release button.

This technique works because when the flash fires, everything is fine and dandy — the subject is exposed perfectly by the flash while the background begins to be exposed by the continuous (ambient) light. When you change the focus to infinity, you make the subject a little bit smaller in the frame. The subject also becomes out of focus, but that doesn't matter much because the flash has already gone off and captured the in-focus subject. The subject changes size just enough to show a little black part of the background that was masked by the subject at the start of the exposure.

How fast you pull the focus to infinity determines how much black line you get. If you pull to infinity super fast and wait for the exposure to end, the black line will be thick; if you pull the focus gently, the line will be thin and defined.

These images look as if the background actually comes around and envelops the subject. Try this technique on anything from a pregnant woman to grandma in front of her wall of pictures. The effect will make the subject stand out nicely from the background. The background takes on a soft, fog-like effect without losing any of the sharp focus on your subject. It's a very pleasing effect that's nearly impossible to replicate in a photo-editing program, and editing definitely takes longer than the couple of minutes it takes you to shoot. Even if you add 20 or 30 minutes of setup time, using this method is light-years faster.

Understanding ISO Settings and Lighting

The *International Standards Organization (ISO)* rating refers to the light sensitivity of a digital camera's sensor. It was initially based on the different film speeds and their sensitivity to light. With film a thing of the past in the digital world, those numbers now refer to how much the signal that's captured by the digital sensor in the camera is amplified. The more the signal is amplified, the less light you need.

Each time the ISO number doubles, the ISO becomes one stop more sensitive to light. For example, ISO 400 is twice as sensitive to light as ISO 200, and ISO 800 is half as sensitive as ISO 1600. (Check out Chapter 2 for the full story on ISO.) ISO gives you a tool for adjusting the camera's overall sensitivity. If you need a fast shutter speed to freeze action but also a deep depth of field and you don't have much light, just increase the ISO. The downside of pushing the ISO higher and higher is that the more the signal from the sensor is amplified, the more digital noise ends up in the image.

You can push the ISO clear up to 1600 or even 3200 if you need to, especially on the newer cameras that have a lot less noise than those from just a few years ago. A little digital noise may even add to the effect you want. Viewers will overlook digital noise in a sharp and well-exposed image, but they won't overlook blurriness. So if you have the need for speed, go with it — don't worry about a little noise.

If you're lighting a scene with your small electronic flash and you want to use the flash with a soft box or even an umbrella, you may lose up to two full stops of light, leaving a limited amount of light to work with. The shutter speed and ISO combination you use determines how bright or dull your

background is. If you want the background to be somewhat bright and have a good amount of detail, you need a slower shutter speed to let more light in — even as low as 1/8 to 1/15 second. If you need to freeze the background, you need a faster shutter speed, so go ahead and set your shutter speed to 1/125 and crank up the ISO until you get a background you're happy with.

Figure 6-5 shows you a two-part image in which the background is adjusted in brightness by adding sensitivity to the camera. I made the left image at ISO 800 with a flash. I shot the image on the right at a staggering ISO 2500, making the camera almost four times more sensitive to light. This technique is similar to dragging the shutter.

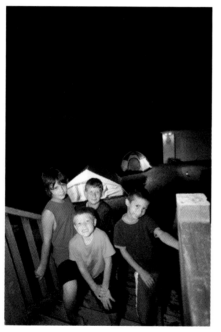 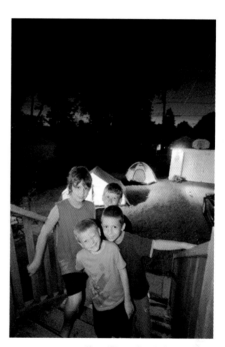

18mm, 1/25 sec., f/4, 800, flash in ttl mode with an omnibounce diffuser *18mm, 1/25 sec., f/4, 2500, flash in ttl mode with an omnibounce diffuser*

Figure 6-5: A group of goofballs getting ready to spend the night in the back yard. Some outdoor lights are on lighting up the yard nicely in both shots, but in the second shot you get a glimpse of the Chicago city glow and a better feel for the yard.

One real advantage of using a higher ISO is that you need less light, which means your flash doesn't have to work as hard. Because it needs less light, the flash can operate at a lower power, which in turn allows the flash to recycle faster and be ready for the next shot sooner.

Don't be afraid to use some of the higher speeds on your camera. They exist for a reason, and if you can get a shot (albeit with some grain or digital noise) that wasn't possible otherwise, so be it. Newer cameras have really improved higher ISO shooting, making it possible to shoot at much higher ISOs with low noise.

7

Using Lighting Equipment to Create the Effect You Want

A flash or strobe just puts out light; determining where that light goes and what kind of effect it creates are up to you. These decisions sound simple until you start trying to make them. This chapter is about using lights and modifiers to your best advantage — small flash units and big studio strobes plus diffusers, reflectors, and a few other tools. Knowing what each tool does and how it works opens up a world of creative possibilities.

REMEMBER

Use the techniques I describe in this chapter as a springboard for your own experimentation. One of the best things about digital photography is the ability to see your work instantly. Seeing the effects of the lights on your subject right after the photo is taken is incredibly helpful and allows you to move or adjust the lights and try again.

Using Flashes for Flattering Effects

Using a small flash with your camera gives you more flexibility than you may think. You don't have to settle for a straight-ahead blast of light when you're using the flash on-camera, and you get even more options by rigging the flash for off-camera use. You can even use your small flash unit to overpower the enormity of Mother Nature's original light source — the sun. How's that for power?

Making the most of on-camera flashes

When you use flashes — lights that sit on top of your camera in the flash hot shoe and fire when you press the shutter release button — light just hits the subject straight on and often isn't very flattering. Here are a few things that can help when using these types of flashes, even though the flash is still attached to the camera:

✔ **Bounce the light:** Because you can adjust the flash head, you can aim the light so that it bounces off any nearby surface. This technique works great when you're shooting in a white-ceilinged room. Aiming the light at the ceiling instead of the subject bounces the light from the flash off the ceiling and onto the subject. This turns that very small, very bright light into a much softer, diffused light source.

✔ **Diffuse the flash:** Many flash units come with a diffuser dome that fits over the head of the flash (see Chapter 14 for a visual). This diffuser changes the light produced by the flash from a small, bright, focused light to a larger, softer light by sending light in all directions from the flash head (see Figure 7-1). Most diffusers are created out of a hard, semi-translucent plastic.

35mm, 1/30 sec., f/5, 640, ttl flash *35mm, 1/30 sec., f/5, 640, diffused flash*

Figure 7-1: Using a diffuser with a bounce card makes for warmer, softer, more evenly distributed light in the second photo.

Because the diffuser reduces the flash's power, you may need to increase the flash's power to get the same amount of illumination that you would get without the diffuser. If your flash doesn't have a diffuser, you can always buy one at a good camera store.

✔ **Add a modifier:** You can find a great many modifiers for flash units, including grids and snoots, which make a smaller, more controlled light; bounce cards that attach to the flash and act as a reflector when a nearby wall or ceiling isn't available; and even small soft boxes, which diffuse the light the same way a studio soft box does for your flash. Chapter 2 tells you about modifiers.

Getting the flash off the camera

The very best thing you can do with your flash is to remove it from the camera. Doing so enables you to move and aim the flash so the light shines where you want it.

If you remove the flash from the camera, you have to figure out a new way to get the flash to fire when you press the shutter release button. The easiest way is to use a special cable that's made for this purpose: a *flash sync cord.* One end goes into the hot shoe on the top of the camera, and the other end has a hot shoe that the flash slides into. This cable allows the flash to fire as if it were attached to the hot shoe on the camera. These cords are what allow you to use those flash brackets (see Chapter 15) that you see the paparazzi using. The flash still fires when the shutter release button is pressed, regardless of where it's pointed.

Some other ways to trigger the flash when it isn't on your camera don't involve wires. As Chapter 4 tells you, both Nikon and Canon have systems in place whereby a flash on the camera (or a dedicated control unit) triggers an external flash.

This flexibility really opens up the possibilities because it allows you to place a flash off the camera and trigger it from the camera without being limited by wires. The system enables you to greatly increase the distance between the flash and the camera. The other upside to using the built-in control is that information from the camera is sent to the flash, and you can control the power output directly from your camera.

Another way to trigger off-camera flashes is with a wireless remote, like the PocketWizard transmitter/receiver pair or transceiver. You attach the transmitter to the camera and the receiver to the flash. The flash fires when you press the shutter button. There are two versions of this system; the more affordable system only sends a trip signal to the flash, so you have to use either an auto setting, where the flash reads its own light and shuts itself off automatically, or a manual power setting. Test the auto system of your flash; I've found most to be remarkably accurate. A newer PocketWizard flex system actually sends all of the TTL data from the camera to the flash so the system works just like the flash is mounted on the hot shoe of the camera.

Taking your flash off your camera really opens up your lighting possibilities. If you want to add a sidelight with more dramatic shadows, just move the light

off to the side. Need to add some light to a specific part of the scene? Just add a flash in that direction. Want to make the subject pop out from the background? Use one flash to light the background and another to light the subject.

Overpowering sunlight with your flash

You can light the same subject in many different ways. The way you choose to light your images is part of the creativity that photography allows you to exercise, especially when you're shooting in a studio. Your options are no less limited when you're shooting outside, as you have either a real bright and specular light or a soft blanket of light that fills in everything nicely on a cloudy day. Regardless of the current weather, you can use your flash to fill in shadows or completely overpower the sun; it's your choice. Simply filling in shadows is fine, but taking more control of your images, even using the sun as fill as you add your own key light to a scene, gives you more control of the lighting conditions.

This technique is easier when you use a larger, more powerful studio strobe system, but you can overpower sunlight or turn day into night with little more than the flash that's probably already in your camera bag. Imagine this technique as combining two different photos — one created with the existing sunlight and one created with the flash. You accomplish this trick by taking the following steps:

1. **Position your subject so that the sun is behind your subject.**

2. **Meter the scene and take a photo, purposely underexposing by a full stop.**

 With the camera set to ISO 200, your underexposed exposure will be pretty close to 1/200 at f/22. This is a stop under the normal daylight exposure.

 Don't select a shutter speed faster then 1/200, as this is at the max sync speed for most modern cameras.

3. **Evaluate the photo you took in Step 2.**

 The background will be a stop under exposed, so a little dark, and your subject's face will be about two full stops underexposed — pretty honking dark.

4. **Use the flash in one of two ways:**

 If you have a larger portable flash system, you'll have to use it in manual mode. You can use a shoe-mount flash in manual as well if you choose.

 TTL flash users can test the camera/flash combo in TTL mode.

5. **Achieve a normal exposure on your subject (f/22 with an ISO of 200), and squeeze off a test shot.**

 Manual users adjust the power output and distance of the unit till you achieve f/22.

TTL users can simply set the flash for TTL with the camera in manual settings.

6. Marvel at your handy work!

Once you experiment with this technique you'll begin to recognize it in editorial work where a single light can create a pretty dramatic image. By adjusting the flash power and aperture, you can decide how light or dark the background will be.

Figure 7-2 was shot with the flash in TTL mode and tripped by a PocketWizard flex transmitter. This let the flash be close to the subject and still use the TTL communication. The camera was back a bit with a long lens to compress the lines behind the subject.

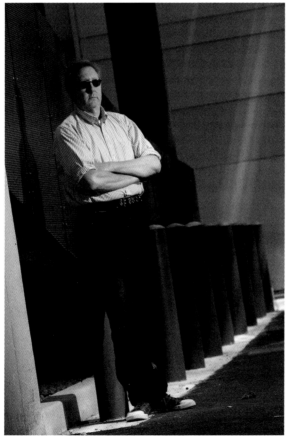

200mm, 1/125 sec., f/8, 400

Figure 7-2: Using a flash to overpower the daylight by a full stop, the darker background adds drama to the subject of the photo.

Figure 7-3 takes the technique of overpowering the sun and builds on it. By making adjustments to the white balance settings of your camera and using gels to change the color of the light produced by your flash or strobe, you can create scenes that range from dramatic to outlandish. To create this image, I added an orange gel to the flash and then performed a custom white balance so that the light produced from the flash is seen as white by the camera. (Chapter 5 tells you how to perform a custom white balance.) Because the orange light the flash put out was neutralized (turned white), the color of the background light was shifted, turning the background a deep, rich blue. The camera added blue to the shot to counteract the orange light of the flash; anything that isn't hit with the orange flash will be blue.

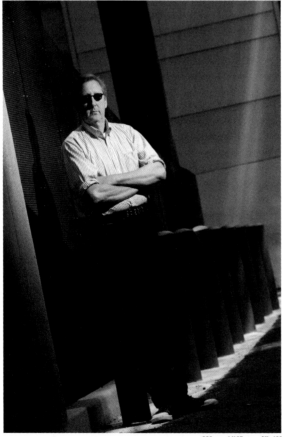

200mm, 1/125 sec., f/8, 400

Figure 7-3: Adding an orange gel to the flash and color balancing neutralize the orange light, leaving a thick, mysterious, and cool blue background.

You can use this technique to turn the background just about any color you want by using the opposite-colored gel on the flash and doing a custom white balance. Check out the color wheel in Figure 7-4, and you see that orange is across from blue — the color of the background in Figure 7-3.

For example, imagine that you want to create a bright red, Mars-like background. You place a blue gel over your flash, overpower the background a tad, and perform a custom white balance like you see in Figure 7-5. The background automatically turns a vibrant red, and the blue light from the flash is neutralized in the final images. (See Figure 7-6.)

You can adjust the foreground, as well. To create Figure 7-7, I followed the same procedure I used for Figure 7-3 (adding an orange gel to the flash and performing a custom white balance), but I went one step further, adding an additional *quarter sun* (a light amber or orange-colored gel) to the flash after I performed the custom white balance. If I had done the white balance after the additional gel, the camera would have neutralized that gel, too.

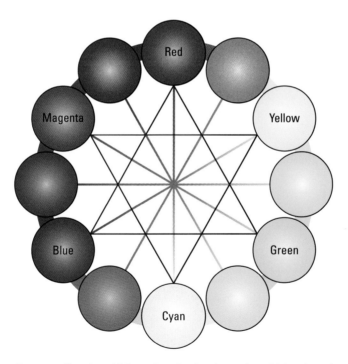

Figure 7-4: Use the additive color wheel to determine which color gel you need to amend your background.

50mm, 1/200 sec., f/11, 200

Figure 7-5: The Lastolite flip-up gray card being lit with a flash with a blue gel.

24mm, 1/200 sec., f/9, 200

Figure 7-6: The "Mars-scape" effect after neutralizing with a custom white balance.

On the Mars set, if you take a yellow gel and place it over the red gel after you do your custom white balance, the subject lit by the flash becomes bright yellow on a red planet.

The power of the flash or strobe is reduced when the light has to go through gels, so increase the power as needed to get the exposure you want.

200mm, 1/80 sec., f/8, 400

Figure 7-7: Adding an additional warming gel to the flash after performing the custom white balance gives the subject some warmth without changing the cool blue background.

Manipulating Strobes

Strobes are those big studio lights that need their own light stand, power sources, and a way to be triggered when you press the shutter release button. These lights are powerful and can be intimidating to use, but a few simple concepts enable you to use them like a champ.

When you slide a small flash onto your camera, the camera does a lot of the hard work for you. It controls the flash and adjusts the power using TTL (through the lens) technology. The image may look like a passport photo or a deer caught in the headlights, but the flash gives you an easy starting point.

When you graduate to studio strobes, life gets a little more confusing — at least to start with — but you can easily get the hang of using strobes. Here's what you need to know:

✔ **Controlling the light:** When you use studio strobes, you need a way to get the lights to fire when you press the shutter release button. You need to attach the light to your camera in some way. The easiest way to do this is to use a sync cable that runs from a sync port on the camera to a sync post of the light. When you press the shutter release button, the sync cable sends a signal to the light, and the light fires. Wireless triggers do the same thing as the sync cable but without the wires. Some studio lights actually have a wireless receiver built in to the light so that all the photographer needs is a transmitter.

When using strobes, you can't use a shutter speed higher than 1/250 second or, in some cases, 1/200 second. Play it safe when using studio strobes, and use a shutter speed of 1/200 or lower.

Sync speed is limited because of the physical limitations of the shutter in the DSLR (Digital Single-Lens Reflex) camera. A DSLR camera allows you to see through the actual lens, giving you the same view as the camera. The focal-plane shutter of a DSLR camera consists of two curtains that open across the front of the film. When you use higher shutter speeds, the second shutter moves right behind the first shutter, and the sensor is exposed through a little slit that moves across the sensor. If you use a flash at one of these faster speeds, then only the part of the sensor behind the open part between the two shutter curtains is exposed to the flash. The sync speed is limited to the fastest speed at which the whole sensor can be open to the flash.

✔ **Adjusting the intensity of the light:** Looking at the controls on a studio strobe can be a bit intimidating. Keep in mind that all a flash does is put out light. If it's set to full power, the unit puts out all of its power; set the unit to half power, and it puts out half of its power.

To get the image you want, you need to be able to control the amount of light produced by the flash. If you want to use a small aperture like f/22, you need more light. Conversely, if you use a bigger aperture like f/4, you need less light. Just adjust the intensity accordingly. Some studio strobes have the light intensity marked as percentages: 100 percent, 50 percent, and so on. Other lights are marked as follows: 1/1, 1/2, 1/4, and so on, which looks a lot more complicated but really isn't. These fractions show you how much light is being output in relationship to full power: 1/1 is full power; 1/2 is half power, putting out 1 stop less light; and so on. For more on stops of light, see Chapter 6.

✔ **Using straight light versus modifiers:** Studio strobes are usually just bare bulbs, which aren't that great to work with because the light they emit is usually harsh and tends to go all over the place. You may use

a bare bulb when you want a hard shadow or very stark lighting. Most of the time, you'll want to soften the light with a soft box, umbrella, or other modifier:

- **Soft boxes** are basically diffusers that you place in front of strobes (and flashes) to create a larger, softer light source. Soft boxes come in a variety of sizes and shapes and are available for any brand of light on the market. These are one of the main tools of the professional studio photographer. When you use a soft box, you get a much more controllable light source but you do lose power, so you need to change the exposure accordingly. Some soft boxes come apart into many pieces and/or have lots of attachments (usually via Velcro); others have few parts, making them easier for beginners, especially those who plan to use them on location. Sometimes a *speed ring,* a specialized piece that allows the soft box to be mounted on the strobe, is also needed.

- **Umbrellas** are the same shape and design as those things that keep the rain off your head but are either translucent or have a reflective inside surface. You can either shoot light through an umbrella, which diffuses it like a soft box, or you can reflect light from the inside of an umbrella, which also diffuses and spreads the light. Some umbrellas have a removable cover that allows you to shoot through or shoot reflected light. The real upside to umbrellas is that they're very inexpensive and easy to take on location. Taking a hack saw to a thrift store white umbrella works if you're on-the-cheap; colored umbrellas could be used for special effects.

- **Other modifiers:** Like their name implies, modifiers are items that change the light produced by studio strobes. Other types of modifiers include grids that fit over the front and help to aim the light and snoots that turn a large light source into a small light source. For more on the different types of modifiers, see Chapter 2.

As you get started using studio strobes, you'll probably wonder how much power the flash should be set on and what f-stop you should use for your photos. Here are the steps to take to set up your shot:

1. **Figure out which f-stop is appropriate for the image you want to create.**

 For example, do you plan to shoot a portrait of one person at f/5.6 or a group of people at f/16?

2. **Set up your lights according to the f-stop you intend to use.**

 Because f/16 is three stops away from f/5.6, you need eight times more light at f/16 than you do at f/5.6. This is because each f/stop is twice as much as the one prior: So f/8 is twice as much light as f/5.6; f/11 is twice as much as f/8, which makes it four times as much light as f/5.6; and so on.

3. **Using a flash meter, read the amount of light falling on your subject:**

 1. **Holding the meter in front of your subject's face, make sure the bulb (the half-ping-pong-ball-looking dome) is pointing straight to the lens.**

 2. **Take a reading of the strobes by hitting the meter button.**

 You'll need to plug in the PC cable that normally plugs in to the camera to trip the strobes when you hit the meter button. If you're using a radio transmitter from the camera to the flash, you'll need to plug the meter and the transmitter together to send the signal to the strobes to fire when you hit the meter button. Several of the higher end Sekonic light meters have a radio transmitter built in so you don't have to unplug the camera.

 3. **Once the strobes fire (or pop as some like to call it), your light meter will give you the reading.**

4. **Use this reading to determine whether you need to turn up or down the power on the power pack.**

 Remember that each f/stop represents twice as much light as the one before and half as much light as the next one. Say your first light meter reading is f/11 with the strobes set to ½ power, but you want to shoot at f/8 to help the backdrop go out of focus a bit more. You need to turn the power down to 1/4 so your exposure comes down 1 stop.

Employing Reflectors and Diffusers

Photographic lights are costly these days, but simple diffusion panels and reflectors can help you define and control the light in your images and make light work the way you want it to. These tools enable you to get the image you see in your head into your camera. Having the knowledge and where-withal to employ these tools at the right time makes the difference between taking a picture and making an amazing photograph.

Determining when diffusers and reflectors are necessary

A *reflector* is used to reflect light or bounce light into your scene. Any item can be used as a reflector as long as it has a surface light can bounce off of. Some very cool off-the-shelf modifiers are available that spring open and have a reflective material stretched across them, allowing you to bounce or

reflect a light easily. You can use a reflector to achieve great results in many situations. The following list gives you a good idea of when to break out that reflector and put it to good use. Use a reflector when

- ✔ A scene includes too much contrast for your personal taste.
- ✔ The tonal range of the scene is well beyond what the digital sensor in your camera can capture.
- ✔ You want to reduce the shadows under your subject's eyes.
- ✔ You intend to highlight your subject's dimension and shape, for example, when you're photographing a bowl of fruit.

Diffusers reduce the amount of light and can take a very bright, small light source and make it much bigger and softer, which, in turn, produces a more flattering light. The best times to use a diffuser are when

- ✔ The light is too bright, as when you're shooting in midday sun. (See Chapter 8 for more on daylight shooting.)
- ✔ You want a softer light for portraits.
- ✔ You're shooting in harsh light. Adding a diffusion panel not only changes the highlights of your subject but also softens the transition from highlight to shadow. If you're doing portraiture, diffusion panels are absolutely indispensable.

Finding special uses for reflectors

Using a reflector just to bounce light back at a subject is pretty simple. Doing so fills in any unwanted shadows, and you can easily adjust the light by changing the reflector's angle. One of my favorite techniques for making a modern portrait involves using reflectors.

I shot Figures 7-8 to 7-10 on a summer afternoon at a busy corner in downtown Chicago. Initially, the overhead lighting at high noon produced shots in which the subject was squinting and looking annoyed. To remedy this, I turned the model around so the sun was at his back, with the result shown in Figure 7-8.

The sun now backlights the subject beautifully, giving fantastic highlights to his hair and clothing. Because he's no longer standing with the sun in his eyes, he isn't squinting, and his entire face looks relaxed and pleasant. I did a custom white balance; otherwise, the open blue sky would have left the subject's face looking a bit blue.

By using the open sky to light your subject's face, you eradicate the harsh shadows, as Figure 7-8 shows. Even if you're caught without reflectors, this step alone helps your image immensely.

500mm, 1/250 sec., f/8, 640 (handheld!)

Figure 7-8: A portrait taken without the aid of reflectors.

I then went a step further, with the aid of a couple reflectors, to turn a solid portrait into a great one, as shown in Figure 7-9.

200mm, 1/250 sec., f/8, 640

Figure 7-9: A very mod portrait using sun and two silver reflectors.

With a couple of reflectors (and a pair of helpers), you, too, can create a portrait that's modern, memorable, and fantastic. Here's what you do:

1. **Pop open two silver-sided reflectors.**

2. **To set up the reflectors so the light strikes the subject's edge, have both of your helpers stand behind your subject and on an angle so the sun can hit the reflector and be reflected onto the shoulder and cheek of your subject.**

Figure 7-10 shows the position of the reflectors in relation to the model. The people holding the reflectors should be close enough to see the spot of light they're reflecting on the subject, so they can move it if necessary.

Figure 7-10: A wide shot showing the position of the two reflectors in relation to the subject.

3. **Take a light meter reading of your subject.**

 Alternatively, you can just set your camera to program auto (where the camera sets both the aperture and shutter speed), to aperture priority (where you set the aperture and the camera sets the shutter speed) or to shutter speed priority (where you set the shutter speed and the camera sets the aperture) and take a photo. Because the light being produced by the reflectors is constant, the built-in meter will see it and adjust the exposure accordingly.

4. **Place your subject in the shade with a darker background and use your reflectors to reflect the direct sun, and you'll be amazed by the way your subject will just pop off the page.**

In Figure 7-11, I placed my subject in the shadows of the Chicago overhead train (the EL) and still had my reflectors in the sun to create this powerful image.

500mm, 1/250 sec., f/8, 640 (handheld!)

Figure 7-11: A similar portrait created by moving the subject into the shade and keeping the background equally dark.

Getting Creative with Other Lighting Tools

When you need to adjust the light but can't move or change the light source, you need to use some of the other tools available to photographers. These tools can block light, change the size of the light, and even change the color of the light. Used correctly, they can turn a lighting nightmare into a workable lighting solution.

Using scrims — or the screen from your front door

Scrims are devices that commonly contain a screen-like metal mesh. You use them in front of a light to reduce the light's intensity without diffusing or spreading the light.

It makes no difference whether you're shooting outdoors or in the studio, the scrim works the same way. A *scrim* is a frame with mesh material stretched across it. The screen should be black or dark in color, or it will produce some diffusion. It reduces the amount of light that strikes the subject without changing the quality or size of the light source the way a diffusion panel does.

Imagine you're in the back yard shooting a picture of your flowers. Your award-winning bright yellow orchid stands in front of some assorted flowers that will make a perfect out-of-focus background. You add a white reflector to reduce the contrast and fill in the shadows on the orchid. The results (shown in Figure 7-12) look fine but not as fantastic as you were hoping. The orchid seems to blend into the other flowers in the background.

200mm, 1/800 sec., f/4.5, 100

Figure 7-12: A flower lit by the sun and a small reflector just out of the frame.

Placing a scrim between the sun and the flower in the foreground reduces the amount of light falling on the flower without diffusing or changing the quality of the light. Figure 7-13 shows you the results. By contrast, using a diffusion panel over the flower gives it an overly soft look that causes the image to lose realism, as you can see on the left. The flower looks like you shot it in the studio.

When you reduce the light on the orchid by using a scrim, you need to either open up the aperture or leave the shutter open longer to compensate for the light that the screen is holding back. Because the light on the flowers in the background isn't changed by a scrim, those flowers are brighter, which makes the flower in the foreground pop off the background.

200mm, 1/640 sec., f/4.5, 100 *200mm, 1/500 sec., f/4, 100*

Figure 7-13: A diffusion panel (left) gives the flower an unnatural light for its setting, whereas a scrim (right) makes the orchid pop off the background.

Figure 7-14 shows a wider angle of the shot so you can see the flower with a Road Rags scrim positioned overhead to block some of the sunlight.

If you don't have a commercially made scrim, work with what you have: The screen from a screen door or a window works just like a scrim. The dirtier the screen, the more light it blocks; the cleaner the screen, the less light it blocks. This effect is similar to what you get with the two different densities of screen that come in the Road Rags kit.

You can use this technique with people or any other subjects. All you need is a screen or a scrim.

Figure 7-14: A wide angle shot showing a RoadRags scrim over the flower.

Banking on a black flag for a negative fill

The black flag is a device that blocks direct light and bounced light. It allows you to remove some of the fill light, creating a negative fill that can add contrast to an otherwise flat scene.

If, for example, you're photographing a blushing bride outside a classic, white-washed church on a cloudy day, the only splashes of color or contrast are the bride's blushing cheeks and her lipstick. A terrific way to remedy this is to have your assistant, or someone's kid brother who was nominated to be your helper for the day, hold a black flag (or a black piece of foam core, or anything opaque and black) parallel to the bride. (See Figure 7-15.) Just as it would with a giant soft box, light falls on your subject from every possible angle instead of directly from one direction, as the sun does on a clear day.

Holding the flag as in Figure 7-15 stops the light from wrapping around her face and body, and actually creates some shading on the side of her body where you place the flag. Start with the flag held as close to her as possible without it being in the shot. If the shadows created by this are too dark, simply start backing the flag away until it looks good. If you get it too far away from the subject, you'll lose the effects completely, so watch the shadows and light carefully.

The effect doesn't work when you're too far from the subject because the soft, white clouds can fill in from just about any and every angle. Once you get the flag far enough back, the soft skylight fills in the subject again.

Figure 7-15: A black-negative fill stops the light from wrapping around your subject and creates contrast.

Building your own reflector, diffuser, or flag system

If you're the do-it-yourself type, you can build a frame capable of holding a variety of fabrics to create your own reflector, diffuser, or flag. You can build the whole system for around $30.

You need to make two stops before you can build your reflector — the hardware store and a fabric store. At the hardware store, pick up the following:

✔ Four 35-inch lengths of ¾-inch PVC pipe, preferably the gray pipe with the thicker interior wall. (If you can't get it cut at the store, pick up a hacksaw, too.)

✔ Four 90-degree PVC elbows. Make sure you get the slip-on kind, not the threaded kind. The elbow joints need to slip over the ends of the pipe pieces.

✔ Fast-drying pipe epoxy.

When you get home, spread a coat of epoxy over the inside of one end of two elbows, and push them over opposite ends of one pipe so that they face the same direction at each end. With the elbows in place, lay the pipe flat on a floor to make sure the elbows are at the same angle.

Glue the two remaining elbows to each end of a second pipe, and then head out to the fabric store while the epoxy dries.

Pick up a roughly 42-x-36-inch piece of whatever fabric suits your needs:

✔ To create a flag, get some thick black felt that will block as much light as possible.

✔ To make a reflector, pick up silver lamé or spandex. For a soft, white reflector, find some good, somewhat reflective, white material.

✔ For a diffuser, look for thin silk that will block a portion of the light.

Fold over two of the short ends of fabric to create a sleeve that you slide the PVC pipes through. If you're good at sewing, perfect — sew the little pocket or sleeve in place. If you can't sew to save your life, your best bet is to find a seamstress or a shoemaker and have the pieces of material sewn for you — you'll get maximum durability and longevity without spending too much. However, I've also seen people tape the pocket with gaffer's tape, staple it, buy snaps, use Velcro, hot-glue it, or use assorted combinations of all of these.

(continued)

(continued)

After you create the sleeves, slide your two un-elbowed lengths of pipe through them, and then connect the loose pipes to the elbows of the other two pieces to form a square.

Gluing the elbows on only two of the pipes enables you to break down the frame for easy storage and replace the material on the frame easily. See the figure for an illustration of the entire operation.

Epoxy

Epoxy

Epoxy

Epoxy

Part III
Lighting for Different Conditions

The 5th Wave — By Rich Tennant

"I've got the color balance set to daylight. I'm just seeing if there's a button that'll fix your hair."

In this part . . .

The sun won't bend to your whim like a studio strobe, and you certainly don't set up your camera to shoot fireworks at night the same way you set up to shoot a sparkling river in the early morning. Being ready to deal with the challenges of different lighting conditions can make the difference between getting your shot and fiddling forever with equipment or coming home to disappointment on your computer screen. This part of the book shows you how to get great results whether you're shooting in daylight, during the night, or in a studio.

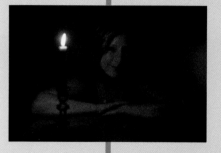

8

From Dawn Till Dusk:
Lighting the Great Outdoors

In This Chapter

▷ Seeing the benefits of early morning and late-day light

▷ Dealing with the harsh light of midday

▷ Handling the challenges of rain and snow

*U*nless you live in Alaska or happen to be a vampire, you probably sleep when it's dark out and tend to be awake, alert, and ready for action when the sun is up. Sunlight is your cue to get rolling, and, if you're lucky, it tells you to go home and eat dinner after a day's work. When it comes to photography, especially outdoor photography, the sun can be your best (and most available) light source.

Year-round, the great outdoors is the subject of and the backdrop for many wonderful images. Even during winter, when others are cursing a deep snowfall, we photographers are filling the thermoses and rejoicing as we head out with our cameras.

Daytime may seem like the perfect time to create your images, but it often leads to disappointment when you review them. The sun is a giant fire hose of paint aimed at a canvas that needs only small, delicate brushstrokes to tell your story. You need to plan ahead and be ready to shape, mold, reflect, deflect, and otherwise harness the sun to serve up your creative vision.

Shooting at Sunrise and Sunset

You did it: You got up and out of bed before sunrise and found a great subject or location that looks just perfect bathed in that golden morning light. The first light of the day — and the last light for that matter — have some very special characteristics in those early morning and late evening hours. The way the light travels through the atmosphere creates a warmer, softer light that just makes everything look better. The angle of the sun creates longer, more dramatic shadows that can make for more interesting images. This time of the day is often called the *golden hour* or *magic hour* because the light is just better.

Preparing for your shoot

One of my early commercial photography instructors, Harry Liles, promoted shooting at sunset instead of sunrise because he was afraid of the 500-pound gorilla: You find what you think will make a great sunrise photo so you set the alarm, head to your location, and set up, when low and behold, the sun pops up and there in the shadows is that proverbial 500-pound gorilla — a wall covered with graffiti, an abandoned car, construction cones — something that you didn't want in your photo pulling attention away from your subject. The best light is fleeting; you only have a couple of minutes, so you've got to be ready. Even a slight delay and you may miss the best light.

Shooting at sunset enables you to consider your shot a little more carefully because you can see everything during setup. You can take the time to carefully compose your image because everything is clearly visible before the sun starts to set. Then you can photograph the scene from the moment the magic hour hits until it's too dark. Photographing during sunrise works backwards: You set up under the cover of darkness and start shooting as soon as that beautiful morning light appears. This strategy doesn't give you much time to recompose if unwanted elements are suddenly present in your frame.

A quick location scouting trip can really pay off. Jaunt out to your location beforehand to determine the subject of your photo, the best vantage point, which lenses to use, and what gear you may need. Take a few quick shots (even if only with your cellphone's built-in camera) so that you can check them out on your computer. You may see things that you could easily overlook when setting up in the dark.

When considering a location for a sunrise or sunset shoot (or any shoot for that matter), consider what you're going to be shooting and plan your lenses and gear accordingly. For example, are you shooting a wide-open landscape that just cries out for the widest angle lens in your bag, or are you going to photograph a portrait where a telephoto lens will help to compress the background and keep the attention on the subject? You can shoot either scene in that same great light, but you use different gear to do it.

Predicting sun and shadows with an iPhone

The app explosion for the iPhone has produced a ton of great apps, including Sun Seeker. If you don't already have an iPhone, you can easily justify the cost of not only the app but the phone itself. Sun Seeker is simply that useful.

Thanks to the GPS tracking in the phone, you simply launch the application and point your phone at the scene you want to shoot. Sun Seeker shows you the path of the sun through the day. It can also show you the path for summer and winter; you can use it to see the minimum and maximum path for the entire year.

A tripod is invaluable on a sunrise or sunset shoot. Getting that first — or last — ray of light usually means a longer shutter speed, and a tripod helps keep your images sharp.

Pay attention to the direction of the sun and, more importantly, where the sun will be travelling while you're photographing. There's nothing wrong with having the sun in your frame as long as you do it on purpose and realize that it will be very bright.

Taking shots when the sun comes up (or goes down)

You shoot during sunrise or sunset because you want to use that great, golden warm light in your images. Making the most of this great golden light depends in large part on how you set up your camera.

Make sure that you set the white balance on your camera correctly so that the colors are what you expect when you process the image later. The easiest way to do this is to set the white balance to daylight, which is usually a little sprocket-looking symbol in the menu. If, out of habit, you bring along a gray card to perform a custom white balance, leave it in your camera bag. Setting a custom white balance completely negates the warm color of light that you hope to capture. A custom white balance neutralizes whatever light falls on your gray card. Poof! There goes your warm, early morning (or late evening) light. In that case, only postproduction white balance adjustment can save you, and only if you shot Raw files.

When shooting sunrises and sunsets, meter carefully and manually set your exposure. The sun is very bright and can easily throw off camera metering. The rule of thumb is to set your camera to the very smallest spot meter, and take a meter reading 20 degrees from the sun.

Because the light meter in your camera is colorblind, it tries to make everything you point it at middle gray. A separate spot meter or a spot attachment for your incident meter (see Chapter 5) works the same way. Any settings the meter gives you will render that part of the scene as middle gray. So when you point the spot meter 20 degrees from the sun, you render that part of the scene middle gray and the sun as white with detail. Chapter 10 describes how to break down your scenes and view them in terms of a grayscale or black-and-white image, and how to look at your scene in terms of seven tonal values.

Figure 8-1 shows a C 130 Hercules taking off into the sunset from Santa Barbara airport. I shot this image on transparency or slide film with a 400mm telephoto lens and metered with an incident meter fitted with a spot attachment. Using this technique, the exposure was perfect and required no adjustments whatsoever in postproduction.

One of the great advantages to shooting with a digital camera is the ability to get instant feedback. After you take a photograph, you can look to see whether you got what you want or you need to try again. When shooting sunrises and sunsets, you have to move quite quickly because the sun doesn't stop moving while you adjust the settings. Keep in mind the basics of exposure, and work quickly. If the image is too bright, for example, decrease the size of the aperture or decrease the amount of time the shutter is open when the shutter release is pressed. For example, if the meter in your camera thinks the scene will be properly exposed when you use a shutter speed of 1/100 second at f/5.6 and ISO 200 but the image looks too bright with those settings, try using a shutter speed of 1/200 second and look again. Or, you could use f/8 instead of f/5.6, which lets in half as much light. The idea is to use the meter reading to get you close, and then make adjustments until you have the exposure that's right for the scene.

Overexposing your scene weakens the colors and impact of the wonderful light, while underexposing the scene muddies the color and makes an otherwise bright and vibrant scene dark and gloomy. Here's how you get the exposure right:

1. **Set your camera to spot mode.**

2. **Set your camera to auto exposure mode.**

3. **Aim through the viewfinder at a part of the sky 20 degrees away from the sun.**

 Avoid taking a meter reading of the sun. Doing so underexposes the whole scene.

4. **Press the shutter release button halfway down to get a meter reading.**

5. **Lock that exposure with the exposure lock feature of your camera.**

6. **Compose your scene and take the photo.**

7. **Check the LCD and rejoice!**

400mm, 1/250 sec., f/22, 80

Figure 8-1: A spot meter enables you to get a perfect exposure even with the bright sun in the shot.

As you shoot sunrises, the light gets brighter and brighter, and you have to adjust accordingly by allowing the shutter to be open for less time or decreasing the aperture size while shooting. Adjust for sunsets by doing the opposite: As the sun falls past the horizon, the shutter needs to be open longer, and/or the aperture needs to be wider. You can also adjust the ISO instead of the aperture and shutter speed.

One of the great things about photographing sunrises and sunsets is that there's a new one every day, and no two are ever the same. If you don't get the shot you want, you can always try again tomorrow.

Using the Sun to Your Benefit: Daytime Shooting

In a perfect world, the sun would always be a little warm, low in the sky, and in just the right location to light your subject, but that's just not the way sunlight works. Most of your pictures show the sun high in the sky because that's when you're up and around. But high-in-the-sky sunlight leads to squinty eyes, raccoon eyes, subjects who want to wear sunglasses and hats,

hard-edged shadows, a lack of depth, and many more issues. As great as a sunny afternoon may feel — and even look — when you're experiencing it, it doesn't provide the most flattering light for photographs.

Have no fear; a lot of great tools and techniques are available to not only fix the lighting but also make it better than ever.

Tools for daylight shooting: Reflectors, diffusers, and fill flash

When you go out and photograph during midday, your main concern is the position of the sun and the angle and intensity of the light. A variety of solutions to this problem exist, and, depending on your subject, location, and needs, adjusting for the light doesn't have to be difficult or complicated.

Each tool at your disposal changes the light in a different way, and your job as the photographer is to pick the one that works best for your situation. For example, the light you'd use to take formal portraits in the back yard is quite different from the way you'd shoot kids jumping through the sprinkler. The following sections take a look at the different tools you can use to modify that midday sun.

Changing sunlight's angle with a reflector

One of the easiest ways to modify that hard, midday sun is to change its angle. Of course, you can't change the angle of the sun or the earth, but you can bounce or reflect the light where you want it to go. You can also actually change the color and intensity of the light at the same time. Many different types of reflectors exist, but they all do the same thing — reflect the light.

You use a reflector to change the direction of some of the light so that it illuminates your subject from a different angle. You can use this technique to remove unwanted shadows under a person's eyes and nose, or to light his face if he's wearing a pesky hat. Reflectors work well for stationary subjects and can result in some great images (see Figure 8-2). However, they don't work well for moving subjects, so don't count on a reflector when you want to photograph your dog bounding along the beach.

Here are some general rules about reflectors:

> ✔ **The bigger the reflector, the softer the light that bounces off it.** This characteristic enables you to change a relatively small light source like the sun, which is very bright but really small, into a bigger, softer light source.

Both photos: 24mm, 1/100 sec., f/7.1, 250

Figure 8-2: The only difference between these two images is a silver reflector being used to light up the dark bell.

✔ **The color of the reflector affects the color of the light.** Light picks up the color of any object it bounces off of, so if you use a red reflector, the light coming off it is red. The most common reflectors for photographers are either gold (warmer light), silver (harder, more specular light), or white (softer, diffused light; see Figure 8-3). I'm not a fan of warm reflectors; the entire scene is one color, and then your fill changes color. I would rather use a reflector to adjust the light in a scene and then adjust color overall separately. It doesn't make sense to me to have your fill another color.

✔ **Almost anything can serve as a reflector.** You don't have to go out and spend big bucks at a photography store unless you really want to. A piece of white foam core does the trick, and I've even seen a sheet of tin foil used on a shoot. My favorite is the flip-up reflector (Figure 8-3) that has a white side and a more metallic side, allowing you to choose how much or how little fill you want in your scene. This type of reflector is so easy to use that you can enlist just about anybody nearby to be your assistant.

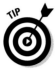

TIP

Using a reflector calls for help — either an assistant who holds the reflector in position or a clamp that holds the reflector steady and allows you to position it correctly.

Because the reflector is constantly reflecting light onto your subject, you don't need to do anything different with the exposure. Just take a meter reading while the reflector is in place, and shoot away.

Reducing light's intensity with a diffuser

120mm (on medium format), 1/125 sec., f/6.3, 50

Figure 8-3: A flip-up reflector is easy to use and gives you two options for the amount of light it reflects.

A diffuser is anything that gets between the light source — in this case, the sun — and the subject. Many times you use diffusers outside without even realizing it. Clouds are a great natural diffuser, and so are the branches of a tree. All of these put something between the light and the subject that filters the light, allowing a softer, more diffused light to pass through. You can also purchase diffusers that are designed specifically for photographers. They can reduce the light by a little or a lot. See Figure 8-4.

Diffusers not only reduce the intensity of light, they change the size of the light source. They enable you to turn a very small light source into a very large one. Diffusing light reduces the tonal range of the scene by softening the shadows and the highlights. It enables you to capture a good exposure without too much work.

Using natural diffusers takes a little practice. When you use them, the camera exposure settings are easy, because it's just a matter of taking a meter reading and then just taking the photo. Keep an eye out for areas of shade that cast even light on your subject. These are areas of diffused light and should be taken advantage of when possible.

24mm, 1/320 sec., f/5.6, 400 *200mm, 1/320 sec., f/5.6, 400*

Figure 8-4: Softening the sunlight with a diffusion panel (left) gives a wonderful soft look to this portrait (right).

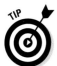

When you use a diffuser, having an assistant to position the diffuser while you take the photograph really helps. You can use clamps and a stand to hold the diffuser, but the stand needs to be tall enough to be placed higher than the subject so it can be between the light and subject.

Using fill flash

You can combat that nasty midday sun by using some fill flash from the camera's built-in flash or from a separate flash unit attached to the hot shoe or used off-camera. (Chapter 4 tells you more about using fill flash.) The simplest way to do this is to have the light from the flash just fill in the areas that are in shadow, especially on the face.

In Figure 8-5, I used fill flash to balance the dappled light caused by the tree. You can also use fill flash to get some light under hats. Fill flash is most successful when you use it at pretty low power, and just fill in the shadows with a little light — not so much that the extra light is noticeable.

35mm, 1/250 sec., f/8, 200

Figure 8-5: Fill flash combats the heavy shadows that bright sun can leave.

Creating different effects with different tools

The tools discussed in the section "Tools for daylight shooting: Reflectors, diffusers, and fill flash" help to reduce the harsh shadows and uneven light that occur when shooting under midday sun. In this section, I show you how those tools perform in a real-life situation.

Imagine that you want to shoot some outdoor portraits for a friend. You want them to be somewhat formal but not stuffy, so you plan on shooting them in a garden.

One of the simplest and most effective ways to compliment your subject in bright sunlight is to backlight him by positioning him with his back to the sun, and then place a soft white reflector to fill in his face and the front of his body. By adjusting the reflector, you can illuminate him straight on, or you can have the light come in from the side and add some character to his face.

Different types of reflectors can cause color casts that may not flatter your subject, so you're better off sticking with white reflectors. Foam core also works well for daylight portraits.

Figure 8-6 shows a basic backlit portrait using a reflector, or bounce card, as a fill for the subject, and Figure 8-7 shows how the shot was set up.

200mm, 1/320 sec., f/5.6, 400

Figure 8-6: Backlighting is a flattering option for outdoor portraits.

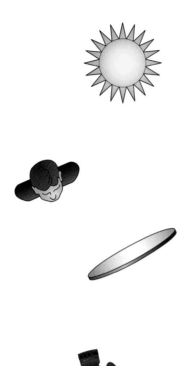

Figure 8-7: Setting up for an outdoor portrait means backlighting your subject and then adding fill light from a reflector.

Compensating for Common Outdoor Lighting Challenges

Weather can play a big part in your outdoor photography in two very important ways. First, weather can make actually using your camera gear incredibly difficult. Second, the weather changes the quality of the light. Both of these can challenge even professional photographers, but when dealt with properly, these lighting issues can be lighting opportunities.

Singing, and shooting, in the rain

Rule Number 1: Keep your equipment dry. Camera makers boast about how well their middle and top-line professional cameras are sealed from dust, rain, and snow, but you don't want to test those claims. If you know you're going to shoot in the rain or if you even think there's a chance of rain, bring along something to cover and protect your camera equipment.

 Op/Tech makes an affordable rain sleeve worth keeping in your bag. Unlike its more expensive counterparts, which are made to last for years, these sleeves are essentially custom-fit plastic bags with drawstrings and a provision for you to pop your finder through. Two versions are available — one that you can use with a flash and one for use without a flash. The difference is that the flash model has a little boot-looking thing on the top that even gives you enough room to use an Omnibounce attachment (a small plastic dome that fits over the head of your flash and diffuses the light) (see Chapter 14) on your flash.

With the exception of keeping your gear dry, shooting in the rain doesn't require a whole lot more exposure adjustment than shooting under normal conditions. Rain can actually be beneficial, because the light tends to be more even, and bright spots and dark shadows are much fewer. The cloud cover acts like a giant diffuser, turning the very bright sun into a much softer and more even light.

When you shoot in rain, you may need to adjust the white balance on your camera to counteract the changes in the color of the light. Images shot under cloud cover tend to look a little colder; they have a blue cast to them. If this is the look you're going for, you're set (see Figure 8-8); if not, set the white balance to cloudy.

 Backlighting enables you to add considerable depth and realism to anything you photograph in the rain. Keep your remote strobes as close as possible to the ground and far back from your subject so that you get a wide spread of light on the rain. You don't want pools of light on the ground; your viewers' attention should stay on your subject, which is enhanced by the nicely lit rain.

The distance you place the strobes from the subject depends on what you're shooting and where you're shooting it. You can get feedback instantly on your camera's LCD, so experiment by moving the strobes until you have the look you want.

800mm, 1/25 sec., f/5.6, 2000

Figure 8-8: Waiting for a train on a rainy afternoon, the blue cast from the heavily overcast day helps add to the mundane feeling of the image.

Shooting in snowy conditions

Something about a fresh snowfall sends most photographers into a frenzy. One of the most unusual things that happens when you head out into the evening or night with a point-and-shoot or a DSLR camera with a flash on top is that the floating little white blobs magically appear everywhere in your images. Suddenly you feel like Mulder or Scully uncovering something special, but it's really just out-of-focus snow lit by a flash.

The effect is actually pretty cool, but when you get tired of it (and you will), if you're using a point-and-shoot, you can just turn off the flash. If you're using a DSLR with a flash unit mounted to the hot shoe, you need to get the flash farther away from the lens, which you do by using a special cable. I like getting the flash as far above the lens as possible, especially when I'm shooting at night and want a realistic effect. Viewers automatically imagine that any nighttime illumination comes from streetlights, and a flash held high emulates that type of light.

Shooting in the snow means protecting your gear from the moisture. You can protect your gear in much the same way you do when it rains (see the preceding section). If you do get some snow on your lens and camera, clean it off as soon as possible.

A big concern when shooting snow is how to expose your scene correctly. You want to expose it so that the snow looks white but still holds detail. The real problem is that the vast area of white tends to throw off the camera's built-in light meter. Because the light meter tries to make everything a middle gray, it tends to underexpose a scene that includes large expanses of white. But if you overexpose snow, you lose detail. (It's okay to slightly overexpose falling snow. Viewers don't expect to see detail in the falling snow; they expect to see it as bright white.)

When shooting in snow, I usually do the following to get the best results:

1. **Set the camera to program mode and meter to read the entire frame.**

2. **Set the exposure compensation to overexpose by 1.5 stops to make the snow white instead of gray.**

3. **Take a photograph and check the LCD histogram to make sure that the snow isn't overexposed.**

 Enabling the flashing highlights on your LCD is a quick way to ensure you aren't overexposing the highlights. You walk a fine line to expose the snow properly. If you overexpose it, you lose all the detail.

4. **Adjust the shutter speed or aperture as needed.**

In snowy conditions, a little light can go a long, long way, because snow actually reflects light. As I tell you in the section "Changing sunlight's angle with a reflector," any white object reflects light all over the place. A snow-covered surface fits that bill.

The shot in Figure 8-9 needed the camera to be in partial spot meter mode to read just the sunny snow, which I intentionally over-exposed to keep bright white. Notice even the bright snow on the edges of the chair held perfect detail without overexposing in the bright morning light.

If you're shooting people in the snow, use spot metering, and take that meter reading from the subjects' faces so that any reflected light is already taken into account.

70mm, 1/400 sec., f/7.1, 100

Figure 8-9: Snow, a tricky exposure situation.

9

An Exciting New World: Shooting at Night

*P*hotographing at night opens the door to a completely different and unique world. You can photograph something in the warm and wonderful light of a sunrise, and you can shoot the same image in the bright overhead light of the noonday sun, but when you go back at night, for some reason everything suddenly looks different. Your eye finds new things to look at and new places to get lost in the image. The nighttime colors are different, unique, and sometimes otherworldly. Nighttime weather can be picturesque as well, especially when you're somewhere with a lot of humidity and temperature changes. Fogs at different altitudes, and wet (and reflective) grass and streets also contribute to a unique palette that's unlike anything you can shoot during the daytime.

In this chapter, I help you choose the right equipment, figure out the best time to shoot, and explore the color palette and light sources nighttime offers. I also give you the lowdown on two nighttime photography favorites: fireworks and candlelight.

There isn't a single image in the world that's worth getting hurt over. Shooting at night introduces a different set of challenges that need to be dealt with accordingly. Don't stray too far from your car, and don't wear headphones — you need to be able to hear anything or anyone heading your direction. Carefully consider two ways out of anywhere. Keep a phone on you — don't leave it in the car — and take along a friend whenever you can.

Outlining the Gear You Need at Night

Shooting in very little light means long exposure times, and long exposures mean that you need to hold your camera absolutely still. The slightest shaking or vibration will make your pictures blurry. All your efforts to prepare for and shoot a great nighttime shot mean nothing if you're counting on your own always-moving body to hold the camera still.

First, you need a tripod. I can't stress having a decent tripod enough. You can pretty much spend as much or as little as you want on a tripod, but don't skimp here. Inexpensive tripods are usually made from thin aluminum that has been stamped out. More expensive tripods are tubular, which in most cases translates to sturdier. The same holds true for the tripod *head,* the part of the tripod that connects the camera to the tripod itself.

Tripods and heads have a weight rating, which is the theoretical maximum weight the tripod is capable of holding. You want to make sure your heaviest camera and lens combination comes in way under the published rating. This ensures maximum stability for long exposures. I have several tripods ranging from lightweight carbon fiber to heavy steel. For nighttime pictures and any long exposures, the sturdier the better.

Motion also comes into play in the way that you trip your camera. You can start an exposure with your hand, of course, but if you're touching your camera, chances are good that you're introducing motion, and you want to avoid motion in a low-light shot. So I recommend tripping your camera in one of these three ways instead:

- ✔ **Self-timer:** The self-timer option is both clever and free. This feature was initially intended to allow you to set up the camera, activate the timer, and run to get in the picture yourself before 10 or 12 seconds pass and the camera takes the shot. However, some cameras give you the option of setting how long the camera delays before taking the picture, introducing greater potential. If you can set your camera's timer to 2 or 3 seconds, you can activate the self-timer gently and then get your hand off the camera before it takes the picture. This reduces the amount of vibration on the camera.

✔ **Cable release:** One end of this cable screws into the shutter release, and the other end has a little plunger or button that depresses the shutter when you press it in. The more modern cable releases are all electronic and plug in to a remote terminal, not the shutter release button. These are actually more desirable, because they have no moving parts — just an electronic signal that trips the shutter.

✔ **Infrared remote:** Some of the more moderately priced cameras don't have the provision for a cable release to be plugged in. If you have one of these cameras, an infrared or IR remote is usually available to fire your camera without any cables or finders touching it. Wired remote controls and IR remotes run the gamut in pricing.

If you look inside the camera with the lens off, you'll see a mirror just behind the lens mount. The lens shines its image onto the mirror, which reflects everything it sees up to a ground glass that you can view through the viewfinder of the camera. When you take a picture, this mirror flips up, and the shutter, which is located behind the mirror and in front of the camera's digital sensor, can open and close, letting the lens expose the image on the camera's digital sensor. This happens each time you take a picture. While the vibrations are minimized through engineering, if you can eliminate them completely, your long nighttime exposures will be even sharper. Check the manual of your camera to see whether your particular camera has a mirror lock or mirror up mode that will lock the mirror up prior to the exposure. If it does, get in the habit of doing this whenever you're shooting on a tripod.

Finally, you can't have enough flashlights on you for a nighttime shoot. I have a little one-AAA-battery flashlight that I carry in my pocket all the time, and a larger and very powerful two-AA-battery LED flashlight that I carry either in a fanny sack or in my back pocket. I keep another flashlight or two in each camera bag. Flashlights help you get your camera set up and ready for action, in addition to helping you look around your location. Having a good flashlight or two goes a long way in nighttime photography.

Selecting the Best Time to Shoot

The *magic hour* is the short period of time after the sun goes down or before the sun comes up, when the sun is lighting up the sky but is just below the horizon so there's no direct sunlight. It makes for beautiful light and, depending on the weather, some amazing skies. But things get really interesting after the magic hour.

After the evening magic hour is over, the sky has some of the most vibrant and rich colors to be found, and they're unique to nighttime photography. In

In Figures 9-1, 9-2, and 9-3, you see a spread of about an hour and how selecting the proper time to shoot can make the difference between a good picture and an amazing photograph. Figure 9-1 is a traditional magic hour photograph, where the ambient light and the skylight are closely matched. I took the shot about 20 minutes after the sun passed below the horizon on a clear night at a marina. If the sky had been even a bit hazy, the image wouldn't be as crisp and clean as this one.

50mm, 1/8 sec., f/2.8, 400

Figure 9-1: A magic hour scene.

I took Figure 9-2 only 20 minutes after the first one. The fall-off in ambient light provided by the sun is substantial, and the overall image looks vastly different. The main lights illuminating the area are now coming from artificial sources. Nearly all of the skylight that was illuminating the area has been lost. What really makes the image so powerful is the deep, rich color in the sky.

The next image (Figure 9-3) is another 20 minutes later. The color in the sky is gone, and it again looks like a completely different location.

The number of streetlights and the direction you're shooting have a drastic impact on the best time to take a shot. It you're shooting in the same direction as the sunset, you have to wait longer to get the blue sky. If you're looking toward the east so the sunset is behind you, the vibrant blue sky appears much sooner — as does the black or colorless sky.

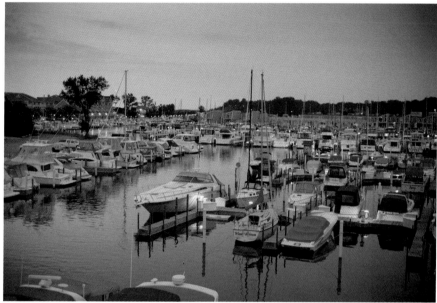

50mm, 2 sec., f/2.8, 400

Figure 9-2: The same scene 20 minutes later, after losing most of the ambient light and gaining the dramatic sky.

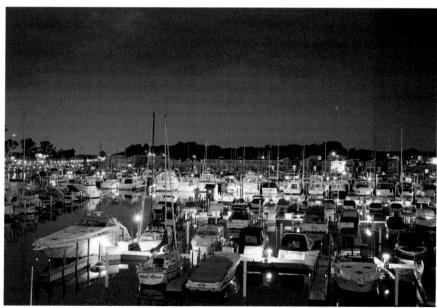

50mm, 12 sec., f/2.8, 400

Figure 9-3: Another 20 minutes later, after losing all the color in the sky.

Before you head out into the world to become a nighttime photographer, do a test shoot like the one you see illustrated in Figures 9-1 to 9-3. You can take the shots in your own back yard when you're grilling. All you really need are a scene that's lit with artificial lighting (like nearby streetlights), nightfall, a tripod, a cable release, a flashlight, and of course, your camera. To get started with nighttime photography, follow these steps:

1. **With your camera, a tripod, your cable release, and a flashlight, head outside about an hour or so before sunset.**

2. **Set up your camera on a tripod.**

 You need a tripod to accommodate the long exposure times that nighttime photography requires.

3. **Select the lowest ISO available to you, which helps you get a clean, noise-free file.**

4. **Plug in your electronic shutter release.**

5. **Set your camera to shoot in the Raw file format.**

 Nighttime images may contain many different-colored light sources. Shooting Raw files ensures you can change or adjust the colors for maximum effect after the fact.

6. **Shoot a couple of test pictures while the sun is still up.**

7. **Every 10 minutes, expose a Raw file until the sky is completely dark.**

 You'll probably need a couple of hours to complete the test.

After you complete the test, head to your computer and download the images. Take a close look at the balance between the amount of ambient light, the light hitting your subject from the streetlights, and the color and saturation of the skylight.

This simple test should help give you an idea about how you can anticipate the particular look that you want for your nighttime images. Sometimes you may want some color in the sky, and other times you may not want any color at all.

If you're in an urban area, you may not be able to get dark sky because of the amount of light reflecting off the ground, but you can still get some good-looking shots. Figure 9-4 was shot well after sunset in a suburban Chicago location. The 30-second exposure gives the low-hanging clouds a very cool look on a windy evening. Because of the amount of light pollution, the only way to get the sky to appear dark is to change it in postproduction. I think the off-color blurring effect adds to the image. Figure 9-5 is a whopping 45-second exposure on the lakefront. The movement of the clouds is one of the cool byproducts of long nighttime exposures. Without the movement in Figure 9-5, the image would lose its impact.

24mm, 15 sec., f/8, 100

Figure 9-4: Sodium vapor light pollution.

65mm, 45 sec., f/11, 40 (large format 4x5 camera)

Figure 9-5: A 45-second backlit skyline with a dramatic cloud blur.

Controlling the Colors of the Night

The cool thing about shooting at night is that color is open to interpretation. When you shoot in the daytime, the sun is a standard that just about everybody everywhere is familiar with. At night, the various pools of color from different light sources, combined with darkness that robs the scene of detail, create a unique palette that isn't standard by any means.

To neutralize or not to neutralize

The choice to neutralize the colors and make everything appear natural or to embrace the variety of colors is entirely up to you. Often, the unique combinations of colors make for compelling images. Figure 9-6 shows you the difference: The one on top has been neutralized for a natural look; the one on the bottom has not.

To provide some clarity and control around the unique color of the night, I perform a custom white balance whenever possible. When I get back home, I can neutralize the scene for perfect color. A scene that's rich in color diversity is often a much more compelling image than a nighttime shot that's neutralized. The neutralization decision also depends on what you're shooting — some subjects look fantastic amid a myriad of color, whereas others may look better completely natural. This is why using a gray card or other white balance tool is valuable — it allows you to easily achieve perfect color should you decide to go that way.

More often than not, I don't use the neutral or properly balanced scene because I feel it takes away from the nighttime feel of the picture. Part of the draw or attraction of shooting at night is the unique perspective that the city and suburban nighttime lighting lends to the surroundings.

This is a very subjective area, though, which is part of the reason that digital and nighttime photography are the perfect combination. By shooting Raw files, you aren't tied to any decisions you make in the field. Anything you do while shooting can be changed or adjusted back at your computer with absolutely no loss of quality whatsoever. If you were shooting film, you'd have to filter like crazy while shooting and then work like crazy in the darkroom to get the colors close to where you wanted them.

Digital cameras couldn't be a better fit for this kind of work.

Both photos: 24mm, 1/6 sec., f/2.8, 640

Figure 9-6: The image on top has been neutralized; the patches of different color really make it pop.

Mixing colors and sources

Just taking a spin around at night shows you what a big mix of colors night offers. Whether you're in the city or out in the boondocks, you'll find a great mix of light sources. Digital photography makes controlling these lights easier than ever, but having a basic understanding of the colors you see and their sources makes you a better photographer.

Handling sodium and mercury vapor lighting

The days of just using a bright light bulb every couple hundred feet to light a city are gone. I'm fortunate to have lived in Riverside, Illinois, the last city in America to be completely lit with old-fashioned gaslights. Talk about a dark place at night.

Sodium vapor is the kind of lighting that most cities seem to be embracing for streetlights. They're easy to spot because they put out a red-orange light. Mercury vapor lighting was the mainstay before sodium vapor lighting became more popular. Mercury vapor lights are bluish green, so their color is more like that which most people associate with nighttime. Sometimes you'll see a combination of sodium and mercury vapor lights.

If you shop at a big-box store, look up the next time you're there. A lot of warehouse-style lighting has three sodium vapor lights and a single mercury light. This is done in an effort to make the color of the light as neutral to the eye as possible.

Photographically speaking, these two different kinds of lights have different looks when you photograph them. Neither lamp puts out the complete color spectrum, so you can't get perfectly neutral color images. But you *can* get very close, so don't let this fact keep you in at night.

Sodium vapor lighting gives your pictures a sickly reddish color that doesn't really make anything look good. It appears red to the eye, but when it's photographed, it turns to a yellow-orange. When I shoot under these lights, I generally make the image completely neutral in color, as I did in Figure 9-4. Carrying a medium or large Lastolite collapsible gray card makes doing a nighttime gray balance easy. You can neutralize the color in postproduction, but it's more efficient to do it while you're shooting.

Figure 9-7 is the uncorrected version of the image shown in Figure 9-4. If the fuel tanks had been lit with a mercury vapor light or a combination of mercury and sodium vapor lights, I probably would have left the color as it was because it would have looked like the greenish blue nighttime lights that are synonymous with night photography. The overly yellow/red tones are not a good look

for this particular image nor most nighttime photography, in my opinion. Note, however, that you can still see traces of the yellow/red tones in the clouds.

24mm, 30 sec., f/13, 100

Figure 9-7: Uncorrected sodium vapor light.

You can also *bracket* your pictures, which means shooting a series of three or five exposures that go from underexposed to properly exposed to overexposed. The overexposed exposures go deep into the shadows, making them bright enough so that you can see detail. On the other hand, the underexposed exposures keep any bright lights or other bright portions in the image from blowing out.

Using custom white balancing to overcome problematic mixed light

Some municipalities mix lighting fixtures throughout their parks and public spaces. When you're shooting in mixed light, your first peek at the LCD on the back of the camera may show you a couple different colors. Your first reaction may be something like, "I can fix it in my photo-editing software." Wrong answer! You're always better off getting as close as possible to your desired final image in-camera before heading to your computer.

Try to think of your computer (and photo-editing software) as a functional tool and not a creative one. Doing so forces you to think through different scenarios while on location, so you can shoot/gather/collect all the components you need to create your vision. If you short-think it on location, you may be stuck when you get back to your computer.

Figure 9-8 shows you how controlling the color as you shoot can give the same image two completely different feels.

Both photos: 24mm, 1/6 sec., f/2.8, 640

Figure 9-8: Two treatments of the same image create a different feel.

The first version is pretty much right out of the camera. You can see how the uncorrected color coupled with my camera angle has made the environment

look cold and unwelcoming. I positioned my camera so the park light is back-lighting the equipment, and I'm looking into shadows. If I had shot from under the light and pointed my camera back toward the equipment, the shadows I was looking into would have disappeared, and the park would have looked more inviting. Pulling all the unnatural color out of the image would have made the image even more appealing and upbeat.

Your LCD screen is a collection of different colors, none of which look like the real-life version of a scene. This is because your brain converts the color to the very best of its ability and does a pretty good job. The LCD looks so diverse because the camera doesn't have the ability to be set for more than one color temperature or color balance at a time.

To make sense out of this, start shooting through some of the color presets on your camera. Shoot the scene in daylight, tungsten, and fluorescent color presets before shooting a custom white balance. After you've shot all these, take a careful look at your LCD. You may be surprised to find that while the custom white balance may look great (and it should), it may not be the best setting for the shot. This is because neutral colorizing often doesn't result in the look of nighttime. If you're lucky enough to have a little bit of fog in the area, you may find a setting that gives you a blue overtone and looks more dramatic and more like nighttime. You usually get bluish coloring if you use the tungsten setting with the mercury vapor lights that seem to be heavily used in parks. Understand that this is a very broad generalization.

Chapter 3 goes into detail on setting the custom white balance of your camera; just don't forget to bring a gray card or collapsible gray balance target with you.

You may be tempted to send me an e-mail telling me that the beauty of shooting Raw is that you can change the image to your heart's content after the fact without losing any quality. Before you do, realize that I'm suggesting that you shoot using these different white balances while you're there so that you can begin to previsualize your final product and actually see it in your mind.

This is one of the true beauties of digital photography. You can create a better product in the long run when you can see exactly what you're doing while you're doing it.

When shooting large spaces, carry the largest white balance target you have. The key to getting the very best color balance is to get your target completely saturated in the light, which may mean putting it near the streetlight rather than right in front of the camera as you would if you were shooting in a studio. Depending on what kind of lens you're shooting with, you may need to take your camera over to your white card in order to fill the frame and get a decent color balance. Once you capture the shot, head back and recompose it, and you're good to go. I recommend shooting another image with the white card in place (this is why you need the largest white balance target), so you also have the target for postproduction purposes. After you shoot a frame with your card in the shot, pull it, and shoot away.

Capturing Popular Nighttime Scenes

After you get your feet wet, you're likely to find all kinds of exciting opportunities for shooting at night. Certain subjects have been capturing photographers' interest for as long as cameras have existed. The beautiful part is that today's cameras lend themselves to feats of low-light photography. In this section, I tell you about using your camera to record two time-tested subjects: fireworks and candlelight.

Finessing fireworks displays

A fireworks display is one of the best seasonal summer events you can possibly photograph (see Figure 9-9). The colors are second to none, and the dramatic displays lend themselves to dazzling photographs. By varying the amount of time you leave the shutter open, you can control how long the trails of light show up.

Depending on where you set up your shoot, you may face a couple limiting factors. The worst is a high level of ambient lighting, which limits the amount of time the shutter can be open. Getting the shutter open and keeping it open without shaking the camera can sometimes prove more challenging than you may think. Little feet and passing cars can easily jiggle the camera just enough to disappoint as well.

If you're in a city and you can find an angle that shows the skyline, a prominent statue, an arch, or another landmark, get set up to include it. As you select your framing of the foreground, make sure to allow plenty of room in the background for the fireworks. If you're in an area without a prominent focal point, set up by giving yourself enough room in the sky to capture all the colors.

Here are the steps for getting great fireworks shots:

1. **Get the camera set up and ready for action.**

 Put the camera in bulb mode. This keeps the shutter open for as long as you hold down the button. Use a slower ISO because the fireworks themselves will be bright enough to expose at a slower speed. An ISO of 100 or 200 should work perfectly. Set the aperture between f/8 and f/11.With your camera on a tripod and your cable release installed, take a test frame.

2. **Determine your foreground.**

 If you have a foreground structure that is lit — a statue, for example — get the exposure for the foreground before shooting your test firework exposure. If it isn't lit and you want to shoot it as a silhouette against the colorful skies, you need to do some test shots to ensure that the subject is, in fact, going to go black.

3. **Test your exposure.**

 After the fireworks start, snap some shots while keeping a keen eye on the LCD screen to make sure the exposures look good. For starters, set the lens at f/11 and, with the camera in bulb mode, depress the shutter just before a burst of fireworks to capture the entire burst. Keep the shutter open while the fireworks trail down. This gives you colorful streaks in the shot.

50mm, 12 sec., f/11, 400

Figure 9-9: Fireworks are a great shooting opportunity.

When you're comfortable with this technique, it's time for the fun part. You need the lid to a box (covered in black paper is ideal) or a dark baseball hat. With the lens covered by your box or hat, open up the shutter while the fireworks are going and begin to paint the sky. Visualize the scope or angle of your lens, and as fireworks burst in these areas, pull your makeshift shutter away from the front of the lens so the burst can be recorded. You can work on a single exposure for some time while you patiently "paint the sky" with explosions and trails of light. Once you expose for a particular part of the sky, quickly cover the lens after the burst and wait for a different part of the sky to be exposed. When you feel you've filled up the sky on your LCD, let the shutter close by letting go of the cable release. Wait impatiently for the picture to pop up on your LCD, and then do your happy dance.

You're essentially painting the sky with light, as I discuss in greater detail in Chapter 15. The only difference here is that you don't have any control over the light source, whereas you do when you're light-painting.

If you aren't going to shoot any silhouette or landscape views and you only want to capture the brightly lit skies, you can have some additional fun. During the show, try this: Zoom your lens in with the shutter, take the camera off your tripod, and rotate or spin the camera with the shutter open and a sky full of color. This creates colorful and whimsical patterns in an already exciting sky.

Capturing candlelight scenes

You may want to shoot portraits or interior architectural shots by candlelight. To do this, start by setting up your tripods and plugging in your cable release. This is a perfect application for an incident light meter because the in-camera meter will be easily tricked by the candle if you choose to include the candle in the shot.

I strongly suggest that you consider showing the candle in your shot. It adds realism and just plain looks better.

When you're lighting with a candle (and it's in the shot as it should be), the candle will go considerably brighter and, in some cases, be overexposed. The amount of overexposure is determined by how close your subject is to the candle. If the subject is right up on the candle, your image won't be that overexposed (see Figure 9-10). If the candle is at one end of a table and you expose for your subject's face at the other end of the table, the candle will be very overexposed. This isn't really a problem, though, because it adds to the ambience of the image.

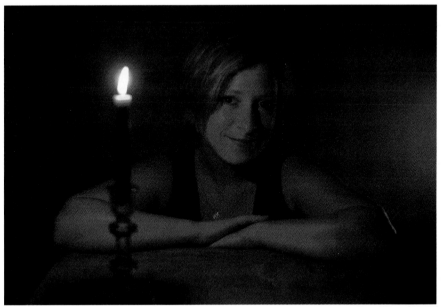

50mm, 1/60 sec., f/2.2, 2000

Figure 9-10: Two candles light this scene nicely: one in the shot sets the tone and serves as the main light source for the image, and a second candle just out of the frame on the right lights the wall to keep this lovely woman from getting lost in the dark.

Your incident meter will properly measure the amount of light falling on your subject's face. Once you set the camera at that exposure, the candle will be nice and bright, and appropriately warm. Don't worry about setting a custom white balance in this situation — set the camera to daylight mode. If you perform a custom white balance, you'll lose the wonderful warmth that's half the reason you wanted to shoot with candles in the first place.

When the camera is on a tripod and you have a meter reading, you're ready for action. If you're shooting portraits, make sure your subject is comfortable and won't be moving during the long exposure.

Just because you're shooting by candlelight doesn't mean that the rules of decent portrait lighting don't apply. The following example shows you how to optimize a candlelit portrait. Say you're shooting a picture of your significant other on the couch with a glass of wine. Follow these steps:

1. **First, help yourself out by using white wine or zinfandel.**

 A dark red wine will be hard to see.

2. **Set one candle to illuminate your partner.**

 This is your key light or main light.

3. **Now fill in the side of your subject's face opposite the key light by placing another candle.**

 To make this a proper fill and make the exposure less than the main light, make sure it's approximately twice as far from the face as the main light (assuming you're using the same kind of candles). This ensures the exposure is ¼ that of the main light.

4. **Lastly, if you have a table in the background, set up a third candle on it.**

 This serves two purposes: It gives the background some light to ground the setting, and it provides the hair light to give your loved one some separation from the background and adds some dimension to the scene.

Just be careful with all the lit candles in the house! Work slowly and move judiciously in your studio whenever anything is burning. Also make sure you have a fire extinguisher nearby. I even have a small one I take on location.

10

Lighting in the Studio

In This Chapter

▷ Matching lighting style to your subject's surface

▷ Using the right size light for the project

▷ Adding light where you want it with reflectors

*T*he studio offers any photographer complete control over all the creative aspects of his vision. I have seen some students who thought they wanted to get into different aspects of photography begin working in the studio and just fall in love with the endless opportunities that can be achieved there. The lighting techniques you pick up while working in a studio can be applied to settings outside of the studio, too. Whether you're in a formal studio or your basement, attic, or garage, once you get behind the wheel, I guarantee you'll have fun, learn a lot, and see improvement in all your images.

Not only does studio shooting enable you to select the proper kind of lighting for your subjects, but it also allows you to create numerous different moods with your lighting. Taking pictures of delicate handmade soap for your best friend's boutique requires a completely different approach than taking product shots of energy drinks. This chapter gives you the tools to create almost anything you want in the studio.

Evaluating the Surface of Your Subject

You know what you're going to shoot. How you shoot it depends in large part on the surface of your subject and everything that surrounds it. Light is very particular about what it hits and what it bounces off of, so the way you light a pile of black towels is very different from the way you light a chrome breadbox.

Imagine one of those big, reflective gazing balls that people put in their gardens. Now imagine a basketball. Both are about the same size, both are available in

similar colors, and yet shining the exact same light at each ball yields completely different results. The same is true if you shine a flashlight at a chrome toaster and an old, worn shoebox. The shiny toaster and ball reflect both the light you hit them with and the entire room you're shooting in. They have reflective, or *specular,* surfaces. The basketball and shoebox have dull or *diffuse* surfaces, which spread light across the surface smoothly and evenly. The duller a surface, the less it reflects and the more evenly it spreads light.

A good deal of the objects you photograph will have a combination of specular and diffuse qualities. For example, purses, belts, and other leather objects combine diffuse material with shiny, reflective buckles. When you light these objects, you may need to experiment with several techniques or styles before you find one that's just what you're looking for.

Cosmetic ads are great examples of specular and diffuse qualities coming together: The cap of the miracle skin-tightening tonic is shiny and mirror-like, but the bottle itself is frosted. High-end advertising photographers handle this situation by shooting two different shots, one with ideal lighting for the reflective cap and a second shot with ideal lighting for the diffused, frosted bottle. In postproduction, the two images are combined into one (see Figures 10-1 and 10-2). For the nitty-gritty details of how I achieved this shot, check out the nearby sidebar, "And the two shall become one."

There is no one right way to light an object. So read everything, look at everything, and experiment all the time. Doing so is by far the best way to learn. Try something, try it again a different way, and then do it yet a third way; take your time with each so you can see not only the large overall changes but the small ones, too.

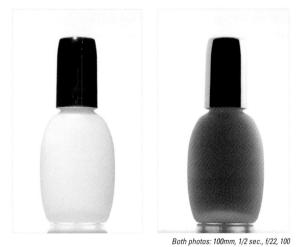

Both photos: 100mm, 1/2 sec., f/22, 100

Figure 10-1: The first shot establishes the background and the diffused or non-reflective bottle, and the second shot is lit for the reflective cap.

Figure 10-2: Two shots morph into one.

Working with Your Main Light Source

Most of the discussion in this chapter centers around two kinds of light:

- ✔ **The main light or key light:** The brightest light in the scene, the main light is the focus of this section. It's also the light that creates the only set of shadows in the scene. (Basically, it's a stand-in for the sun.) When you first start working in the studio, your key light is the very first light that you flip on and begin to work with. Its positioning not only lights the subject or scene but also reveals shape and texture, and sets the mood of the shot. The size of your main light is crucial to all these aspects and determines how much more light you need.

- ✔ **A fill light:** Discussed later in this chapter, the fill light completes the lighting in your scene, allowing you to alter the mood or get rid of shadows that fall where you don't want them. Your fill light may come from a reflector (something called, appropriately enough, a *fill card*) which simply bounces light back into the scene to fill in the shadows created by the main light. For larger scenes or subjects, you may need to use a separate light for the fill. Doing so makes controlling just how much or little fill you get easier.

Size matters: Comparing the effects of small and large main light sources

When you set out to light something in the studio, know that the size of your light source is driven by the size of your subject. The way that you light metals, glass, and other shiny objects is different from the way you light most

non-reflective objects, but in each case size matters. You use the exact same methodology to light a Mercedes in a huge studio as you do to light your child's little Matchbox Mercedes on the dining room table. The only difference is the size of the tools. (Hint: The bigger car requires a bigger light.)

Take a close look at Figure 10-3. I lit the image on the left using a very large soft box (see Chapter 4) close to the tabletop set and placed it at an angle so that it illuminates both the set and the backdrop. Two things make this a pleasing image. The first is a very smooth and even transition between the dark and bright side of the bread. This smooth transition makes the bread look perfectly appetizing and fresh. The second is a smooth, almost buttery, highlight in the wine glass. The classic shape of the wine glass is shown off in striking fashion. The extra-large and extra-soft light source provides both of these pleasing effects.

And the two shall become one

Figure 10-2 shows a finished product shot, which is actually a combination of two tabletop shots. Here's how it was done.

I lit the first shot I made for the white background and the frosted bottle only, not the shiny cap. The light green bottle was etched, so it could take light from pretty much any angle without getting a reflection from the light source the way a strobe reflects in someone's glasses. To light the bottle, I placed a small tungsten Fresnel light above the bottle and a little bit forward of it, toward the camera. I wanted to pick up the shadow on the very top of the bottle from the cap. The diffused bottle was looking so flat in the first shots that a hint of a hard shadow was needed to add some dimension.

The white background was a combination of white paper and white plexiglass, on which the bottle was sitting. To get a clean and pure white background, I used two Mole Richardson "Babys." These two 1,000-watt, focusable Fresnel fixtures were placed on the floor, illuminating the background paper. This same background

paper is reflected in the white plexiglass that the bottle is sitting on. This is what gives the bottle that dreamy, floating-in-space look. It's the same "black glass" technique that I discuss later in the chapter.

Because the cap of the bottle was completely reflective, I needed to use some large, diffused light sources to get a clean, smooth light in the highlights on the sides of the mirrored cap. A small, 18-inch-square diffusion panel was placed to the right of the cap, and a light was shined through it to evenly illuminate the diffusion panel. To get the reflection in the other side of the bottle cap, a white piece of foam core was placed next to the bottle top. This reflected the illuminated white diffusion panel on the other side of the cap. I did a little bit of adjusting to get the reflections symmetrical, and made the second image.

Back at the computer, I used Photoshop to replace the darker cap from the first shot with the cap from the second shot, and voilá! — the shot was completed.

Both photos: 100mm, 1/160 sec., f/29, 100

Figure 10-3: The only difference in this simple still life is the size of the light source: a larger soft box on the left, a single small source on the right.

I lit the image on the right with a single, unmodified strobe light in approximately the same location, and I used a fill card or reflector to bounce light into the shadow areas. You see more detail in the crust of the bread, but it doesn't look as appetizing. The effects of the smaller light source on the wine glass create an unattractive hot spot instead of the smooth highlight accenting its classic shape. The image has lost its relaxing look. Technically, both images are sharp and well exposed, yet the first image is a photograph while the second image is a picture.

I'm constantly amazed by how many times I see photographers using a medium or large soft box to light a subject 12 or 15 feet away. You can get the same quality of light by using a small soft box set close to your subject, and you save power.

A smaller light means harder shadows and more contrast, which is great for highlighting detail. A larger, diffused light source means smoother highlights, a softer transition from light to dark, and less contrasty scenes. This kind of light works well with a variety of subjects and is necessary for specular or shiny subjects.

Enlarging your main light with a diffusion panel

A diffusion panel (see Chapter 4) is nothing more than a frame with translucent material stretched across it. The panel spreads out the light you shine through it, making the diffusion panel the new light source, which is larger than just the single light. The diffusion panel also reduces the intensity of the light. An unmodified light in the corner of your living room will light up your couch and maybe the things around it, depending on how far from the couch you set it. Shining that same light through a diffusion panel will light your entire living room with a soft, pleasing light, from the carpet to the ceiling.

You can buy commercially made diffusion panels or use PVC pipes to build your own diffusion panel. Heck, you can even use a simple white shower curtain (one of my favorite budget lighting tools). Whichever you choose, make sure it's tight and as wrinkle-free as possible. Any wrinkles will show up reflected in the highlight of your specular subject.

To see how much this one tool improves the light on a challenging subject (a gazing ball), follow these steps:

1. **Place your diffusion material as close to the gazing ball as you can, keeping it just outside of what the camera can see.**

2. **Pull your light back so it shines through your diffusion material as evenly as possible without spilling over the edges and onto your set.**

 Your light source can be a flash, a photographic hot light, a halogen work-light, or even direct light from the sun. Any kind of light will work. For Figure 10-4, I used a 1,000-watt studio hot light.

3. **Step back to take a look at your handiwork.**

 You see an even light spread across the reflective surface of the gazing ball. If you don't get a smooth highlight, try moving the diffusing panel back until your light covers the panel without spilling around its edges.

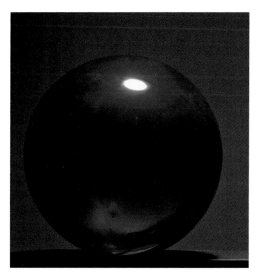 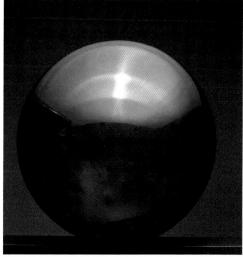

Both photos: 120mm, 6 sec., f/22, 50

Figure 10-4: A garden gazing ball lit with a small source (left) and a large light source shining through a diffusion panel (right).

You can use this technique on anything that's shiny, metallic, or reflective, from car parts to sunglasses. After you create this smooth, flowing highlight, experiment with the placement of the highlight on the subject. The right place to set up your light depends on your subject rather than a hard-and-fast rule. Figures 10-5, 10-6, and 10-7 show how simply moving the diffusion panel around the subject can drastically change your image as follows:

✔ **Lighting the subject from above:** In Figure 10-5, the large diffusion panel is just a little bit above and to the left of the camera's lens, covering most of the bottle with highlight. Although the lighting is smooth and even, it obscures the product label, making it hard to read and not showing the color as it really appears on the bottle. If you were shooting this for The Coca-Cola Company, the image most likely wouldn't be accepted.

✔ **Lighting from the front of the subject:** Figure 10-6 shows the diffusion panel moved to 90 degrees camera right. You can clearly see where the highlight is hitting the bottle. As in Figure 10-5, the label isn't quite ideal, but you can see both the true color and the color after the light has changed it. You generally don't want the highlight to be so obviously placed right through the front of the bottle — it's distracting, and you want your lighting to direct the viewer's eye.

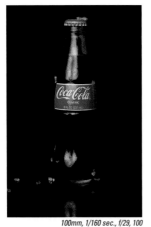

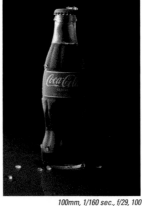

100mm, 1/160 sec., f/29, 100 *100mm, 1/160 sec., f/29, 100*

Figure 10-5: The effect of a diffusion panel placed right over the camera.

Figure 10-6: Moving the diffusion panel 90 degrees to the left shows the highlight reflected in the bottle.

✔ **Lighting from behind the subject:** Figure 10-7 shows lighting that's a bit more polished or finished on the bottle. The only difference between this figure and the former two is the position of the diffusion panel. Simply sliding it around until it's parallel and slightly behind the bottle makes a world of difference by creating a dramatic highlight that emphasizes the iconic shape of the Coke bottle.

I placed a simple (but large) foam core reflector to the right of the set and as close as it could go before getting in the shot. This adds some fill light in the front of the bottle and gives the mist and the ice chips detail.

I also placed a small reflector cut from the lid of an aluminum take-home food container. The dull but metallic side of the cardboard lid is ideal as a reflector for small tabletop sets. Placing this reflector behind the bottle redirects some light through the cola to liven it up a bit. If you're shooting a lighter-colored beverage, you can use just a white piece of paper or cardboard as your reflector. You can also experiment with the angle of the reflector to control how much light passes through the drink.

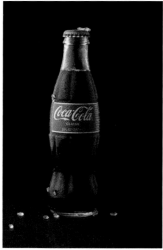

100mm, 1/160 sec., f/29, 100

Figure 10-7: The pick of the litter, the light and a small reflector are placed behind the Coke bottle so l ight shines through the soda. A small reflector to the right provides a little fill light.

Thirst-inspiring effects

To make the bottle look frosty and ready to drink in the picture, I gave it a very light spritz with a water-glycerin mix in a cheap drugstore spray bottle. The glycerin makes the water a little thicker and less runny. There's no exact recipe, but I usually mix it using 80-percent water and 20-percent glycerin. I misted the bottle once before the shoot and shot all three images within a half hour or so without having to re-mist the bottle. To top off the frosty Coke bottle, I've added a couple carefully placed, water-absorbing polymers from a garden store. These polymers are designed to be mixed into your garden to keep the soil moist between watering. They look kind of like clear gelatin. You need to soak them in water to activate them; after they grow, you need to squish them up in your fingers to make them smaller and get them to look more like ice.

Here's an example of shooting a subject in the studio with different surfaces. Some are reflective, some are dull, and one will absorb just about everything you shine on it. Figure 10-8 is for my blog, and the topic is building a custom mount for using the iPhone 4 as a handheld HD video camera.

- ✔ The glass accessory wide-angle lens is . . . well . . . glass, so it's completely reflective, as is the glass front panel of the phone itself.
- ✔ The handgrip isn't quite as reflective, while the microphone is completely diffused, or nonreflective.
- ✔ Lastly, the foam cover of the mic literally sucks up just about any light you give it.

All of these different surfaces combine to create a bit of a surface-induced lighting challenge. If you're up for the challenge, read on.

To get the main lighting set, I placed a 3-x-3-foot flat panel just out of the frame on the right and shined two 1000-watt mole Richardson studio lights through it. A picture of these lights can be found in Chapter 4. By using a large, flat diffusion source, you can create a smooth highlight in the metal surface of the phone clamp that makes up most of the image. I chose to light the panel as evenly as possible to make the reflection as even as possible, but you can create gradations in the metal simply by placing a gradation in the diffusion panel. If you want a round "bull's-eye" of light on the surface — one that has a bright center and fades to darkness — then place your bull's-eye in the panel. Check out your results as they're reflected in the phone mount.

The microphone was lit with a mirror that was placed just over the set, positioned to catch some of the hard light that was spilling over the top of the 3-x-3-foot diffusion panel. Because the plastic surface of the microphone is diffused, the placement of the mirror wasn't as critical as it would have been had the surface of the mic been reflective.

The nice highlight on the tip of the foam windscreen is simply due to its close proximity to the diffusion panel. The final touch comes from shining a single light on the background and focusing it into an out-of-focus circle of light behind my phone mount.

100mm, 1/5 sec., f/14, 100

Figure 10-8: A single, large, diffusion panel lights multiple reflective surfaces of the custom phone mount.

Positioning your main light

Knowing exactly where to position your main light is tough because there is no right or wrong — just looks or effects that you may or may not like. With that in mind, here are some suggestions to help you along your way:

✔ Frontal lighting tends to flatten out your subject and remove detail. Like an on-camera flash, it fills all the cracks and details in your subject, leaving your image in need of drama.

✔ Moving your light (small or large) over to either side, say 45 degrees, allows light to rake across your subject, creating shadows and revealing texture. You need both light and shadows to define shape and texture in your subject.

✔ Lighting from directly above gives your images a dramatic or theatrical feel, especially if you use smaller light sources. Adding grids or snoots (see Chapter 7) to create a smaller shaft of light furthers this effect. Using a large diffusion panel directly over the set gives you a completely different, less dramatic and flat light. A lot of product shots are done this way — not the dramatic shots of Nike shoes on the back cover of *Runners World* magazine but the "Sunday circular" kind of product shots. Large, flat, overhead lighting is a safe way to shoot in the studio, but your images will be lacking in the drama department. Use sparingly.

✔ Backlighting subjects is especially effective for revealing texture. When shooting food, try placing the main light behind and to the rear of the subject. Usually this is about 135 degrees from the camera. This setup accents the texture of the food nicely, letting the viewer really see just how moist something is; sauces pop to life. Even if you're using window light, placing it behind the plate is an effective technique.

When you backlight a subject, you need to use lots and lots of reflectors to fill in the front of your subject. Lighting from above and behind your subject essentially puts the front of your subject in a shadow. Multiple reflectors help in this situation.

Lastly, remember that when you set up your main light, you should study how it's falling on your subject by itself, without any other lights on. Look at your shadows and highlights; study the transition from shadow to highlight. Once you're happy with your main light, you can add a fill light.

Once you see how careful placement of a light source can be the difference between a ho-hum image and a fantastic one, it's time to experiment with various surfaces and all kinds of different lights.

Adding color to your main light to create a mood or evoke emotion

Professional photographers have long controlled colors of their imagery by both selecting the colors of what they're shooting and controlling the color of the light they're shooting. The two can work together to make for stunning imagery, or a bad combination can deliver a fatal blow to an image.

The studio provides the facility for ultimate control over your entire scene, so begin to develop your thoughts and ideas utilizing not just the color and tonality of your subject but of your lighting as well. Using color is the fastest way to create moods or to convey an emotion.

Using color balance and color temperature to your advantage

Here's a nifty little tidbit that wasn't possible in the analog world. Adjusting the color in small increments after you shoot is nothing new; it was a marquee feature in Photoshop 1.0, and when Raw became accessible to the mainstream, it became a standard part of everybody's workflow. As I preach to my students, creating a system that is straightforward both when shooting and in postproduction saves time and creates more consistent images. Consistency is key: If you did something you like a year ago, there's no reason you shouldn't be able to re-create it today without having to spend time testing and tweaking in front of the computer.

Back in the day, professional photographers shooting color slide film would have to carry lots of filters that would be used in various situations, including warming up and cooling down images and filtering out greens and other detracting colors from images. But in a digital world, not only is this no longer necessary, but you can also go a step farther. You can white balance the image (see Chapter 5) and do the equivalent of adding a color filter at the same time.

The process is super easy: Instead of using a neutral white or gray card to color balance your digital camera, you use a card or other source that has a little color. If you color balance on something with a little blue in it, the camera adds warmth to the shot. XRite makes a system called the ColorChecker Passport that provides the photographer several key functions, among them something they call Enhancement Targets. They're simply a series of squares that get bluer and warmer with each chip. The one you use as your white balance determines how warm or cool your image will be. They even have chips that can enhance grass and foliage or make skies bluer.

You can use this technique with anything; the xRite system gives you the same warmth you'd get by adding warming filters to the lens of your camera. I've known people (okay, only one) to carry a pale blue pillowcase to use as a white balance target. It was a very light shade of blue that added the perfect amount of warmth to portraits. Women loved the way it made their skin look. You can even print a series of swatches with your own printer to use as warming targets. If it gets worn, you can always print another.

A key way to improve your studio lighting is to keep your darkest dark and your brightest bright within the range of what your camera can record. This helps you keep valuable detail in the image. Think of everything as a grayscale, which I talk about in Chapter 5. The gist of it is this: Imagining all the components of a photograph in grayscale helps you select a color palette that assists your lighting and ultimately your pictures. So if your job as a photographer is to define shape and texture through your images, let the color and tonality you select help tell the story.

The only difference between the two shots in Figure 10-9 is the background color: the photo on the left is a simple neutral gray, and the photo on the right has been cooled down by placing a Roscoe "half blue" *gel* (a colored piece of acetate that changes the color of the light in a prescribed amount) over the light. You can warm up or cool down your shots in postproduction,

but I prefer to be creative when shooting rather than on the computer. The cooler light on the right fits the image much better. Changing the physical color of the scene matches the emotional content of the photograph, making it a more successful image.

A cool technique that wasn't possible before photo printers but has since become very easy to do is printing your own background paper. If you're planning to use a paper sweep that comes on a roll that you buy from a store, you can do something even cooler. If you have a 13-x-19-inch or larger printer that can print in full-frame or borderless mode, get some matte paper — which is delicate, so handle with care — and imagine the perfect color for the background of your photo. Consider everything from simple solid colors to gradients and textures — the sky's the limit! Think about the ability to match the color of your subject perfectly to create a monotone extravaganza.

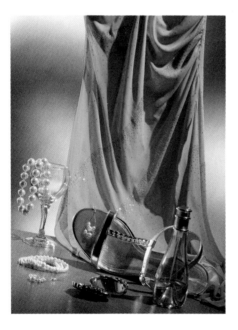

Both photos: 120mm, 1/125 sec., f/20, 100

Figure 10-9: A simple tabletop scene with neutral light (left) and a gel background light to give the image a cool evening feeling (right).

Completing Your Shot with Fill Lights

Fill lights add that finishing touch to your scene by filling in the shadow areas where a little more light is needed. You can use reflectors to easily do this, or you can use a dedicated fill light.

There's only one sun in the sky, so your lighting should have only one set of shadows as well. If you use more than one set, your shot will begin to look overlit and artificial. This rule applies to anything you light. It's especially important to keep in mind if you plan to use another light for your fill. You need to make sure you add just enough power to your set to lighten up the shadows without affecting your main light.

Using reflectors as fill lights

As you begin to take critical control of your lighting, the studio is the best place to learn. Cables just seem to multiply while you're shooting, so I always try to use reflectors instead of additional lights as much as I can in the studio.

Reflectors are designed to bounce light back into your scene. You can get them in a variety of sizes, shapes, and colors, but they all serve the same essential function of reflecting light.

After you get your main lighting source set where you like it, take a careful look at where you need additional light on the set. I prefer to use just a reflector as my fill, because it's easy to get soft light into the dark shadows without adding another set of shadows to the set.

Keeping track of the shadows is also important if you want to use a reflector with a shiny surface. Although most reflectors provide soft, diffused light, reflectors with shiny surfaces can throw a very hard, specular light. Be careful not to overdo it with these type of reflectors.

Fill light should be as large as possible. I like just using a large piece of foam core as my fill light. I get it close to the set and bounce light in like it's coming from a large soft box. I use three or four around and above the set to bring up the ambient exposure.

You can buy all kinds of commercial reflectors; some of the flip-up kind are triangle in shape and have an integrated handle to make them easier to hold in your hand while shooting. A cool idea, but if you want to systematically increase the consistency of your exposures, then holding the reflector in one hand and the camera in the other can make that difficult. Regardless of what kind of reflector you use, you should always mount it to a holder or clip it to your set to retain as much consistency as possible.

When using pieces of foam core for reflectors on your set, use an "A" clamp (you can get one at your local hardware store) to hold your reflector right where you want it. Lots of commercial reflector holders are available, but the two-dollar "A" clamp remains a tried-and-true solution. I recommend picking up some small and medium-sized ones to have available in your studio.

Mixing tungsten and daylight in one scene

The old spaghetti westerns made day look like night by using an innovative method that you can emulate in the studio. These pioneering moviemakers would underexpose tungsten balanced film and shoot at high noon so trees would have shadows similar to the ones caused by moonlight on a clear night. Underexposing a shot makes it dark, and the film stock's tungsten color balance turns the outdoor scene blue, thus creating . . . night!

You can use this technique in the studio for more than just creating a warmly lit interior scene with blue nighttime visible through a window. You can make a blue background for a product shot practically vibrate with richness. Start by lighting your scene with tungsten or hot lights (see Chapter 4) and perform a custom white balance as you normally would. Then take blue seamless paper, a blue bedsheet, cardboard that you painted blue — whatever you intend to use for your background — and light it with strobe light. The strobe's light will be blue due to its daylight color balance. But it won't vibrate with color yet, so go one step further and cover the background light in a blue gel. Metering for constant light and the temporary flash burst can be tricky. Test exposures will need to be evaluated closely and appropriate adjustments either to flash power or shutter speed likely will be necessary. The saturation you get will be remarkable. This figure was lit in this way; the helicopter (okay, it's my helicopter) in the foreground was lit with hot lights while the vibrating electric blue background was lit with strobes with blue gels.

200mm, 1/4 sec., f/10, 100

You can also reverse this process to give you an incredibly warm and wonderful amber background. Light the scene with strobe lights, and perform a custom white balance. Next, light your reddish-orange background with tungsten light, which is warm anyway. A yellow, red, or orange gel on the light makes the background more saturated.

If you set out to use a reflector as your fill light source, you need to position your main light so the edge of its beam lights your subject. This allows the brighter center portion of your main light to hit the reflector and get bounced back into the scene. Figure 10-10 shows how to maximize your main light while using a reflector for fill light.

This approach makes it possible to control just how much light is reflected and where that light is directed back into your set in the form of fill. Your choice of reflector determines the degree of control you have over your final product.

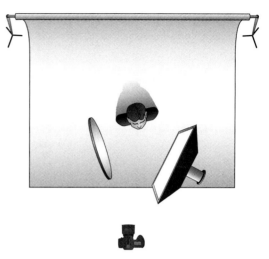

Figure 10-10: Set up your light so one edge lights your subject and the other edge hits your reflector and bounces onto your subject.

Using a flip-up reflector with the shiny silver side in bounces the greatest amount of light into the set and gives you the closest ratio, or difference, between light and dark. (See the next section for more about ratios.) Be extremely careful with these reflectors, because they tend to be so reflective that the subject can quickly pick up a secondary set of shadows and look quite artificial. Often you can completely eliminate the shadow, giving you a 1:1 ratio. Your final product will have even lighting between the shadow and highlight.

The next softest reflector is generally a better choice. Turning the flip-up reflector over reveals a soft white reflector that provides a more natural amount of fill light. It isn't as bright or pronounced as the mirror-like reflector. You generally get what's known as a 1:2 or 1:3 ratio between the light and dark sides of the subject. These are the most common ratios, and they yield the most natural-looking results.

Another thing to be aware of is the proximity of the reflector to the set. Obviously, the closer the reflector is to the set, the more light it bounces back into the set. The closer the reflector is to the set the softer it needs to be, because you just want to fill in shadows.

I'm a huge fan of using foam core from art, hobby, or even some grocery stores placed super-close to my set. I often have it just out of view of the lens. It has a dull finish, which keeps the light from being directional, and its light weight makes it perfect for taping or "A"-clamping next to, above, and all around the set as needed. In Figure 10-11, you can see the foam core in use for the Coke bottle shot shown in Figure 10-7.

Using reflectors to create lighting ratios

Professional photographers measure the difference between light and dark in ratios. A 1:1 ratio represents an even distribution from the lit side of the image to the opposite side of the image. These ratios go clear past 1:16, which essentially has zero fill and gives you a deep, rich shadow opposite the key light. You don't need to calculate these ratios exactly, but you do need to keep an eye on the contrast between highlight and shadow. Controlling these ratios gives you greater power over your imagery.

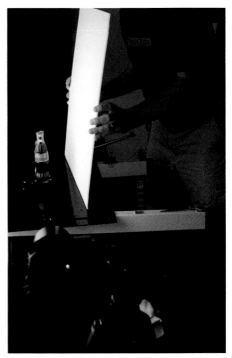

 As you gain experience with lighting, you'll be able to venture a pretty good guess regarding the ratio you're creating. In the meantime, the easiest and most effective way to measure ratios is to use your incident or hand meter (see Chapter 5). Take a reading on the bright, lit side of the subject, and then take a second reading on the shadow side of the subject. You want to keep both within 3 stops of each other.

Figure 10-11: Using foam core to fill in the label, ice crystals, and water in the Coke bottle shot.

Adding an additional fill light

In some cases you need to use a second light source for the fill. This is generally true when you're shooting larger things and you just can't get enough fill on your subject. You can use a large or an extra-large soft box if you're shooting with flash, or a larger diffusion panel — or even rice paper or a shower curtain — if you're using tungsten or hot lights. If you have a lower white ceiling, like an office ceiling, you can simply bounce light up into the ceiling.

 Hot lights can be dangerous around rice paper, sheets, and shower curtains, so make sure that the lights aren't too close or touching the material.

After setting up, you can either meter or take a test shot to see what kind of highlight-to-shadow ratio you have. Using a second light source allows you to control this ratio easier, because after you're set up, you won't need to move the light into or out of the shot to control the power as you would with a

reflector. If you want the image to be flatter, have less contrast and a smaller highlight-to-shadow ratio, you can add power to your fill. If you want more contrast, you can reduce the amount of light going to the fill and increasing the ratio between highlight and shadow.

The ability to power up or down the fill independently is an advantage over using reflectors. With a little testing, you can get exactly as much or as little fill as you want. Any lighting ratio you desire can be achieved easily. Just don't forget to use a large soft box or large diffusion panel, because you don't want any additional shadows coming from your fill light.

Enhancing Tonality: Creating a Grayscale Zone System in Your Studio

The *zone system* is what Ansel Adams invented and used to create his amazing black-and-white imagery. The system in its simplest form is a combination of metering and controlling the development of your film and paper to maximize and get every possible bit of tonality into final print. You can apply this exact methodology to digital regardless of your end result, whether your images will end up on Flickr or Facebook or printed, the overarching concept remains the same.

The zone system methodology applies quite nicely in a studio setting where you control the light from highlight to shadow. Creating the perfect lighting range on your set when you shoot increases your image quality and saves hours in postproduction.

You can use either an incident or reflected meter, but I've found this exercise more successful and a bit faster when I use an incident meter. With the lights in your final position, begin taking meter readings at the brightest part of the scene. Once you have an idea of the reading in the brightest part of your scene, begin metering the darkest part of the scene. You want to make sure that your shadows are between four and six stops of your highlights. This ensures detail throughout the image. So if your highlight is reading around f/16 (which is white with detail exposure), the darkest part of the shot or your shadows should fall around f/4, or black with detail.

If your scene includes lighting that's outside of this range — that is, if it has very bright highlights and deep, dark shadows — you need to bring the scene in closer in tonality or make the brightest part of the scene less bright and/ or make the darkest shadow a bit lighter. The most efficient way to do this is to lighten the shadows a tad by using a reflector to bounce some light into them. Meter again, and see whether it's enough. If so, start shooting. If not,

adjust your reflectors, add additional reflectors, or even switch to a brighter reflector like a silver one to lighten the shadows.

You can approximately achieve the very same outcome by simply viewing the histogram on the back of the camera to see if your scene includes tonality that is outside of what the camera can record. By studying your scene first and then using your light meter, you gain a better understanding of light and how your camera records it. This will help you develop into a better photographer.

Figure 10-12 shows you the range of exposure readings that are in the scene.

100mm, 1sec., f/16, 100

Shadow exposure F/4 Highlight exposure F/16 Normal exposure F/8

Figure 10-12: You can see the difference from the brightest to the darkest part of the scene.

Digital cameras have a wide tonal range that's getting wider with each generation, but keep your end use in mind. If a shot is going to be used online, keep it within a 6- or 7-stop range. If you plan to use a high-end inkjet printer, you can hold detail well outside of the 7-stop range, but you need to test to know just how wide your range can be to hold detail in the final print.

Rooms with a View: Lighting Interiors

1 f I had my way, everybody who wanted to make a career in any area of photography would study architectural photography. Overcoming the unique lighting and lens challenges you encounter when shooting interiors prepares you for just about anything.

When you set up to photograph a room, you may be able to rearrange the furniture and even address the mish-mash of lights, but the walls, windows, and architectural details stay right where they are. You don't get to rotate the room so that the sun falls where you need it. You can, however, carefully select the best lights, time of day, lens, viewpoint, and angle to compose the image in the most effective way.

In this chapter, you find out how to manage light sources of varying colors, determine the best time to shoot, and set up your lighting to get a natural-looking shot with maximum impact. I also help you decide which lens to use and choose the best angle to shoot from.

Meeting the Mixed-Lighting Challenge

Your first concern when you walk into the room is the source — or multiple sources — of light. Is the room lit by sunlight streaming through the window or track lighting along the ceiling? Maybe it's a combination of both, and that's when the problems start.

Your eyes (and brain) automatically adjust to different light sources; a piece of white paper under a fluorescent light, sunlight, or incandescent light looks white to the human eye. But to a camera, the paper looks different in each situation, which is why you can (and must) set the camera so that it reproduces colors correctly under specific light sources. You do this by setting the white balance (Chapter 3 gives you the how-to details).

So when you walk into a room that has two different light sources, which one should you set your camera to render accurately? You can't set the camera for two different white balances at the same time. The key is to neutralize one or more of the light sources and make them all look the same to the camera.

Practicing with available light

You need to be able to use available light before you start adding your own lights to the mix. Acquiring the necessary skills is easy: Just find the room of your house with the craziest number of different light sources, and start practicing. Your first run-through won't yield portfolio pieces, so don't worry about cleaning the place to within an inch of perfection.

Bathrooms often include a cornucopia of light sources and reflections, making them good places to practice (see Figure 11-1). You're likely to find a fluorescent fixture in the ceiling, tungsten bulbs in the sconces, and a window that's either draped or has glass blocks. All of these light sources look the same to your eye but not to the sensor in your camera.

Snap a picture of a mixed-light room, and when you take a peek at the back of the camera, you're likely to find

✔ Green around the fluorescents

✔ Overly warm light from the tungsten or halogen lights

✔ Blue, normal, or warm-colored light through the window, depending on the time of day

Both photos: 35mm, 1 sec., f/16, 200

Figure 11-1: Two bathroom shots, both with daylight, tungsten, and fluorescent lights (the fluorescent is out of frame but you can see it reflected in the cabinet and faucet). After applying a Rocso 3308 tough minusgreen gel to the fixture, the shot is more appealing (right).

Consider which light sources you can change easily and which ones are unchangeable. Can enough of the different types of light sources be changed to make the color uniform? By practicing in different situations, you begin to see the different lights and, more importantly, which ones to turn on or off, and which ones can be changed versus those that can't.

Because all the light will look fine to your eye, taking test shots under different lights when the output isn't important puts you ahead of the game. Then when you're shooting for keeps, you won't have to spend time figuring out how to deal with different light sources.

Neutralizing fluorescents

If you were in an office that was lit only by fluorescents, you could just perform a custom white balance and be done with it. But because other colors of light are also in the scene, you need to neutralize the green from the fluorescent lights without changing any other colors in the shot.

You neutralize the green by covering the fluorescent bulbs with magenta gels. You can buy rolls of magenta-colored gels from a photographic supplier and cover all the fluorescent tubes in the shot. You need to get to the tubes themselves, so depending on what kind of light you have, you may need to slide down the cover over the tubes, pop off a plastic cover, or simply flex a plastic cover in the ceiling that sits in front of the tubes. It's important to get the right hue of magenta because it's a specific hue that must be used to counteract the green of the lights. Don't buy just any magenta gel; check with your photo supplier for the right colored gel.

The flood of environmentally friendly compact fluorescent light bulbs complicates lighting challenges further. These bulbs come in so many different color temperatures that you may end up with a half dozen different color temperatures in a given interior.

Changing the other bulbs in the room so that they're all the same type of fluorescent may be the easiest fix, if it's possible to do so. This enables you to just set the white balance on your camera for fluorescent. If all else fails, turn the overhead fluorescents off, and bounce a light off the ceiling or wall behind you.

Performing a custom white balance

As in most settings, a custom white balance is the way to go when you're dealing with mixed light. Chapter 3 takes you step by step through performing a custom white balance.

The larger the area that you can take a reading from, the better. Using a larger test area allows more light to fall across the surface and provides a better blend of the colors. A smaller area is more influenced by either the predominant source of light in the room or the one it's closer to.

Place the gray card in a part of the room that receives light from both windows and the interior tungsten lighting sources. Doing so allows the tungsten to naturally go a little less warm and the daylight to naturally go a little less blue. Your final picture will be a closer mix with the tungsten lamps in the shot looking a little warm and the daylight coming in looking a bit blue.

Creating a perfect blue hue

Take a peek at an architectural magazine or a Web site that features interior photography, and you'll notice a lot of shots with a deep, rich blue outside the windows, not unlike the first shot in Figure 11-2. Using this technique adds a level of sophistication to your work. Figure 11-2 also shows the same shot with nighttime and daylight through the window (kinda blah). Without the dramatic blue light through the window, the image is flat and boring at best.

14mm, 15 sec., f/9, 100

14mm, 1/15 sec., f/2.8, 100

14mm, 3.2 sec., f/14, 100

Figure 11-2: A pre-sunrise blue light adds drama to the scene. Otherwise, the shot lacks polish.

This effect is caused by adjusting the white balance in your camera so that you take advantage of the different light sources and their different colors. To achieve this effect, you need the sun (check!) and an interior tungsten light source — a lamp, for example, or a flash or strobe with a gel placed over it to simulate tungsten light. The Rosco gel for this is called a Full Sun or Roscosun CTO. CTO stands for "convert to orange" because its orange color converts the blue 5,500-degree daylight to the warmer 3,200-degree tungsten light. Lessening orange versions are available and are called ¾ sun, ½ sun, ¼ sun, and ⅛ sun.

Imagine you're photographing the den of a residential home and want the large bank of windows behind the couch to have the rich, blue color you see in glossy architecture magazines. Because the entire place is lit with track lights and a quartz halogen floor lamp — all tungsten light sources — you're in perfect shape in terms of color balance.

Here's the secret: When you set the white balance on your camera to tungsten, the sunlight turns blue in your image. The room looks natural because the light sources in the room are all tungsten. This works as long as the outside light isn't as bright as the inside light. I usually start shooting when the inside and the outside are about the same brightness. The richness of the blue that's visible through the window depends on the brightness outside the window. As it gets darker outside, the blue will get deeper and richer.

Follow these steps to make sure you capture that dramatic blue lighting:

1. **Get to your location a good hour before sunrise (or, if you don't mind missing dinner, an hour before sunset), and flip on any lights or strobes you're using for the shot.**

 You can add lights to any part of the room you want — for example, you may add a snoot to your portable flash unit to shine some light on an easy chair that's getting lost in a darkened corner. Just remember that each of the lights needs to either be a tungsten light or be gelled so it looks like a tungsten light to the camera.

 Use a daylight-to-tungsten conversion gel, sometimes called a CTO. Cut a strip of the gel, and cover the front of your flash with it by using tape, a rubber band, Velcro, or whatever you have on hand.

2. **With your white balance set to tungsten, shoot a bracket of exposures every six to ten minutes.**

 Shooting a *bracket* (a series of exposures, usually three to five, including at least one that's underexposed, one that's properly exposed, and one that's overexposed) ensures that you get the inside exposure perfect. In your first bracket, you'll probably have very little light showing through the windows. As the hour progresses and you shoot a bracket every six to ten minutes, the blue through the windows will begin to build. Keeping the f-stop the same through your bracket (and using a tripod) will allow for high dynamic range (HDR) processing later. (See Chapter 16 for more on HDR processing.)

3. **When your light is starting to look good, shoot a bracket every three to four minutes.**

 The optimal time comes and goes pretty quickly.

Nighttime Is Not the Right Time: Shooting When Sunlight's Abundant

The very best way to light an interior is not to. Unless you're shooting a basement without windows, pretty much any room with a window has a perfect time to be photographed. The less you need to light a room, the more natural it looks.

Figure 11-3 shows a room lit by morning light coming through the windows. All I did for this shot was bring up the level of the ambient light by bouncing a flash into the wall and ceiling *behind* me to fill in or open up the shadows. It was important that the extra light look natural and not overpower the light streaming through the window.

24mm, 1/4 sec., f/11.5, 100

Figure 11-3: Morning light illuminates this scene beautifully.

Not every room has a well-placed window to light the space perfectly, but chances are good that you can use available light. Watch the window light pass through a room throughout a day, and you'll most likely find a time of day when the light looks best — probably in the early morning or late afternoon when the sun is lower in the sky and warmer.

To throw another kink into the cog, the earth doesn't stay put, so this perfect light may exist only during a short time of the year. When I worked at the Museum of Science and Industry, I knew that I could get daylight on the front of the building only for about a week or so each year — and only at sunrise.

Check sunrise and sunset times (see Chapter 4) to figure out when the light will be right. You also want to be nimble enough in your approach that when lavish light presents itself, you're ready to capture it.

Building the Scene One Light at a Time

The traditional way of shooting architecture is a craft that is every bit as applicable today with digital cameras as it has been since its inception. It's a process that can't be rushed — similar to making fine wine.

Spend some time looking around the room, finding the best angle and lens combination to tell the story that you want to tell. (See the upcoming sections "Selecting the Best Lens for the Job" and "Finding the Best Camera Angle" for more info on these topics.) Get the camera on a tripod and the exposure settings all set before considering the light.

Putting your lights in place

Imagine you're shooting a room that includes a couple of desk lights and a small window that looks into some ivy and bushes. You need to add most of the light to the shot, and you need to add those lights thoughtfully. You can't just plop a single 1,000-watt tungsten light or a large studio flash system in the middle of the room and call it a day. Light doesn't come like that in real life, and it shouldn't in your images either if you want to keep them looking natural. The idea is to light the room so it looks as if the light is occurring naturally — not added by you.

Adding the accents

Begin lighting the room by adding any and all accent lights. These provide small pools of brighter light or spotlights that direct the viewer's eye to the interesting parts of the scene, for example, the leather couch, the mahogany roll top-desk, or whatever it is that gives the room its character. Use those smaller flash units that you usually see in the hot shoe of a camera or small tungsten spotlights — either can provide smaller, individual pools of light that show the viewer what to look at. Take a photo with just these lights turned on, and make sure that they're lighting the areas you want to draw attention to. The brightest area in a photograph naturally draws the viewer's eye to it.

TIP

Include no more than three pools of accent light in the shot. Too many accent lights can confuse the viewer and make the shot look too busy. The lights in Figure 11-4 pull your eyes to the areas of interest in the photo.

Don't worry if these areas seem a tad too bright at this point. After you add the ambient or fill light to the shot, they won't be so pronounced.

24mm tilt shift, 5 sec., f/18, 100

Figure 11-4: Accent lights highlight the couch and chairs, the books on the table, and the beam work.

Upping the ambient lighting

Increasing the ambient lighting is a little trickier than setting the accent lights, because ambient light needs to look natural. It shouldn't just appear from somewhere you wouldn't expect light to be.

Here are some ways you can increase the ambient lighting:

✔ **Use a large soft box or large diffusion flats to add soft, shadowless, directionless light to the shot.** Use the largest soft box, or even two, to achieve this. Place the lights as high as possible so that even though the light is supposed to be soft, any shadows created are on the floor, where they're supposed to be.

✔ **Depending on the color of the walls, you can bounce a light onto the opposite wall and let the reflected light fill the room.** This is a great way to get a really large white light source to use as a fill if the walls are truly white. Cream walls can work out nicely if you're shooting a residential interior; they may be too warm if you're shooting an office or other nonresidential interior.

✔ **If the ceiling is white, you can aim a light at the ceiling and have it bounce down into the room.** This turns the whole ceiling into a soft, white light source.

✔ **Set up a number of lower wattage lights, attaching spun glass to the front with clothespins.** The spun glass is a fiberglass material that actually looks kind of like a dryer sheet and won't melt in the high heat of the light. Even though it's melt-proof and won't burn, you only want to clip it to a frame designed to hold gels and diffusion materials. The spun glass spreads the lights and, by increasing the size of the light source, makes the shadows softer.

All these methods help to light the room evenly, but here's the key to getting a well-lit shot: The fill light needs to be at a lower power than the accent lights. This arrangement lets the light created by the small flashes or spots be brighter, drawing attention to those areas, adding a little drama to the shot, and keeping the image from being boring.

Check your lighting ratio

You need to adjust the overall lighting after the room is set up and the individual lights are aimed correctly. The easiest way to adjust the lighting ratio is as follows:

1. **Set the camera on a tripod, and compose the scene.**

2. **Set your camera in manual mode with the shutter speed set for 1/200 second and the f-stop set at f/8.**

 The choice of f/8 is arbitrary. If you want a shallow depth of field, then use a greater f-stop (f/2.8, for example), and if you want a deeper depth of field, then use a smaller f-stop (f/22, for example). The majority of architectural photography is shot around the f/22 side of the lens to get the entire interior in focus.

3. **Turn off the main lights, and take the photograph with just your accent lights on.**

4. **If you aren't using a hand meter, then adjust your exposure with the LCD and histogram until the area that is lit by the small flashes looks right.**

You do this by either adjusting the aperture, which will change the depth of field, or by adjusting the flash output of the lights. The rest of the scene should look a little dark.

If the ambient light is natural light, either coming in through the windows or from a continuous light source, then adjust the shutter speed until the scene is lit to your liking.

If the scene is lit by strobe, turn the output on the strobe to the minimum and turn it on. Adjust the power output of the fill light until it looks the way you want it.

Depending on the size of the light and the size of the room, you need to adjust the light until you've added enough fill light to light the room but not so much that it's the same as the accent lights.

Make sure that all the light sources are gelled so that all the lights present produce the same color of light. The addition of a blue window light can take a good image to great; a polished version of the interior from the color in the window (see Figure 11-5). Details like light switches and scrapes in the paint also have been cleaned up in this final version.

24mm tilt shift, 5 sec., f/18, 100

Figure 11-5: The final image with the blue window light stripped in and some moderate cleanup done in postproduction, including addition of the second ceiling fixture (the original one was broken clean off as the shot was set up).

Finding solutions for common problems

Here are some other common lighting situations you may come across and the best solutions to getting the right light.

A room with a lot of windows

Rooms with a lot of windows are a challenge to photograph for two distinct reasons: the amount of light they let in and the reflections that show up on the glass.

The light streaming in through the windows is actually the easier problem to solve: Just turn off the spotlights, set the exposure based on the window light, and purposely underexpose the image by one stop. Then turn the small spotlights back on, and adjust them so that the areas they light are properly exposed.

Correcting for your reflection is all about positioning yourself and the lights properly. Keep the lights up high and aimed down to reduce the reflection or glare.

You don't want to shoot a room full of windows when the light is very bright. Doing so means that you lose detail in whatever shows up through the windows and can cause harsh shadows in the areas the light doesn't reach. Wait until the sun is on the other side of the building so that the light is direct.

Small rooms

Small rooms take less light to illuminate, and a single spot of brighter light is usually enough to draw the viewer's attention to the main subject in the room. A single, smaller soft box placed up high should be enough to throw light into the whole room.

Keep the flash power low so that there's a difference in illumination between the room light and the spotlights.

Very dark rooms

In some cases, a room has a dark and gloomy look that's just right for your shot. Just stop and think about how the light creates the mood and feel of the room. In these cases, the brightest parts of the room don't need to be much brighter than the dark parts. A little lighting can go a long way.

Using grids on the spots or flashes makes the light tighter and more controlled and helps you light up the important parts of the room without the light spilling over into other parts of your scene.

If you have a very dark room that you need to evenly illuminate, the best bet is to aim a strobe or flash at the ceiling and have the light bounce down into the room. Light coming from above looks more natural. You may even need to add a second or third flash or strobe aimed at different parts of the ceiling to get more even lighting.

Selecting the Best Lens for the Job

Architectural photographers are faced with a challenge unlike any other photographer — in order to do their job they have absolutely no choice but to photograph in some very small quarters with the expectation of being able to capture the entire room. Advertising photographers often build a room (or set actually) that is perfect for a particular shot; location photographers and editorial photographers perform most of their jobs on location and in specific rooms but seldom are required to capture the entire room in a single photo the way architectural photographers are. As such, I've seen some architectural photographers who seem to carry more lenses than a camera store!

Architectural photographers have long relied on specialized wide-angle lenses called *tilt shifts* or *perspective control* lenses to tell their stories. The lenses enable you to shoot in areas in which you can't move backwards or use longer focal lengths to correct the distortion. These lenses, such as the Canon 24mm Shift lens, correct for distortion that you get if you tip a lens up to get an entire room or building in the frame by actually letting the front of the lens go up and down in front of the camera on a small track. The 2 or so inches that the lens can travel up or down actually translates into being able to see 12 to 15 feet higher in an interior scene or tens of hundreds of feet on an exterior scene. See Figure 11-6.

Figure 11-7 shows you the converging lines you get when you tip the camera. By using a tilt-shift or PC lens, you can keep the camera perfectly level and actually adjust the front portion of the lens to rise up while remaining parallel to the camera. This keeps all the parallel lines in the scene perfectly parallel in the shot.

The only drawback to using tilt shift and perspective control lenses is the price. Both the Canon and Nikon lenses are very expensive, costing over $2,000 apiece. In cities with larger camera stores, you can rent these lenses, or you can use one of the online camera rental services like LensRental (www.lensrental.com).

Figure 11-6: A tilt-shift lens at the top and bottom of its shift range.

Both photos: 24mm tilt shift, 1/80 sec., f/9, 320

Figure 11-7: Converging lines caused by tipping the camera up (top) are corrected by performing a vertical shift on the lens (bottom).

If you plan just to dabble with interior photography and don't want to spend money unnecessarily, I suggest you use the following lenses, depending on the type of camera you have:

- **For a full-frame sensor camera:** Start in the 24mm range, and see how that looks. A 50mm focal length is considered normal view, with the photograph matching what you would see with your eyes in the room. By going wider than normal, you can give the room a feeling of space.

- **For a cropped sensor camera:** You need to use a wider angle lens to get the same feeling a 24mm would give you on a full-frame sensor camera. Start at around 18mm, a very common focal length for less-expensive zoom lenses; it's usually the starting focal length on the lens that comes with the camera.

No matter what lens you use, set the camera on a tripod, and try to keep it from pointing either up or down. Doing so helps solve the converging lines problem without having to spend a lot for a single specialized lens. You can always crop the image using software in postproduction to get rid of too much floor and ceiling.

Super-wide-angle lenses or fisheye lenses can work to make an interesting photograph, but you have to be extra careful about where you place the lights, because these lenses can capture a lot of space and may see those lights you have in the corners.

Finding the Best Camera Angle

While Photoshop can fix a lot of lighting and lens problems after the fact, it can't move the camera if you put it in the wrong spot. To make sure you take photos at appropriate angles, take time to study the interior at different times of day. Scouting with your camera in hand really is the only way to ensure that when you begin to set up lights, you've selected the right angle for the shot.

The best way to shoot a room depends on its specific features, the furniture, and the views through the windows. Take a good look around, and think about which parts of the room tell the story of the interior. Is there a fireplace that you want to include or a quiet sitting area in a corner that makes

the room peaceful? Start with these features, and then consider which furniture gives the room its character and how it can be moved in or out of the scene. You may need to adjust the position of the furniture to make the room look its best in the final image.

In most cases, just popping on a super-wide lens and shooting the entire room would be the easiest things to do, but they will probably work against you. Certain features of the room or furniture components are probably repeated and aren't vital to the final image, so including them tends to clutter your image and detract from the composition.

One of the keys to making an interior look spacious is to compose the image so that it shows only two walls. Showing three walls of a normal four-wall room tends to make the room look smaller than it really is. Choosing to show only two walls of a room makes the room feel more intimate (even if it's large) but not too small, and lets the viewer focus on the details and purpose of the room without feeling like he's looking at a blueprint or a bird's-eye view of the space.

Another way to make sure that you show the room from the best angle is to shoot from regular eye height, between 5 and 6 feet from the ground. Doing so makes the room seem more inviting and looks more natural.

Watch for reflections of your camera and lights in glass and other reflective surfaces. If you see unwanted reflections, adjust the angle of your camera slightly and try again. Small changes can make a big difference when it comes to reflections.

If you use a wide-angle or super-wide-angle lens in a smaller room, pay particular attention to the furniture at the very edges of the frame, because the physics of wide-angle lenses can cause edge distortion and make the furniture look curved with some lenses. Figure 11-8 provides a prime example of what to avoid if you're looking to capture a room as it really is.

10mm, 1/60 sec., f/5.6, 200

17mm, 1/60 sec., f/5.6, 200

Figure 11-8: The more appropriate version (bottom) was taken with a less wide lens from farther back, making the room look more natural.

Part IV
Making Ordinary Photos Extraordinary with Lighting

The 5th Wave By Rich Tennant

NATIONAL TABLOID
PHOTO IMAGING
WORKSHOP

"Remember, your Elvis should appear bald and slightly hunched. Nice Big Foot, Brad. Keep your two-headed animals in the shadows and your alien spacecrafts crisp and defined."

In this part . . .

Shooting a shiny new car in the sunlight is a very different challenge from shooting a person in a studio, and in this part of the book, you find out how to deal with either of those situations. I give you ideas for creative techniques like shooting splashes (messy but fun!), painting with light, and getting extremely close to your still-life subjects. And because it's the rare photo that can't stand a few tweaks after the fact, I take you through common improvements that photo-processing software can make.

12

Portrait Lighting

Some of the most powerful images ever made are images of people. Portrait photography is a popular specialty among photographers at all levels — from amateurs to accomplished professionals. Pictures that reveal someone's true character rely on thoughtful lighting, which can range from the simplest of simple to the most complex lighting setups.

This chapter gives you tips and suggestions for making your everyday pictures of friends and loved ones better, as well as setting up full-blown studio sessions that range from very traditional portraiture to contemporary glamour and far beyond.

Grasping Traditional Portrait Lighting Patterns

The best way to get a solid understanding about how to light people is to study the four traditional lighting patterns. I encourage you to follow the diagrams and shoot these patterns yourself. I also encourage you to find a patient and willing subject, because this can take a little bit of time the first time around, and at the end of the day, you're not exactly going to come away with a set of portfolio busters. But you will have

a fantastic understanding of how to look at a person's face and determine how to light that face to get the most complimentary likeness possible. Then I tell you how to enhance the perfect face pattern with lighting that'll make your subject's hair shine.

Gathering the gear you need

To shoot these patterns yourself, you need only two simple tungsten or hot lights. The fill light should be softened with a simple umbrella. (Chapter 4 tells you about lights and accessories.) The main or key light needs to be in its simplest, unmodified form. So grab two lights on light stands, a tripod, and your camera.

You can shoot portraits in a room with a normal 8-foot ceiling just fine, but a 10- or 12-foot ceiling gives you more room to set up your lights. For the examples that follow, I used three lights: a main light or key, a fill light, and a light to create the gradation on the background. As you begin, focus on (photo joke) discovering how each of these four lighting patterns makes the very same face look different. While you don't need to worry about using background paper for the background, find a simple clean and clear wall that doesn't take away or distract from the headshots you're making.

For a lens, you should use what's called a *portrait lens.* This is a slight tele-photo lens that gives you a nice, full-frame headshot without having to get too terribly close to your subjects, which may make them uncomfortable. You want your subjects to be at ease, because their state of mind will show in your pictures.

If the camera you're shooting with has a partial or APS-sized chip, a 50mm or longer lens will suffice as a portrait lens. When using a full-frame camera, you will need a 70 mm lens or longer. If you have a zoom lens, you can adjust it to approximately the portrait lens focal length and you'll be set.

Fill the frame with the subject as you see in the examples to ensure you get a good look at the differences in the lighting patterns.

Playing with light patterns

The following four classic lighting patterns are the basis for portrait photography and should be practiced and understood before you start to branch out and experiment with your own lighting.

Rembrandt

The Rembrandt pattern was named after the famous Dutch painter. A majority of his portraits and almost all of his self-portraits were painted in light that includes a triangle of light on the cheek.

Figure 12-1 shows a Rembrandt lighting pattern on Margareta's face (that's what I named my mannequin head); Figure 12-2 shows the lighting diagram to achieve this pattern on the face.

The Rembrandt lighting pattern

- Emphasizes facial contour and texture
- Looks very dramatic
- Is a good choice for full or rounder faces, double chins, square jaws, and wide noses
- Doesn't flatter narrow faces
- Draws attention to rough or ruddy skin

120mm, 1/125 sec., f/8, 100

Figure 12-1: A Rembrandt lighting pattern.

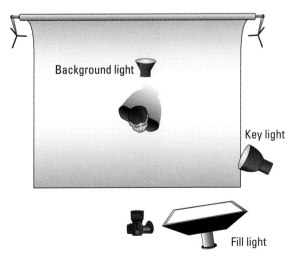

Figure 12-2: The diagram to achieve a Rembrandt lighting pattern.

As you position the key light to create the diamond-shaped highlight on your subject's face, make sure that the light doesn't end up in the subject's eye or too close to the lips. Your model's face determines exactly how high your main light needs to be. The light should be at the same height as your subject's cheek. Also make sure you don't create a shadow in the far eye.

Your fill light shouldn't leave a shadow or any other indication of its existence on the subject's face. Its only purpose is to lighten the shadows.

You'll need to experiment with how close or far away your fill light needs to be to achieve a comfortable balance between it and your main light. Using an incident meter to achieve the proper balance is ideal. First, shade the meter from the fill light and point it directly at the key light for a reading. Then do the same for the fill light, shading it from the key light and pointing it directly at the fill light to get a reading. A comfortable balance between the brighter main light and the dimmer fill light is between 1½ and 2 stops of light. This emphasizes the pattern on your subject's face. Refer to Chapter 5 if using the incident meter isn't yet second nature for you. It will be — for a photographer who uses multiple lights, the incident meter is invaluable.

Paramount

The paramount lighting pattern is also referred to as the butterfly pattern because of the butterfly-shaped shadow it creates around the subject's nose. Figure 12-3 shows you a portrait that uses the paramount lighting pattern. (Margareta, my mannequin head model, has a little teeny weenie paramount pattern in this photo, but it's there. On an actual human it would be even more pronounced, I promise.) Of the four traditional patterns, the paramount is the trickiest to set up because the key light needs to be directly above the fill light, as you can see in Figure 12-4. If you're shooting in a room with an 8-foot ceiling, this will be the most difficult shot for you because the key light needs to go up pretty high.

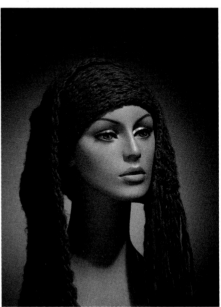

120mm, 1/125 sec., f/8, 100

Figure 12-3: A paramount or butterfly lighting pattern.

The paramount lighting pattern

✔ Flattens features

✔ Shows very little texture

✔ Gives a broad look to narrow faces (and isn't a good choice for wide faces)

✔ Emphasizes cheekbones

The butterfly-shaped shadow under the nose should be centered and end halfway between the top of the upper lip and the bottom of the nose. If you don't have enough shadow, the light is too low, and you will lose the way the subject's cheekbones are highlighted by this pattern. If you have too much shadow under the nose, chances are the eyes are also shadowed, which is a real drawback.

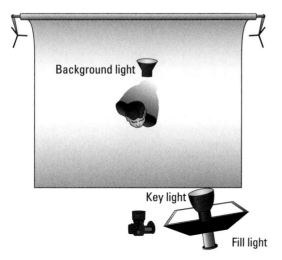

Figure 12-4: The diagram to achieve a paramount lighting pattern.

The placement and shape of the shadow are critical to this pattern's effectiveness and, when handled correctly, serve as good indicators that the other attributes of this pattern will fall into place.

Loop

The loop pattern places a perfect shadow of your subject's nose smack dab on the cheek that's closest to the camera. This shadow is generally shaped

like a loop, which is where this pattern got its name. The loop is my favorite of all the lighting patterns. It also seems to be the most recognizable when you're watching movies or TV. This is a particularly versatile pattern if you're photographing lots of people and you need the lighting in the photos to match. A larger light source creates a more pleasing image.

Make sure that the shadow stays on the cheek. If your light gets too far opposite the camera, the shadow will come off the person's face. Also make sure that the shadow doesn't touch the subject's lip (or moustache or goatee). It should stay neatly on the cheek. Figure 12-5 shows a loop pattern, and Figure 12-6 shows a diagram of how to set up the pattern.

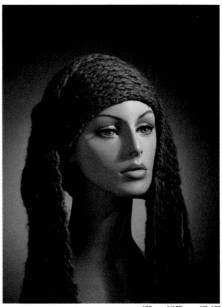

120mm, 1/125 sec., f/8, 100

Figure 12-5: A loop lighting pattern.

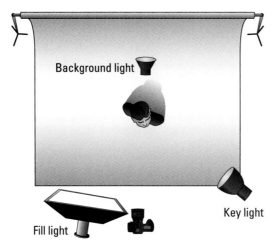

Figure 12-6: The diagram to achieve a loop lighting pattern.

The loop pattern

- ✔ Broadens the face
- ✔ Especially flatters narrow faces and deep-set eyes
- ✔ Evens out ruddy skin
- ✔ Softens facial contours and textures
- ✔ Isn't recommended for round faces

Split

The split halves a person's face in terms of light: One side of the face is lit with a hard light, while the other side is lit by fill light. You generally use this light for character studies and theatrical applications rather than for portraiture.

The pattern creates a lot of contrast across your model's face. This pattern shows a lot of texture, which, depending on your subject's complexion, may be unflattering. Any pattern that shows a lot of texture can be dangerous and needs to be considered and used carefully.

When you're setting up your main light, you'll be amazed by how small changes go a long way. Your key light illuminates only half of the face but spans across ¾ of the forehead. This is ideal, but the exact coverage on the forehead isn't as important as the lighting on the face. Your model's facial structure will determine just how far the light will travel across the forehead. Figure 12-7 shows a split pattern, and Figure 12-8 shows a diagram of how to set up the pattern.

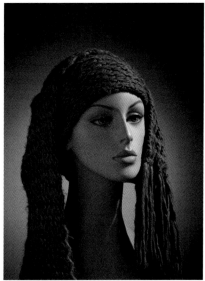

120mm, 1/125 sec., f/8, 100

Figure 12-7: A split lighting pattern.

The split lighting pattern

- ✔ Provides dramatic lighting for strong texture and character studies
- ✔ Shows a lot of texture
- ✔ Slenderizes and narrows the face
- ✔ Illuminates deep-set eyes

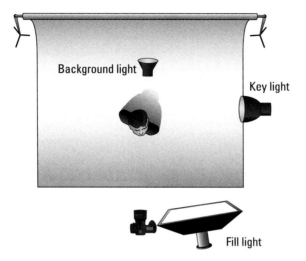

Figure 12-8: The diagram to achieve a split lighting pattern.

Use a go-between (GOBO) — a card or flag whose purpose is to cast a shadow on something — to prevent lens flare, because the key light wraps pretty far around the subject. Nowadays, GOBO usually refers to shading the lens, but the term's earlier roots go back to stage lighting, where a GOBO would be used to place a shadow on-stage for dramatic effect.

Adding a grid or snoot for a hair light

A *hair light* is a light source that you place above and behind the person you're photographing. It adds two valuable things to your photograph: It makes your subject's hair shine and look clean, and it helps to separate your subject from the background. A properly placed hair light is a foot or so higher than the top of your subject's head and far enough behind and off to the side of the head to achieve a nice sheen on your subject's hair. For you math geeks, this will be at approximately a 135-degree angle to the camera. The exact location of the hair light and which side it's placed on vary based on the hairstyle (and how much hair your subject has — sorry!) and the direction in which you have your subject posed.

You want only a little bit of light from a hair light. You don't want any light hitting the face or your subject's shoulders — just a circle of light (begin singing the *Lion King* song now) that's between 4 and 6 inches max. The best way to get such a small spot of light without overdoing it is to use either a grid or a snoot.

A *snoot* is a tube or pipe that attaches to the front of your light and limits the angle of the light coming out. *Grids* are sometimes called honeycomb grids or

grid spots because they look like a honeycomb, and they create a spotlight. The angle of the light is controlled by the width or proximity of the grids. The light of a grid is more desirable for portraits because it offers a nice, smooth gradation of light. Snoots, on the other hand, give a sharp-edged circle of light. Figure 12-9 is a fantastic example of dramatic lighting made possible by a grid. Photographer Tyler Lundberg suspended a single Dynalite strobe head that was fitted with a 10-degree grid over the bathtub for this portrait. Detail and a bit of fill was added with a Speedlight just to the right of the camera bouncing into a white card. Chapter 4 tells you more about snoots and grids.

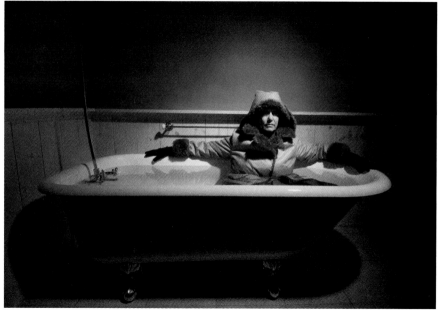

Image courtesy of Tyler Lundberg (www.tylerlundberg.com)

Figure 12-9: Nothing says creepy like using a grid to add an eerie element to an already odd scene.

Getting into Position: Traditional Poses for Portraits

Just as with the lighting patterns, how you pose your subject can help or hurt your images. In some cases the pose is simply your choice — your opinion of how your subject looks best or what will help accomplish your idea or concept. The head position must work in harmony with the lighting pattern. The four most common head positions for portraits (see Figure 12-10) are the following:

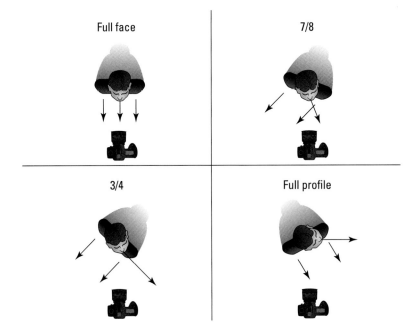

Figure 12-10: The four traditional head positions.

✔ **The full face pose:** The full face, or mug shot, is something along the lines of what you get from the department of motor vehicles: a full, straight-on view of the subject's face, including the ears. With finessed lighting, this is also the pose used for very slick glamour-style head-shots. Check it out the next time you're at the magazine stand.

✔ **The ⅞ pose:** Turn a smidge from the full face, and you get the ⅞ position. The far ear disappears, and the nose is slightly off-axis. Because a lot of the model's face shows, this is a good position for broadening a narrow face. Five different people will be at five different angles by the time their ear just disappears behind their cheek. Don't fight it; watch for the disappearing ear and call it a day. This head position also emphasizes the jaw line and broadens a narrow face.

✔ **The ¾ pose:** Turning the face farther still gives you a ¾ pose. This pose slenderizes a face, making a broad face thinner. The nose should not break out of the profile of the face. If it does, have your model turn back slightly until the nose is inside the cheek line. It's not the end of the world if the nose breaks the line, you just want to be as precise as possible with your lighting posing. Take charge, and take the pictures you want to take.

✔ **The full profile pose:** A full profile shows the subject from the side, so that the nose is 90 degrees from where it would be in a full-face position. For most people, this pose is unflattering, and it's better as a character study than for creating a complimentary likeness of an individual. To use this pose, you want your model's head turned so that the eyelash of her far eye — but not the eye itself — is included in the image. If you have the subject turn her neck too far, an ugly muscle sticks out; you can minimize this by turning her body so she's not on such a sharp angle. You want to lower the shoulder closest to the camera a bit so you get a clean profile starting at the neck. If you're shooting with this dramatic position, have the model look at something slightly toward the camera side to minimize the whites of her eyes.

Bringing Out the Best in Your Subject with Corrective Lighting Techniques

Playing around with traditional lighting patterns (see the earlier section "Grasping Traditional Portrait Lighting Patterns") helps you understand how light can mask or reveal your subject. Proper lighting techniques can reduce or even eliminate the need to do any postproduction on your subject's photograph. The following list gives you some general tips for bringing out the best in your subject:

✔ **Angular nose:** Using a combination of the paramount pattern and tilting the head ever so slightly up and toward the camera helps deemphasize the nose. The paramount ensures the shadow doesn't draw attention to the nose. The tilt up and toward the lens positions the nose so it's facing more toward the camera, so you don't see as much of the side of the nose. Just watch the shadow to ensure it looks natural and doesn't attract attention.

✔ **Baldness:** Is it too obvious to say that you don't use a hair light on a model who has no hair? Doing so creates a large highlight and possibly a lens flare. A lower camera position deemphasizes the lack of hair. The split pattern is not your best choice, because it emphasizes the forehead.

✔ **Deep-set eyes:** Keep the key light low so that it doesn't create or enhance shadows. Use an ample amount of fill light to minimize the depth or darkness of the shadows.

✔ **Double chin:** Raise your key light and tilt the model's chin upward and outward to help the chin fall into a shadow. Raising the camera to ensure you are at or above eve level helps. You may want to try getting up on a ladder and having your subject look up at you a bit, which stretches and minimizes the chin.

✔ **Facial defects:** If a subject is uncomfortable with a certain aspect of his face, maybe a scar or birthmark, you can conceal that defect by having it on the shadow side of split lighting. Using less fill light or backing out your reflector creates more contrast that helps to conceal the darker side of the face.

✔ **Glasses:** A general rule of thumb is to tilt glasses downward, but watch the reflection of your fill light, fill card, or reflector carefully; usually people watch the main light carefully and give less attention to the fill when shooting. Using a smaller source or placing a larger source farther around the side of the person minimizes reflection.

✔ **Long nose:** Tilt the chin upward so your subject's face is angled toward the lens. The closer your subject is to looking straight into the camera, the shorter the nose appears. Don't get carried away though — you don't want to end up with a mug shot. Lower the key light and your camera. You should be looking straight into the model's face. Using a paramount lighting pattern keeps the shadow from the nose short.

✔ **Narrow chin:** Tilt the chin upward, but be careful not to go so far that you can see under the chin. The idea is just to make it a tad less angular.

✔ **Prominent ears:** Hide the far ear by using a ¾ pose. Check out the section "Getting into Position: Traditional Poses for Portraits" to find out more about poses.

✔ **Prominent forehead:** Tilt the chin upward, and lower the position of the camera. Stay away from the split lighting pattern, because it emphasizes the forehead.

✔ **Protruding eyes:** Have the subject look downward a tad. Doing so helps to close or reduce the gap between the pupil and the white of the eye.

✔ **Wrinkled face:** Use large, soft, diffused light sources, which help fill in the wrinkles and wrap light around the face. The flatter, broad quality of the paramount and loop patterns also helps to reduce wrinkles. Try a slight softening filter over the lens, but be careful not to go all Barbara Walters on your subject.

Using Raw Sunlight (When You Have to) for Perfectly Lit Portraits

In an ideal portrait situation, you get to make all the decisions about your lighting. You always have the perfect amount of equipment with you, and the sun is always in the perfect spot on the horizon just when you need it.

For those times when you need to shoot a portrait of someone at the wrong time of day, however, you do have some options for working with the light that's available. The following sections tell you how.

The down-and-dirty approach

If someone asks you to shoot a photo on the fly, here's the best bare-minimum approach:

1. **Quickly scout the location with the idea of backlighting your subject.**

 Placing your subject's back to the bright sun keeps him from squinting and gives him a pleasing backlight. If you're shooting someone who is blond or bald, you may want to find a tree or some other shade to shoot under. Your best bet is to find shade that's backlit. The background looks better if it "blows out" or gets overexposed because you're exposing for the shade.

2. **Use an incident hand meter to get an exposure on the subject's face.**

 If you're using the in-camera meter, zoom or walk in to fill the frame with your subject's face and get the proper exposure. You don't want the meter to be fooled by the brighter background.

3. **Manually perform a custom white balance.**

 The white balance is crucial because you're essentially lighting the face with either the clear blue sky or reflected light from grass. Your subject will either look lifeless (bluish) or sickly (green), depending on the predominate light that's hitting the face. A custom white balance fixes this.

If you can, add a reflector. Ideally, you have a helper to hold the reflector so the sun is hitting it and lighting your subject's face. If you don't have a proper photo flip-up reflector, you can use anything from a single sheet of 8½-x-11-inch paper to a full sheet of poster board. The larger and softer, the better. I still recommend a custom white balance, but it's not as necessary in this situation because the predominate light is reflected sunlight, which should be pretty close to normal 5,500-degree Kelvin daylight.

Taking your time with key shifting

Now for the "I have some time and some gear" version, I want to introduce a technique called *key shifting,* which means that instead of the sun being your main or key light, you create a new key or main light source. This is a popular portrait technique because it makes your model jump off the page instead of getting lost in the background.

Take a quick mental break from wrapping your head around this and imagine how high-end street fashion looks . . . got it? Okay, back to portraiture.

The perfectly lit window portrait, with or without rice

I dreamt up one of my favorite tricks after covering the windows of a studio I worked in with rice paper. The studio was on the first floor in a "transitioning neighborhood," which everyone knows is a polite way to say it wasn't too safe. We didn't want people to see what we were doing into the wee hours and the amount of gear we had lying around. The windows were covered in black foam core, which made for a really gloomy place. Wanting to make it brighter and happier, I pulled down the foam core and started covering the windows with rice paper. I went home, and didn't think much about it until I came in the next Monday morning and saw how the studio looked with tons of diffused white light pouring into the shooting bays.

Not only did it make the studio a happier place to spend long hours, but it also made me head out to the art supply store and get a roll of rice paper that has had a place in my light stand bag ever since.

The very best time to call it into play is when you're asked to shoot a picture of someone in an office setting. Office interiors are ultimately one of the most mundane settings known to mankind. If I didn't work in a school with the largest interior design program in the world, I would think they actually spent time trying to

engineer the place for maximum boredom. But I digress; here's how to fix it in 8 seconds flat!

This technique comes in handy if you're shooting a busy executive who doesn't really want to give you a whole lot of time anyway. Do a quick scan of the office. If hard light is coming in, you're in luck. If not, you may want to scope out another location. Cover the window that's letting in the bright sunlight with rice paper, and turn off the overhead lights. Place your subject toward the back of the window so the light that's being diffused as it comes through the window has the opportunity to wrap around your subject. I recommend doing a custom white balance because you may pick up some color from the environment. Then you're home-free.

The reason this technique works so well is the sun has enough light and power to hit your diffusion paper (rice paper in this case; a white shower curtain or bed sheet will work too, although not quite as efficiently) and still light the room with a good amount of light. When you stop down for bright light, the rest of the room will go dark. If you do this without rice paper on either an overcast day or by a window that isn't getting direct light, you'll still be able to achieve a nice light on your subject, but the room won't effectively "go away" like it will on a bright, rice-lit day.

You need a reflector and a diffuser to set up this technique. The reflector could be anything from a true photo reflector to some white poster board, foam core — anything you can use to bounce the sunlight.

A *diffuser* (also called a *translucent reflector* or a *scrim*) is a silky, parachute-like nylon material that you put between the sun and your subject to soften and diffuse the sunlight. Chapter 4 gives you the details about diffusers.

If you're lucky, you have some helpers who can simply hold the diffuser between the sun and your subject to prevent your subject from being hit with direct sunlight. If you're working alone or have a shortage of helpers (you'll need two), the same place that sold you the diffuser should have hardware that helps you mount it to a light stand. *Be careful* — this will turn into a sail faster than you can say "Oh, crap!" This can be especially dangerous because attached to the sail will be a sharp metal light stand capable of taking out innocent and unassuming bystanders. If you must work alone on a breezy day, you'll need to use sandbags (also available at the store where you got the diffusion panel and hardware) or some other kind of weight to help secure the stand.

Now that you have your diffusion panel in place, this is going to become your fill light. This is where the "shift" comes in. You now use your reflector to create the main light that will make your subject's face shine.

Hopefully you have a second helper who can hold the reflector; if not, the alternative is to mount that on a stand also. As you position the reflector, keep in mind the lighting patterns and corrective techniques discussed earlier in this chapter. You want to position the reflector so that the sun hits it and then bounces into your scene to light your subject. Try to keep it off to the side a little bit so you can get a nice highlight and a little shadow on the face. Casting some highlights and shadows in the right places on the subject's face helps define the subject's positive attributes and creates a complimentary likeness of your subject.

Ideally, you'll meter with a hand meter, but you can also achieve a decent meter reading by zooming in to fill the frame with your subject's face. This is critical because using a diffuser to soften the light on your subject causes the background to become brighter. This also helps you draw attention to your subject. If you don't meter properly, the camera will see some of the lighter background and underexpose, or make the person's face too dark.

Figure 12-11 shows my son's rock star babysitter backlit by the sun on the left. A flip-up white reflector fills in her face with sunlight. If you look in her eyes carefully, you can see the reflector's, well, reflection. This shot took only a couple of minutes to take. In the photo on the right, the subject is lit using the key shifting technique. Because the light falling on her face has been both softened and reduced by almost two stops, the grass and flowers behind her really pop. I also used a 200mm telephoto lens and shot at f/5.6 to reduce the depth of field so the background's soft and out of focus. Had the flowers been tack sharp, they would've taken away from the subject. The light and fluffy out-of-focus background caps off this shot. Both shots took approximately the same amount of time, but for the second one I needed a specialized piece of gear that you may not always have with you, the diffuser. The backlit reflector shot could be made using almost anything white as a reflector, from a pizza box to an actual photo reflector.

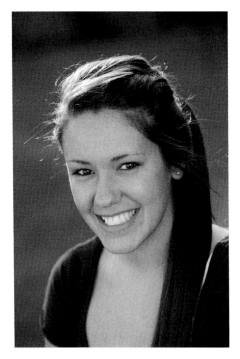
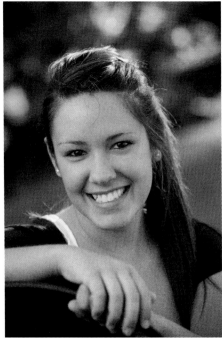

Both photos: 200mm, 1/320 sec., f/5.6, 320

Figure 12-11: The first photo was taken on the fly with the sun and a white fill card. The second photo was made using the key shifting technique and an acrylic mirror for the hair light.

Lighting Big Groups of People

You may be at a big event like a family reunion or a company picnic when someone undoubtedly says, "Hey, let's do a group picture. [Insert your name here] has a nice camera. . . ." At this point you try the invisibility serum one last time to no avail, and you find yourself in charge of shooting a group shot of 100-some-odd people.

No need to fret; this is actually easier than you think. Just take charge quickly, or you'll be doomed! Talk loudly and gesture with your arms as you look around for a suitable location. If you're really nervous, start framing everything with both index fingers and thumbs in L shapes, as if you're Steven Spielberg. This will buy you a little time while you try to remember this chapter.

All you need to do to get this right is follow these simple directions.

Lining them up: Posing

Getting all your subjects in the frame can be tough work. Not only do all the subjects need to be posed in a comfortable, natural way, they need to be set up so that the light reaches them all in a flattering way.

Here are some ideas for getting everybody into the frame:

- ✔ **Steps are your number-one pick for getting a large group of people into a picture.** You can even have kids and pets sit on the steps, but stay away from having adults sit down. Their clothes and bodies never look right.

- ✔ **Look for a ladder, tree, van, or roof you can climb up on to get the shot.** Pack them in close together like cattle in Texas, and shoot away. Having your subjects look up at you ensures that you can see everybody's face and no one's mug gets lost in the crowd. This also gives them something to talk about later.

- ✔ **Look for a park bench or even the bed of a pickup truck that you can use to support and drape people over and in.** Anything to break up rows and rows of people helps tremendously. Using large props also keeps you from spending too much time trying to get everybody lined up perfectly.

Lighting them up

Here's the ironic thing: You don't want to light a bit. The idea of trying to get a complementary light across 100 faces gives me chills. You don't even want to try to use fill flash — you want nothing!

What you need to do is find a location that has even and complementary light already there waiting for you. Outside under a big tree is ideal (see Figure 12-12), as are the front steps of the courthouse on the shady side. Cloudy days (as you can imagine) are extremely useful for this shot.

Shooting inside generally causes more headaches than it's worth. Steps are easier to find, but even lighting is rare. Don't make this trade-off; take even lighting over posing any day of the week. People can overlook posing (you're shooting 100 people after all), but if you can't get a decent print because half the group is washed out and the other half is in deep shadows, you'll be the next topic of discussion at the water cooler!

35mm lens, 1/200 sec., f/9, 400

Figure 12-12: Even the baby makes an appearance in this family photo.

Hand in hand with the need to find 20 or so feet of even lighting is the need for a tripod. You'll need one if you plan on using the self-timer so you can be in the picture too. I wholeheartedly recommend using a tripod even if you don't want to be in the picture. Of course, this is complicated if you're on a roof or a ladder, but valuable nonetheless. Again, you don't want to dash the expectations of 100 of your family members or co-workers by providing images that are even the least bit blurry. Blurring is an easy thing to avoid; you'll have more important things to focus on (photo pun) than trying to hold the camera still. Plus, nothing says "professional" faster than slapping your camera atop a beefy tripod before taking a picture.

On the same note, it's okay to slide your camera up to 400, 500, or even 640 ISO if necessary in order to get a decent exposure. A little digital noise is easily overlooked if you provide a great picture that's stuck on everybody's computer for the next month or two. A safe exposure is a shutter speed of 1/125 or above and an aperture of f/8 or above.

Setting Up for Glamour Beauty Photography

White backgrounds and clean, fresh-looking lighting have long been hallmarks of fashion and glamour lighting. The combo creates photos that are clean and absolutely timeless, and using it is remarkably straightforward.

Making your subject the star with a powered white background

A clean, crisp white background has long been synonymous with studio lighting. It forces the viewer to pay attention to not only the person in the photograph but also the outline of the person. Long, flowing dinner gowns and totally buff athletes look just as great as an expectant mom.

Using a white background is a very common technique that goes hand in hand with the clamshell and other beauty and glamour techniques. If you learn how to create this technique in the studio, you can save countless hours in photo-editing software trying to retouch, outline, or otherwise make the background white.

Figure 12-13 shows a bird's-eye view of your setup to achieve a perfectly white background.

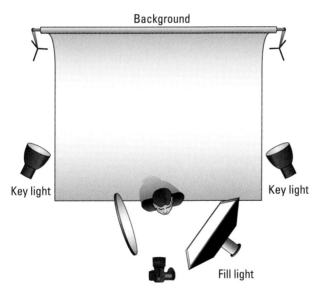

Figure 12-13: The lighting diagram for a powered white background shot.

You need either a roll of white background paper or a white wall for this to work. You start by setting up what some people call *copy stand lighting* — two strobes with normal reflectors on light stands pointing to the background at 45-degree angles.

You want to get these far enough away so that the light hitting the background is smooth and even all the way across. The farther away you're able to get the lights, the more even it will be across the background. The closer the lights are, the more uneven the light will be. For this technique you need it as even as possible, so back the lights off as much as you can. Use your handheld incident meter to check the lighting across the entire sweep, from top to bottom and left to right, to ensure the exposure is within ¼ stop.

Once you have the background set up, you can set up your clamshell lighting (discussed in the next section), or any kind of lighting you want. You need to use at least a short telephoto lens, but a little longer lens will help you in this case. You want to get your model as far away from the white background as possible. This will keep any of the white light from the background from hitting her face or clothing. The background lighting is for the background only — it shouldn't hit the model at all.

In terms of exposure, you want to make sure the background is 2 to 2½ stops brighter than the light on the subject. If your clamshell lighting will be at f/11, you want your background to read between f/22 and f/22½. If you think about the grayscale (Chapter 5), you'll recall that white with detail is two stops away from middle gray. White without detail is 2½ stops away from middle gray. Getting the perfect balance between the background and the subject is important to getting this technique to work perfectly. If it's not bright enough, it won't be perfectly white; if it's too bright, the light will flair out the subject. This will make your model look washed out, and the image will have low contrast and won't be sharp. Any overlighting will be pretty obvious when you review the images. You can also review the histogram of the image to see exactly where the white value lies. It should be right on the right edge of the scale without going off the scale. If it's off the scale, you're almost sure to get some negative flaring effects in your image. The histogram makes it easier to get the exposure perfect.

Getting stylized shots with clamshell lighting

Clamshell lighting has been a popular lighting technique since shortly after the wheel was invented. It can be seen on the cover of any number of monthly fashion magazines and is every bit as attractive today as it was when it became "in vogue" years back.

This highly stylized glamour lighting gives your model a clean, fresh-looking face with very minimal shadows and smooth, shiny hair. It works best with models who already have high or defined cheekbones, because the lack of shadows will flatten out an already flat face. In addition to using this technique for glamour and beauty photography, it's fantastically popular for high school seniors.

I've heard it referred to several ways, but the most appropriate term is simply *clamshell lighting,* because it looks like a clamshell when you set it up. Figure 12-14 shows the setup, and Figure 12-15 shows the results.

You need a portrait lens, a strobe system with two heads, and two medium soft boxes to set this up. I also recommend using this in conjunction with the powered white background technique discussed in the preceding section.

Have your model sit on a stool instead of standing for the shoot. Glamour photography depends on careful, small moves that make or break the photo. You can have fantastic lighting set up, but if the model's head is tilted just a tad in the wrong direction, you'll have created just another photo. Get the head positioned just perfectly — the perfect look on the model's face coupled with perfect light — and you'll have created something truly special. Slowing down for this technique gives you the opportunity to concentrate on creating that perfectly amazing photo. Follow these steps:

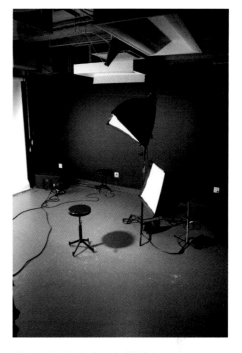

Figure 12-14: A clamshell lighting setup.

1. **Using the height of a seated model as your reference, rough in your camera position.**

 Position the lens about even with the model's eyes. The height of the camera will accent the feature it's even with, so if, for example, you're shooting a lipstick ad, you may want to place the lens on the same level as the model's lips. For a more creative look (as opposed to trying to re-create a "standard" look), keeping the camera below or above eye level tends to open up new creative doors and eliminate a commercial or institutional look.

2. **Position the top soft box at an angle that extends from the lens to the model's head.**

 Depending on how tight you're framing and the exact lens you're using, the soft box may not reach back to the lens. This is fine; you just want to ensure that the soft box is suspended over the model's face evenly so that you achieve the smooth skin equated with glamour lighting.

100mm 1/125 sec., f/8, 100

Figure 12-15: The results from the clamshell technique.

3. **Set up your second soft box or a sheet of white foam core symmetrical to the top light so it covers the underside of the face evenly.**

 You'll probably need to use a floor stand or background stand to get the light low enough. These stands are basically light stands that go lower than a regular light stand. You can also prop the light in place on a box and secure it with a sandbag if you don't have a floor stand.

4. **Meter and set the power ratios.**

 For this technique to work properly, you need to get the two light sources within 1 stop of each other, if not closer. The exact ratio is a combination of personal taste, facial structure, and skin tonality (more on setting the ratio in the next section). The goal is to have the neck and the areas under the chin, nose, and eyes just a shade (barely, almost, a smidge, a touch) darker than the model's cheeks, forehead, lips, and so on.

 Hold the meter so it's pointed at the camera and approximately in the same place and angle as those of your subject's face. Make sure the bulb sees both the top and the bottom soft boxes. Hold the meter so the half dome, where the light is measured, stands in for your model's face. Get the aperture that you should set the camera to, set the camera, and do a test shot.

Coloring the background with gels

Once you've set up a portrait shot, try putting colored gels on the strobes in the background. You can make the background any color you like with colored gels. You can control how deep the color is by turning the power up or down on the background. If the background reads f/8 with a red or blue gel on the background strobes, and the light on your model reads f/11, your background will essentially be a stop underexposed. This gives you a very deep and saturated color. If the background reading is f/16 and your model reading is f/11, the background will turn brighter than the gel itself, so it will be a light blue or red. Digital photography makes setting up this lighting so much easier, because you can see exactly how the color looks at the time of the shot. The accompanying figure shows this technique in full effect. Here, photo student Stephanie Remelius matches the color of her model's dress to the background perfectly in-camera without any postproduction work.

Image courtesy of Stephanie Remelius (www.stephanieremelius.com)

The easiest way to achieve clamshell lighting is to use a studio strobe system, because you need ample power to stop the lens down from f/11 to f/16 or so to ensure the model's entire face is in focus. This also gives you the advantage of being able to send the exact same amount of light to each of the two soft boxes. Then you can physically slide the model a smidge closer to the top box to achieve the ratio you're looking for. When you use your incident meter to read this scene, point the meter directly at the soft box while shading the meter's bulb from the other light. This ensures that you're only reading the light from the one soft box. Repeat this procedure with both the top and bottom soft boxes, and make whatever adjustments are necessary until the bottom soft box is putting out a little less light than the top.

13

Lighting Advanced Subjects

In This Chapter

⟩ Shooting shiny surfaces without unwanted reflections

⟩ Bringing flavor to food photography

⟩ Capturing liquids, splashes, and pours like a pro

⟩ Using the magic hour to shoot big subjects like cars and trains

*I*f you haven't tried to shoot a photograph of, say, a fish at the aquarium and ended up with a shot of yourself and your camera reflected in the aquarium glass, I bet you've at least seen this type of photograph. Reflections add new challenges for lighting, but the techniques that enable you to light your subject are still at play. Often, you just need to use more of them at once to ensure you get the photograph you want.

In this chapter, I give you the tips you need to make sure you photograph your subject rather than whatever it's reflecting. I also tell you how to shoot other tricky subjects, like food, large objects (think planes, trains, and automobiles) and liquid splashes.

Shooting All Things Reflective

Photographing reflective objects, whether your subject or the surface the subject is resting on is shiny, requires a bit of a different approach from photographing a person or an interior. When you look at a reflective or shiny object, you often see the environment reflected in the object. When you shoot something shiny, chances are that your photograph shows the room as much as it shows the object. Creating large areas of smooth, white light is the

secret to successful photographs of reflective objects, as the following sections explain.

Working with shiny surfaces: Using black glass as a tabletop

Shooting on black glass is a technique that was huge from the late 1970s through the early '80s or so. For some time, you couldn't pick up a catalog or magazine without seeing an image made on a shiny piece of black glass. The stuff is making a comeback today as well.

You can buy black glass from any glass supplier. It's colored during the manufacturing process. Unlike a tinted window, where a thin layer of tinted film is added to the top of the glass, black glass is black through and through. When you set it on a tabletop, it's perfectly smooth, just like a piece of regular glass, but you can't see anything through it. Objects on black glass are lit by light that is reflected off the backdrop behind them. You highlight your product with reflections of light created on the wall behind the black glass. Because you're lighting a large space behind the set, you can create very smooth and visually appealing gradations. Figure 13-1 is a fantastic example of a black glass image.

100mm, 4 sec., f/16, 100

Figure 13-1: A prime black glass sample using a bull's-eye of light around the object.

If you shoot a picture of flowers on black glass, you can create a highlight around the flowers and make the background fade from white to black or any shade in between. You can create a wide variety of backgrounds in a relatively short amount of time.

You can use the technique that you use to shoot a subject atop black glass on a tabletop to shoot a subject on any reflective surface. Use it for shooting on a mirror or to capture a crystal clear lake, which looks a lot like a sheet of black glass, doesn't it?

The concept behind black glass is pretty simple and straightforward. Figure 13-2 shows a setup. Behind the set would be a white paper background sweep. You can use genuine photo paper or a clean, clear white wall. Either way, you want an empty white background behind the set so you see it reflected in the black-glass tabletop surface.

Not unlike shooting pool, this technique is all about getting the angle just right. If you look at the side view sketch of the set in Figure 13-2, you see that you are lighting the object sitting on the black-glass tabletop and the background sweep of paper behind the tabletop set separately. A diffusion panel to soften and spread the light over the tabletop set and just out of the frame of the camera lights the tabletop to give the softest light possible. Depending on what you're photographing, you may want to add a second light to add some highlights and texture to your lighting. Mirrors and white reflectors are good for this purpose.

The background sweep of white paper (or even a clean white wall) is lit with the two lights, set up at approximately 45-degree angles to the paper. The black glass reflects the paper, which is why your backdrop needs to be clean.

The background should be a short distance from the tabletop set. If it were against the tabletop set or even too close to the set, the light from the background would bounce back in and affect the lighting of your tabletop set. The same goes for the light that you use to light up your tabletop scene. If the set is too close to the background, the light will spill from the set onto the backdrop and change what you're reflecting into the scene.

Follow these steps to set up your own black-glass shot:

1. **Place your black glass on sawhorses or a tabletop surface.**

 You want a table small enough that the edges of the black glass are near or hang over the edges of the table.

2. **Set up your camera on the tripod, and compose your shot.**

 As always, keep in mind the kind of shot you're going for and the message you want to send.

3. **Set up the lights that are going to shine on your background paper or wall.**

 Adjust them to give you the perfect black-glass reflection.

4. **Slide the diffusion flat over your set to provide a soft light on your subject.**

5. **Shine your main light through the diffusion flat that is above the set.**

 Watch your subject as you place your light; even some small moves on the diffusion panel could change the light on the subject.

6. **Check for dark spots on your subject.**

 You may want to add a reflector just out of frame to add some fill. A small mirror is a nice way to add a little pop of light in a dark spot.

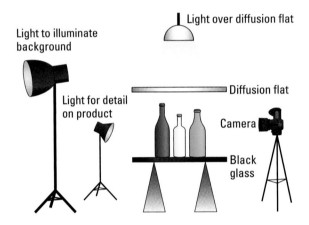

Figure 13-2: A diagram of the black-glass setup.

The way you light the backdrop (or plain white wall of your living room) creates different moods and effects in the photo. Say you want a bull's-eye around your subject: Focus all the background light in a tight circle. You need to play with the exact position of your circle of light on the wall to make sure that when it's reflected, it ends up right where you want it. You can make smooth gradations from top to bottom by lighting the background paper in a backwards gradation. If you want the background under the set to go smoothly from dark at the bottom to bright at the top, light the paper so that it's bright at the bottom and dark at the top. Creating this gradation is easier if you lower the lights close to the ground and illuminate the paper from the bottom up. The gradation you create in the paper is reversed in the reflection in the glass. If you want the gradation to go from the left to the right, create a gradation that goes from right to left on the background.

Because you're working with a reflection, you need to remember that the way you light your backdrop is going to be reversed in your glass. One way to get used to looking at this is to put a sticky note on the wall and then look at where it falls on the black glass reflection. Move it all over the background, checking it out through the camera. You'll see the out-of-focus sticky note move around on the black glass.

Also, you should use an f-stop that produces just enough depth-of-field to cover the subject and not one that covers the backdrop or lit wall.

Working with shiny subjects: Treating everything like a chrome toaster

If the world were made up of chrome toasters, a couple of interesting scenarios would result. The first oddity would be the ridiculous amount of toast everyone would be eating. The second oddity (and the one you need to be concerned with from a photography standpoint) is what you'd see reflected in the sides of all those chrome/retro art-deco toasters.

If you look in the Sunday circular, you'll notice that whenever a chrome toaster is on sale, you don't see the entire photo studio reflected in the side of the chrome masterpiece. What's more, it's lit in such a way that you can actually tell that it's chrome.

Before you roll up your sleeves and get busy, think about this: The chrome toaster, while shiny and worthy of producing a popular breakfast side, can be anything that is reflective, big, or small. A car, a computer monitor, a piece of jewelry, a watch, or just about any other shiny subject is, in fact, a "chrome toaster." You're defining shape and texture with reflected — not direct — light, which means you use the exact same technique to shoot just about anything shiny!

Professionally photographed shiny objects include highlights that show off the object's shape but reflect only smooth and seamless light (and not other objects nearby).

So there you are: a chrome toaster on one side and you with a camera on the other. A little tumbleweed blowing through and the sound of a trumpet — the perfect face-off. Make the first move; line up your camera and create your composition.

Make your tabletop as small as possible so that you can more easily get diffusion panels and other lighting tools close to the set. Prepare a bunch of different sized tabletops that can be used on top of sawhorses. These tabletops can be anything; scraps of wood and old shelves work very well. My favorite material — ½- or 1-inch foam core — is a bit pricy but worth the cost if you

plan to shoot a lot of tabletop images. You can get it specifically from a foam core supplier or from an art store; it's super lightweight, rigid, and easy to cut with a matte knife.

If you're shooting a 10-inch-long toaster on a tabletop, shoot it on an angle with a longer focal length, which doesn't distort the image. The tabletop you shoot it on is ideally about 12 to 18 inches wide. For the sample shot in Figure 13-3, I didn't need to worry too much about the tabletop surface because of my low camera angle, which doesn't show the tabletop.

Figure 13-3: The unlit toaster on the set.

Even if you're shooting brushed stainless steel, which won't give you a perfect reflection, you can see a reflection of whatever is on the other side of the room. If you have a pink wall opposite the toaster, you'll see pink reflected in the side of the toaster; if the wall is black, you'll see black.

Getting a great shot depends on using good-quality diffusion material. Whatever diffusion material you use, make sure that it's clean and free of mars. If you're using a homemade panel that's covered in rice paper, give it a fresh, new covering. If you're using true blue Roscoe diffusion material, you can actually wipe it down with a warm, wet washcloth. The collapsible flip-up diffusers are hard to clean, so hopefully yours is newer and in good condition. A nifty little technique if you're shooting with tungsten hot lights is to actually shake the diffusion panel gently during the exposure to make sure none of its imperfections show up in the reflection. Chapter 4 tells you more about diffusion panels.

Follow these steps to create smooth, even light on a reflective subject:

1. **Set up a diffusion panel so that the long side of the toaster has a clean surface to reflect.**

 Make sure that the diffusion material isn't the same distance from the toaster as the camera. You want the diffusion material to be as out of focus as possible. Make sure that you see the diffusion panel — and only the diffusion panel — in the side of the toaster.

2. **Flip on a light behind the diffusion panel so that it shines into the diffusion panel.**

 The panel should be lit evenly as it is in Figure 13-4; be careful to ensure no light spills onto the backdrop.

3. **Take a meter reading with a reflected meter. (See Chapter 5.)**

 While you stand as close to the lens as possible, view the toaster through the reflected meter; with the side of the toaster filling the frame, take a meter reading.

 The meter gives you an exposure for middle gray. Because the side of the toaster should be white with detail, you want to open up two stops from the reading. So if the reading is 1/60 at f/11, open up to 1/15 to make the toaster a perfect white with detail.

4. **Light your background.**

 For the sample shot, I put a soft halo over the toaster by shining a light into the backdrop and using only the top portion of the circle of light it put out. This backlight helps give shape to the toaster and ensures that you can see the entire outline of the toaster, keeping its shape intact. If you left the background black, you'd have to light all the way around the toaster to keep it from getting lost on the background.

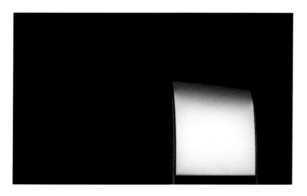

Figure 13-4: The main light reflecting in the side of the toaster.

5. **Light the side of the toaster closer to the lens.**

 A large white reflector — set up so that when you look into that side all you see is the smooth white reflector — gets enough light from the large white diffusion panel that lights the other side of the toaster. A reflector is the best option because you don't want the same brightness on both sides of the toaster; lighting the short side ½ stop darker than the long side keeps the toaster from looking flat. A clean piece of white foam core is the perfect tool for this situation.

6. **Shine a small spotlight with a snoot onto the controls and push handle of the toaster.**

 Doing so gives shape, tonality, and realism to the toaster. How close to or far away from the toaster you place this light depends on how bright it is. For Figure 13-5 I chose a low-wattage light because I wanted to place it close to the toaster for maximum control.

7. **(Optional) Light the top of the toaster.**

 If you shoot with the camera high enough that the toaster's top shows, use a large diffusion panel across the top of the set so that the toaster reflects only the diffusion material. After you position the panel, add a light to light up the panel.

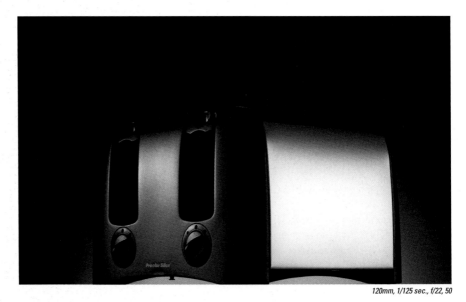

120mm, 1/125 sec., f/22, 50

Figure 13-5: The completed toaster shot with the background light and detail light on the handle.

If you want to see a prime example of different lighting techniques, look at a car magazine. You'll find examples of both reflected and non-reflected lighting inside. Shooting a car in a studio is a very costly endeavor and generally isn't done for the cars featured in the articles. Study the images closely and you'll be able to tell where the light is coming from and how big or small it is. If you look at the car shots in the advertisements, however, you'll see amazing examples of the exact same technique that was used to light the toaster. Pretty cool, eh?

Photographing Liquids

Photographing liquids can pose a challenge. The color of the drink can be influenced by the lights, the background, even the shape of the glass. Glassware itself is tricky, and filling it with a beverage adds to your challenge. Capturing a pour or splash at the perfect moment is no small feat, either. Despite these hurdles (and the mess the shots entail), the exciting images that you see in advertisements and magazines are totally within reach.

Shooting liquids when they're still

You've got to walk before you run, so shooting beverages that aren't moving is a good first step toward shooting liquids as they splash or pour. Water, beer, wine, soda, and just about any translucent liquid are pretty straightforward to photograph. The color of the drink determines how much or how little light you need to shine through the drink in order to portray the color accurately. The darker the drink, the more light you need. Water, white wines, and other light drinks may not need any light at all. With darker liquids, however, you need to get light to pass through the liquid on the way to the lens so that the image captures the color of the liquid. Lighting from behind the drink is key. In addition, not unlike the toaster I discuss in the preceding section, using a larger, diffused light ensures that the color of the drink remains true in the image.

One straightforward method I use to photograph still liquids is to light the backdrop or wall behind the drink and let the light show the drink. The iconic image of a glass of red wine shown in Figure 13-6 was made in less than 5 minutes by illuminating a circle on the wall and positioning the wine in front of it. The caveat for using this method is that your background light needs to be somewhat bright; a dramatic dark gradation behind the glass won't provide enough light to make the wine look like wine. If it's too dark, it may look like a yummy glass of used motor oil.

Here are the steps for setting up the shot in Figure 13-6:

1. **Light your background.**

 Not unlike the soft halo that I put over the toaster in the section "Working with shiny subjects: Treating everything like a chrome toaster," you shine a light on the wall in a soft, round circle.

2. **Find the sweet spot.**

 To get a sense of the best spot to set up your glass, just grab it and walk in and out of the light while watching the effects in the glass and the wine. When you find the premium spot, set up the sawhorse, table, or whatever you're using to sit the glass on, and place your glass.

3. **Get the camera lined up on the glass.**

 Shoot the glass from a low angle.

100mm, 1/60 sec., f/5.6, 320

Figure 13-6: The one-light wine setup.

4. **Take a meter reading.**

 I meter the wall with my incident meter and open up a stop from the meter reading I get. The brightest part of the light in my shot is actually blocked by the glass. By the time the light passes through the glass, the light will be perfect! Of course, your mileage may vary, but it sure works well for me.

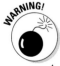

If you're shooting a glass of milk, a shake, or any other non-translucent beverage, this technique doesn't work. Light that the way you would the shiny toaster — as the reflective object that it is.

If you want to light a bottle, check out the instructions in Chapter 10. There I explain how using a large soft box on one side of a bottle and a simple white fill card on the opposite side ensures that the light outlines the shape of the glass or the bottle, and how adding a small card directly behind the bottle gives a little bit of color and brightness to the drink.

Capturing splashes: Visualizing chaos, and then creating it

How many times have you seen a cool photograph where the cherry is dropping into the glass of soda or the drink is splashing out over the lime wedge on the side of the glass? When you see these examples of drop or splash photography, do you immediately dismiss them as having been created by photo-editing software? While the fact of the matter is you may be looking at a good deal of photo manipulation, it wasn't always that way, and it doesn't have to be that way now. Most of the pours and splashes you see in advertising really are composites made up from a bunch of different drops or pours with little bits and pieces pulled from here and there to comprise the final image. But they still started with decent shots, which laid the groundwork for the composite.

Staging your shot

The key to getting these types of shots is careful setup, lighting, and timing.

It pays to be careful when you shoot splashes; you'll make quite a mess. To make matters worse, this mess will be in an area where electricity is flowing generously, so take extreme caution when you put together your set. You want to keep the power pack for your strobes off the floor; an upside-down milk crate is ideal for this. Make sure the cables are running away from the set and not right under it.

The first thing to do is to build the set where the flash will take place. This can be a table or any flat surface, but I recommend doing it in the top of a large Rubbermaid cart that's essentially a giant plastic pan on wheels. It has high walls that I can tell you from experience hold substantially more than several gallons of assorted liquids. When you set up your shot, it's important to consider how much liquid will be spilled by the time you have repeated the splash 20 or 30 times! It adds up quickly. If you have a drain in your basement or garage, that may be the perfect spot. I also wholeheartedly recommend using water. The last thing you want is milk (which will sour) or soda (which will be stickier than all get out) all over the floor and ceiling. Yes, I said ceiling.

You will need a container that will hold the liquid where the splash takes place. For this example I used a plain drinking glass filled nearly to the top with plain old water. The water glass is placed in the center of the cart and the camera and lights are set up around it.

REMEMBER When you set up your camera, remember that your primary concern is keeping the camera and lenses dry; stay away from super-wide-angle lenses that you put right on top of the set; instead, use a telephoto zoom or prime lens that puts your camera farther away from the action but allows you to fill the frame with the splash.

The camera is set up back from the glass and by using a longer focal length, I can fill the frame with the splash and not be too worried that the camera or lens will get wet. The camera needs to be set on a tripod because it will be activated by a remote trigger and it's impossible to handhold the camera steady enough and focused enough waiting for the object that will create the splash to drop.

When you set the camera, it's important to pick the right aperture. The more you stop down the aperture, the more depth of field you get, which will get the front and back of the glass, along with the splash, in acceptable focus.

Because the image is being lit by strobes, the flash of light will freeze the water as it is splashed, so you have to decide on the aperture to use and then increase or decrease the output of the strobes until you have the proper exposure. If you look at the sample splash in Figure 13-7, you see that the front and rear tip of the glass are slightly out of focus. This is okay for this image because the main subject of the image is the splash itself. Just be aware that you may not be able to get the entire glass in focus with the shallow depth of field, especially when using a longer focal length. The key is to experiment with the power setting of the lights and the aperture control on your camera.

120mm, 1/125 sec., f/8, 100

Figure 13-7: A detail showing the slim amount of focus you often have to work with. You can see only the very edge of the glass is in sharp focus.

Make sure that you compose your image with enough space to allow the event to stay in the frame. If you have a tall splash coming out of the glass, you need to allow enough room at the top of the frame for the splash.

Lighting your splash

Place two small soft boxes just behind the glass a bit. Because they're so close to the action, it's a great idea to use some clear plastic drop-cloths from the hardware store over the lights to keep them from getting wet when the splash is created. Doing so provides a good, clean reflection in the glass itself and backlights the airborne liquid nicely. Position these soft boxes as close to the action as you can without having them in the shot.

As I said earlier, timing is really key to getting the best flash shot, and it's the hardest part to master. The good news is that you don't have to try to time it manually but instead can use a dedicated piece of equipment. It's called a *delay timer,* and it actually fires your strobes for you automatically at the right moment.

A professional delay timer works on the same principal as a garage opener's safety feature. An infrared LED sends a beam of light to another infrared LED that's receiving or looking for the beam of light. If anything breaks that beam while the door is in action, the door stops immediately.

When you drop a lime, an ice cube, or whatever you're photographing between the two infrared LEDs, they send a signal to the timer that they're hooked to. This signal begins an adjustable timer that fires your strobes. If you want to catch the object just breaking the surface of the liquid, you can adjust the timer to trip there. For Figure 13-8 we were able to control the splash by adjusting the amount of delay. If you want to photograph the cube hitting the bottom of the glass, you add more delay to the unit so the strobes fire a split second later to get a deeper splash. Figure 13-9 shows the timer used to trigger the strobes. Several manufacturers make these delay units, and they're for rent in larger cities.

120mm, bulb, f/8, 100

Figure 13-8: A splash captured by students in my class.

Figure 13-9: A wider view showing the entire set with the delay timer in place over the glass.

Using a macro or tilt shift lens

Macro lenses are the standard choice for photographers who want to get up close and personal with their subjects. Using a macro, or close focus, lens enables you to fill the frame with not just the subject, such as a plate of food, but also the crinkles in the French fries on the plate, for example.

If you're looking to get a macro lens, you should be aware of the specific measuring system by which the lenses are rated. You want to get a lens that can give you a 1:1 image. Imagine photographing a penny with a macro lens that can go down to 1:1. The lens can focus close enough to show the penny at its actual size on the sensor of your camera.

The other lens that people sometimes use for photographing food is called a tilt shift lens. A *tilt shift lens* allows the photographer to actually change the angle of the lens mounted to the camera. This gives the photographer the ability to shoot images with only a single, narrow line of focus in them. If you look at the covers of food magazines, you'll find some images with a very specific and selective focus.

Here two images show a healthy option to focus on, a bowl of fruit. The first figure has a normal looking plane of focus while the second image shows the background and the left side of the bowl radically out of focus. This unique look was accomplished with a tilt shift lens (a **45mm** Canon tilt shift lens to be exact). You can place the focus wherever you want in a shot with these lenses, making for lots of creative options.

Note: Tilt shift lenses are expensive and can have a steep learning curve to get great results, so be ready to invest some time and money.

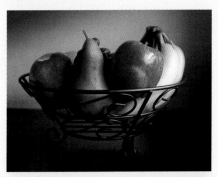

Both photos: 45mm t/s, 1/60 sec., f/5, 320

Food: A Fusion of Science and Style

Pick up a cookbook or food magazine, and you see all kinds of vibrant color and luscious texture, from the salad so fresh and lively that you feel healthier just looking at it to the cake with bright, whipped frosting you want to scoop up with a finger. Showing detail to create appetizing food photography relies on great lighting. Use a few time-tested lighting techniques to create images that viewers can almost taste.

When too much light is the perfect amount

One very popular and fitting style for lighting food is very *high key,* which means that most of the tonality in the image is bright and light; the whites, light grays, and bright colors appear very light. High-key lighting gives food depth and added texture — especially breads and cakes, which are made up of many little pores and bubbles.

The tonality of your subject is determined by the exposure, not the color itself. You can make dark blue or black very bright through your lighting. All you do is overexpose the image.

Imagine you are cooking and you see a nice scene of one of your utensils being backlit by the window it's sitting in front of. You grab your camera ready to take a photo fit for your blog. You get the framing just perfect, the wooden spoon looks great through the finder. Using the in-camera meter you set the exposure and you squeeze off a shot. Excited to view your handiwork, you flip over the camera to check out the LCD, and yeah, it looks like what you're looking at, but it seems flat and lifeless (see Figure 13-10). What happened?

The shot looks flat because the meter did all it can do: that is, make your scene middle gray. To compound matters, the tabletop is gray, a perfect recipe for dullness.

So overexpose it; let the background blow out a bit to build drama and visual excitement. Open up 1½ stops or so, and low and behold — there's the photo you saw in your mind's eye!

Food often is lightened via overall exposure and tonality for creativity purposes. If your original exposure is ½ second at f/8, open one full stop so that your new exposure is 1 second at f/8. This setting makes your darker subjects look brighter and more appetizing.

70mm, 1/125 sec., f/3.5, 400 *70mm, 1/60 sec., f/3.5, 400*

Figure 13-10: The first version is a perfectly fine exposure, but overexposing builds drama in the second photo.

Use this technique only for darker foods; if you were to do the exact same thing with a white cake with white icing, you'd lose detail everywhere in the cake, and the image would look like an accident. Show restraint even with dark foods: If you go too far with this technique, the food won't look right.

You can apply this technique in the studio when you photograph darker foods. The goal is to make sure that nothing in the image loses exposure. If the dark cake is on a white plate, the cake may look good, but the plate may disappear or lose detail. To create successful (and appetizing) high-key shots in the studio, first look at your set. Make sure that all your tonality is similar so when you overexpose it, you don't have giant areas with zero detail, and the entire set is lit. Creating a high-key masterpiece depends on even and flat lighting, which helps to evenly overexpose the shot.

You can always make a dark image brighter in postproduction, but if you lose detail because the exposure is too bright when you shoot, that detail is gone for good. Check your histogram to see whether you're on target. As long as you can see the little mountain of the histogram, you still have detail in your shot. Figure 13-11 shows you a perfectly exposed high-key shot that maintains detail in the image.

Figure 13-11: The histogram for a well-exposed, high-key shot.

Using light to show texture, detail, and even flavor

I couldn't end a food section without showing a full-blown food shot. The shots in this section go from flat to fancy right in front of your eyes. I give you six pictures — five food shots and a single shot of the set. In the examples, I use a short telephoto macro lens mounted to a professional medium format capture system for maximum detail and quality, but you can use any camera. The style of lighting I describe in this section is similar to what you find in a cookbook or an advertisement. Magazines and newspapers light in a much more basic manner.

Here are the steps that you take to get a great food shot:

1. **Line up your shot.**

 Fill the frame, get close, and make it big. Viewers don't want to see the plate; they want cake. In this case, a cupcake!

 After working through a couple of different potential compositions, I decided on what you see in Figure 13-12 because it shows the creamy texture of the cupcake, and the unwrapped liner adds a graphic element to the image.

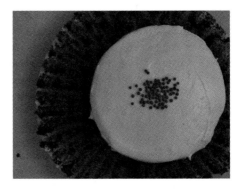

Figure 13-12: The final composition before any lights.

2. **Plug in your first light, a medium soft box placed directly over the set and pretty close to the cake.**

This light provides general illumination for the set and fill-in lighting to show the details in the dark cake and the icing. Figure 13-13 shows you the effect it gives. Using only a single, huge light source makes the cake appear flat and somewhat uninteresting.

3. **Add a strobe with a standard reflector to the back of the set and a little off to one side.**

 Place the strobe approximately 135 degrees behind the subject and high enough that the top of the cake gets some of the light. This light gives detail and realism to the cake.

 Take some time with it to see exactly where the best placement should be to make the food look its best. Turn off all the other lights when you work with this light to make sure that it's in the best spot. Figure 13-14 shows the image beginning to come alive with the additional light.

Figure 13-13: The effects of a medium soft box over the set.

Figure 13-14: Adding a light above and behind the set to add depth, realism, and flavor (yes, flavor) to the shot.

4. **Flag off the camera.**

 Flagging off the camera or, more specifically, flagging off the lens, means blocking any light that may otherwise shine into the lens. You can use anything from your hand to the go-bo (go between) to block the light; failing to flag off your camera can cause lens flare and reduce contrast.

 If you have plenty of room on the table between the cake and the camera, set up a card on the table to block any light from coming into the lens. If you don't have any room, my favorite alternative is to use an A clamp from the hardware store to clip a larger card to a light stand. In this instance, because the cake is so dark, I'm using a white piece of foam core as a reflector and to flag off the front of the lens.

5. **Add spot fill, spot shade, and spot tone.**

 This step makes your pictures better than the next guy's. You need

 - Bamboo skewer sticks
 - Light stands

- Tacky wax or museum wax (they're the same stuff)

- Masking tape

- A couple feet of metal mesh screen material (the plastic kind can burn or melt) from the hardware store

- One sheet of silver foil poster board from the art or hobby store

To create the perfect highlighting and toning on your food, use small reflectors (1-inch square up to 3 x 4 inches, depending on the size of your subject) to bounce light into dark spots or where you need a perfect little glint of light. These can be made by cutting the silver foil poster board into the required sizes. You can then position the reflectors by using a little ball of the sticky wax to attach them onto the light stands and/or bamboo skewers. If you use a skewer, adhere your mini-reflector to the stick, then adhere the other end of the stick to the table and just out of the frame with another ball of tacky wax. This lets you place the reflectors exactly where you need them. You can also take pieces of the board and cut and fold them into little tents that can be positioned to reflect the light.

To add a bit of shading on a hotspot or to add some tonality to your composition, you can use the same technique with a 1- or 2-inch square of metal screen mesh material between the light and the subject. If you need to shade something even more, you can use a small piece of cream-colored masking tape on a skewer placed close to the subject. The closer you place the tape to the subject, the harder the shadows are.

In the beginning of the chapter, I mention using foam core for a tabletop. Doing so is perfect for adding small highlights and shade, because you can stick the skewer right into the table. Figure 13-15 shows the skewer technique in action.

And finally, the final shot; Figure 13-16.

Figure 13-15: The behind-the-scenes placement of all the lights, cards, and screens.

120mm, 1/125 sec., f/22, 50

Figure 13-16: The final food shot.

Set up your lighting to reflect the time of day the food you're shooting is generally consumed. For example, a bowl of cereal that appears on a nightstand with lighting that mimics nighttime doesn't make as much sense as an image made in a kitchen setting with light that mimics sunrise. By the same token, a beautifully lit steak doesn't make as much sense in the morning kitchen as it does in a setting reminiscent of an evening restaurant.

Lighting Planes, Trains, and Automobiles

Unless you're shooting very high-end advertising and have a huge budget, you probably won't be using a gigantic (and I mean gigantic) soft box to light a vehicle. Don't fret; you can get fabulous results without a truckload or two of lighting equipment to light these amazing machines. Everything you need is already around you, as long as you have patience, a watch, and a sunrise/sunset calendar. Using the sun is a lot easier and a heck of a lot cheaper.

Clouds, the magic hour, and giant soft boxes

The plane, train, or automobile you want to shoot is nothing more than a giant toaster when it comes to lighting. A vehicle is mostly shiny, and its shape is defined by highlights and shadows that are reflected in its shiny paint.

In a perfect world, you'd start with a soft box directly over the vehicle and then make some adjustments to the position until the highlight that was reflected looked good. An enormous soft box isn't easy to come by, but you can still get smooth, soft, shadowless light. A cloudy day gives you a fantastic quality of light that works quite well. Performing a custom white balance (see Chapter 3) corrects the blue cast that the clouds give the shot.

I took the shot of the notchback in Figure 13-17 using the cloudy day technique. The clouds defined the trademark Porsche curve perfectly. If this image had been shot on a sunny day, the highlights and strong contrast from the sun would have taken away from the shot. This shot is more about the shape of the car being mimicked in the curves of the Greek Orthodox Church it was photographed in front of.

40mm, 1.2 sec., f/11, 40

Figure 13-17: A 1958 Porsche photographed on a cloudy day.

I took the shot of the classic Boss Mustang CHP (Figure 13-18) cruiser in an equally affordable manner against the California coastline. I set up the shot in the late afternoon to be ready for sunset. The car was positioned on the cliff so that the side of the car was getting direct sunlight. When the sun went down, the smooth line of the horizon was reflected in the side of the car.

Getting this shot required me to work a little faster than the cloudy day shot. I got everything set so that I was ready to snap the shot as soon as the sun dropped below the skyline. I knew I wanted only the smooth light that I would get in the *magic hour* (the 40 or so minutes before sunrise or after sunset when the sun lights the sky but not the subject directly). Because of the camera's position in relationship to the car and the horizon line, I knew I was in good shape to get the color in the reflected sky. If the car hadn't been white and black but had some color, capturing color in the sky wouldn't have been as important. Without color in the car or the background, I needed some color to make the car pop off the page.

210mm (large format 4x5), 1 sec., f/22, 40

Figure 13-18: A California Highway Patrol cruiser photographed at sunset.

The magic hour isn't a time to use a custom white balance. Had I done so, I would have lost the beautiful, subtle, warm colors that are reflected in the side of the car. Because I shot right after the sun fell below the horizon line, the light still has a good amount of directionality. If I'd made the image 20 minutes later, I'd have lost the horizon line in the side of the car and the wonderful directional quality of the light.

There are times when you can use hard daylight to your benefit, though. I photographed the train in Figure 13-19 as it barreled west at rush hour jammed full of commuters. I was testing a 1000mm mirror lens and had gone to this location earlier in the week and recorded some completely underwhelming images. After looking at them I thought how great would it be to capture a perfect bank shot of the setting sun reflected in the side of the train. With the trees along the side of the track, getting the hot ball of fire to reflect into the lens was going to be impossible, but capturing the warm afternoon setting sun in the side of the train would be doable. I set the camera low to the ground to try to get as much of the sky and its warm light to bounce off the shiny silver commuter train, and voilà!

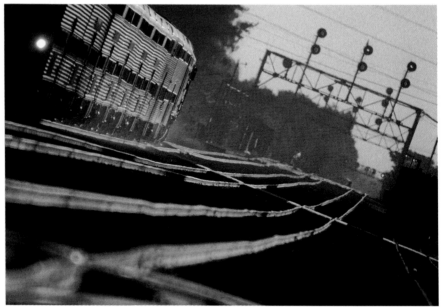

1000mm, 1/250 sec., f/10, 200

Figure 13-19: A shiny silver commuter train bathed in late afternoon sunlight.

Lenses and backgrounds

One of the reasons both of the car shots in Figures 13-17 and 13-18 are successful is the simplistic nature of the backgrounds. I made both shots with short telephoto lenses, but the backgrounds provided clean and clear reflections in the cars.

When you scout locations, finding a spot that has nothing behind it is as important as finding a location with a compelling background to put the car in front of. When the sun starts fading, the last things you want to see are trees, streetlights, and buildings reflected in the car.

350mm, 1/4 sec., f/16, 40

Figure 13-20: Honda against a hangar at sunset.

Using lenses that range from short telephoto to full telephoto helps you isolate the car, but keep in mind that the car is not flat like a toaster. If it were, you could keep the reflections clean and clear with relative ease. Because a car has curves, it reflects the environment all around it. I made Figure 13-20 in front of an abandoned hangar using the magic hour technique with a long focal length. The clean highlight reflected in the car was made possible by the fact that I was in a giant field.

I can't overstress the importance of the backside of the location. Spending some time getting a spot with a clean and empty area behind you saves you hours of frustration sitting in front of the computer, trying to get the car to look clean.

Carry a couple of lenses with you when you're scouting so you can get a clear idea of what will and won't work. Keep in mind that if you use the magic hour technique, you'll likely spend more time tromping around looking for the perfect angle and background than you will actually shooting the picture. Don't skimp on the location scout.

Capturing the Action: Event Photography

*E*vent photography is a broad term that encompasses photojournalism, sports photography, public relations (PR), and even your family's birthdays, holidays, and so on. Most photo enthusiasts are roped into shooting everything under the sun once their family and co-workers discover they have a bag full of cameras and lights. A good amount of what you shoot falls into the "event photography" category.

In this chapter, I begin by helping you figure out what equipment you'll need to shoot the event and how to take it with you. Then I tell you how to adapt your lighting to the room or environment you're shooting in. Whether you're shooting a play, a sports event, or a family gathering around the Christmas tree, you'll find the advice you need here.

The Typical Event Shooter's Bag-o'-Tricks

Event photographers come in two monumentally different persuasions. The first is affectionately referred to as the everything-bringer. He's easy to spot at a swanky party because he's generally carrying either a giant backpack or camera bag (or both) and dragging along a roller bag chock-full

of more stuff. The second type of photographer takes a simpler approach: He arrives with a couple of camera bodies with a lens apiece and a flash — maybe two. He's wearing a svelte suit and a confident smile (because he has already read this chapter and knows he'll get great results that will be cherished forever — or at least please the client enough that he'll get hired again). So what do you really need in order to get great shots quickly in less-than-ideal situations? Check out this list:

- ✔ **A digital camera or two:** The camera(s) must have the ability to perform a custom white balance and shoot a Raw file. When working a PR job, for example, I carry a camera around my neck with a flash and a 24–70mm, f/2.8 zoom lens, and I loop a second camera (without a flash) over my shoulder with a 70–200mm, f/2.8 telephoto zoom. This second camera is perfect for shooting someone who's delivering a toast or addressing an audience from a podium at an event.

- ✔ **A decent lens:** The maximum aperture on the average kit lens floats up to a whopping f/5.6 or further when you zoom in — meaning that you may need a staggering 16 times more light to make the same image you'd get with an f/1.4 lens. You're better served with a prime lens, that is, one with a fixed focal length. Prime lenses may not be as versatile as a zoom lens, but they usually have a wider maximum aperture and cost less than their zoom counterparts. You can get a fixed focal length, 50mm lens with a maximum aperture of f/1.4 or f/1.8 for under $300. There are zoom lenses that will keep the same maximum aperture no matter what focal length they are used at, but these tend to be more expensive. For example, the Nikon 24–70mm f/2.8 costs more than $1,500.

 The normal lens for a camera with a full-size, 35mm sensor is a 50mm lens. This lens gives your pictures approximately the same angle of view as that which your own eye sees. A 35mm lens used on a full-frame sensor is considered a moderate wide angle that a lot of event photographers like to use because it gives them a wider view, which is especially handy if they're in a crowded room.

- ✔ **Flash:** You can go two ways here. You can choose a more affordable, off-brand flash that can be used with any camera or a pricier flash that's made for your camera brand and reads the amount of light through the lens (TTL). Chapter 4 tells you more about flashes.

- ✔ **Batteries:** If you plan to shoot a lot of events with your camera-mounted flash, you'll find that an external battery is really a lifesaver. The flash will always be charged and ready for the next shot. Canon and Nikon sell battery packs for their flashes that hold six to eight AA batteries and are used along with the regular batteries in the flash. The battery comes with a pouch that can be hooked to your belt and a power cable that attaches to the flash. A second type of external flash battery is a rechargeable power pack that can be used with multiple flash models.

I'm not a fan of rechargeable batteries for flash units. One of the unfortunate characteristics of a rechargeable battery is that it runs fine for a while and then dies all of a sudden. A regular AA battery dies slowly, so you don't get stranded as suddenly. If you're photographing still-life scenes, you're a bit safer if the batteries suddenly die than if you're in the middle of concert or wedding!

✔ **Cables:** I encourage you to carry two of each and every cable that you need, to be safe. If you're hired to provide imagery for an event, you have to be able to deliver on that promise.

✔ **Flash bracket:** Another indispensible tool for event photography is a *flash bracket* that mounts to the camera and holds the flash high above the lens, higher than the hot shoe on top of the camera does. In most cases, the bracket allows you to shoot both vertical and horizontal pictures while keeping the flash over the lens. Getting your flash higher above the lens helps to prevent red-eye and creates natural shadows under the nose and chin as well as some shading on the cheekbones. The higher you can get the flash, the better your lighting will be. The only drawback is that a vast majority of brackets are quite large and can't be hung around your neck on a strap, which can make them awkward to carry and use. Check out the nearby sidebar, "Bracket alternatives: Using gloves and wrist straps," for tips on other setups that may work better for you.

✔ **Diffuser:** Adding a dome diffuser to the flash head will help to produce a more even and pleasing light. These plastic domes, like the Sto-Fen OmniBounce, work great, and if you angle the flash head so it points over the head of your subject, the light will have a more natural look. You may have to increase the power to the flash because the diffusers will reduce the brightness. If the event has low ceilings, you can also bounce the light off the ceiling to produce a softer, more pleasing light. More on diffusers and light modifiers a little later in this chapter.

If you're using a flash diffuser, keep your subject within 6 to 12 feet to get maximum results from the diffuser.

Figure 14-1 shows a camera set up for event photography. The Quick Flip bracket holds a camera body with a 17 to 55mm, f/2.8 lens (the perfect all-around lens for an event), and a TTL cable connects the camera and flash to each other, ensuring proper communication between the two. Lastly, notice the diffuser attached to the flash. This helps to reduce the harsh shadow an unmodified flash can cast on your subject. The second shot shows the bracket flipped for a vertical image; note that the flash stays above the lens.

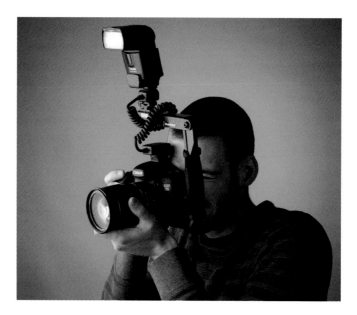

Figure 14-1: A camera set up with a bracket for taking horizontal and vertical pictures.

Matching the Room with the Lighting Technique

Whether you're shooting a fancy-pants party or an indoor press conference, chances are that an event location isn't lit just right for the shots you want to take. But you do have options for improving the lighting situation. The following sections introduce you to them. For more on tackling outdoor lighting challenges, see Chapter 8.

Surveying the scene and getting your gear ready

When you first show up at an event, you need to figure out how much or how little flash the scene requires. If you're shooting an outdoor birthday party at high noon, you need only a little fill flash to capture the happiness on the face of the birthday boy or girl. The situation is more challenging if you're photographing a State Dinner in the candlelit rotunda, and you need to capture every detail in the dress of the first lady as she waltzes across the dance floor. Ideally, you want to use the light that's already available at the location and just augment with your own flash.

Bracket alternatives: Using gloves and wrist straps

When you're shooting with a flash bracket, you don't want your presence to draw attention or cause a scene. Check out this photo of my father taken in the '60s. He and a second photographer were assigned to cover a swanky cocktail party. As I explain in the section "The Typical Event Shooter's Bag-o-Tricks," the higher you get the flash over the lens, the more natural your lighting will look. Now I imagine the lighting he achieved with this bracket was fantastic, but I also suspect he was the talk of the party after

the fact. Had thunder and lightning been in the forecast, he probably would have had to call in sick just for safety's sake.

If you want to get your flash crazy high over your lens but don't want to show up looking like a lightning rod, here are some nifty tricks to try:

✔ **Using a glove:** The most ingenious setup I've seen is a photographer who attached a flash to his hand (a glove actually) and held his hand up right before each shot. He took a fingerless glove and sewed Velcro to the back of the hand part of the glove. With some Velcro on the flash, the two stuck together. His fingers were free so that he could zoom, focus, and get all ready for the shot. If you don't think you can pull off the one-gloved, Michael Jackson look, you could use really thick rubber bands (like the kind on broccoli or zucchini) to attach the flash to your hand.

✔ **Using a wrist strap:** The least desirable method in the ingenious family of flash bracket tricks is the wrist strap. You screw a wrist strap to the screw on the bottom of the coiled TTL cable that connects your flash to your camera. This lets the flash dangle from your wrist while you focus, zoom, and get ready for the shot. Then when you're set, you swing the flash into your hand and extend your arm upward for the picture. If you're the least bit accident-prone or clumsy, this isn't the method for you. The flash tends to knock into things and generally get beat up as it swings around on your wrist.

If you want to take any of these methods a step further and you're wearing a jacket or sport coat, you can run the TTL cable from the flash to the camera through your sleeve. If you're using a larger battery on your belt, this helps to keep the wires neat and tidy as well.

The lighting you choose depends on who you're shooting the pictures for and how the pictures will be used. You have room to experiment when you're shooting for yourself or another family member, but if you're shooting for a magazine, you need to deliver what the client wants.

Begin by taking a meter reading with your incident light meter in the room or space in which you'll be shooting. This will give you a baseline reading of the existing or ambient light.

Table 14-1 gives suggestions and guidelines for when you find yourself shooting an event in a far-from-ideal situation. Use it as a guideline after your camera gives you a meter reading.

Table 14-1	Using the Right Technique for the Room
First, meter with your in-camera meter. Then take one of these paths:	
If your meter suggests f/4 or below, do the following:	*If your meter suggests f/5.6 or f/8, do the following:*
This room is dark, and you risk blurring the background if you try too hard to expose for it. It's not worth the risk.	There's enough light in the room to use the ambient room light for a little fill, which is a very good thing. Make the room about 2 stops underexposed from the normal exposure.
Set the shutter speed to 1/30.	If the exposure is 1/30 at f/5.6, set your shutter speed to 1/60 to make the exposure 1 stop underexposed.
If your lens has a maximum opening of f/2.8, set the aperture to f/5.6. If your lens has an aperture that starts around f/3.5 and floats up to f/5.6, set your aperture to f/8.	Set your aperture to f/6.3. (This is between f/5.6 and f/8, making the exposure another ½ stop underexposed.)
Make sure the flash has fresh batteries and is set to TTL exposure.	With your ambient exposure 1½ stops underexposed, you can now set your flash to TTL, and it will put out the perfect amount of light to expose your images for an aperture of f/6.3.

If you're working in a challenging situation, like the aforementioned darkened rotunda, you have to consider the amount of ambient light you have to work with. The worst thing you can do is to plop the flash on the camera or the bracket and let the camera set itself to 1/60 second at f/5.6, or whatever the default exposure may be. This is bad because it doesn't let any of the

background light into the image, and it makes your subjects look like they're being lit with some headlights in the middle of nowhere. Your images will end up looking flat and will lose any life and personality.

To ensure that your subject is grounded in the scene, keep the background from going too dark. If you can see some of the scene behind the main subject, your viewer will have a much better understanding of the story through your pictures. See Figure 14-2.

35mm, 1/15 sec., f/5.6, 400 *35mm, 1/60 sec., f/5.6, 400*

Figure 14-2: With more background visible, this simple shot (left) looks more natural than the version with a darker background (right).

I like to make the background 1½ to 2½ stops underexposed. This makes the background dark, but not black. If you make the background too bright, you'll begin to get some blurring and double exposure of the subject, which you can't fix in postproduction. This is because the flash isn't overpowering the ambient or existing light enough at the slower shutter speeds.

Adding lighting modifiers for on-camera flashes

During my years as a photographer at the world-famous Museum of Science and Industry in Chicago, I spent a good amount of time shooting various high-brow events that the museum hosted. Shooting these events meant shooting hundreds and hundreds of images in a single evening. I didn't have the time or space to drag around a flash on a stand with an umbrella to provide soft, shadowless light for my subjects. I turned to the next best thing (and the logical solution for an event like this) — mounting the flash on a bracket and attaching a lighting modifier.

Most light modifiers work by increasing the size of the flash's light and spreading the light out so that it lights both your subject and the environment while increasing the amount of ambient light in the room. Some of these flash modifiers, flash bouncers in particular, work best when you tilt the head of your flash at a straight-up, 90-degree angle. The unit then bounces light out in several directions — in some cases, a full 180 degrees. Many of these products are designed to send some light forward toward your subject, but the majority of the light is sent up and out to bounce off the ceiling and walls.

Figure 14-3 shows a few examples of various styles of flash modifiers. The Lumiquest modifier on the left allows some light to pass through and bounce off the ceiling. The OmniBounce, one of my favorites, throws out light in every direction. And the wildly affordable homemade bounce card on the right sort of bridges the gap between the two by bouncing some light off the ceiling and reflecting some straight forward. This one bounces enough light straight forward that it works well even without a ceiling.

If you're shooting in an office building with a lowered ceiling, these modifiers work exceedingly well. If you happen to be shooting someone next to a white wall in a room that has a low white ceiling, the bounced ambient light effect will be even stronger. But if you're shooting in the middle of a church, museum, or anyplace where the ceiling is six stories up, you'll lose any light you try to bounce off the ceiling.

In these cases, modifiers that simply spread out the light serve you better. My favorite is a simple bounce card, a flat white card that bounces the light forward, or a diffusion dome like the product called OmniBounce made by a company called Sto-Fen. This is a little, white, plastic, soft box-like device that attaches to the front of the flash; you can see it in Figure 14-3.

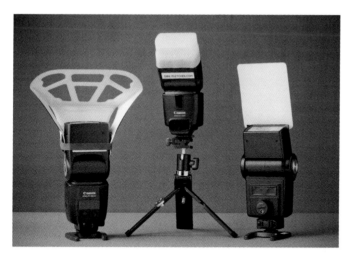

Figure 14-3: Three styles of flash modifiers.

Both of these types of diffusers, the bounce card and the diffusion domes, spread out light from the flash. The light can't travel as far when you use them, so get as close to your subject as the situation allows. All of these products work best inside of 12 feet; 6 to 10 feet is truly ideal if you consider the geometry of the situation. If your subject is beyond 15 feet or so away, you're best off removing any and all diffusers so you have some hope of your flash's light reaching your subject.

Some manufacturers are making very large products that work on the same principal of getting the light higher above the camera and spreading it out. These products are tricky for a couple reasons:

✔ When you aren't using a product, it needs to fit into your camera bag and still leave some room for, oh I don't know, your camera and some lenses perhaps. One product in particular is larger than the camera itself.

✔ The only real way to soften and diffuse light is to spread it out and increase the size of your light source. So take a look at the modifier head on, just as your subject would see it. How wide is the unit? Is it wider than a straight bounce card? If increasing the size (or width) of your light source is the only way to soften the light, wouldn't they both do the same job? Also take a peek at the price tag — yep, there it is — a couple of these products are easily over a C note — yikes.

Building the perfect light modifier for less than a cup of coffee

You can easily make a simple, effective bounce card that won't break the bank and may even help you get some more money in the bank! By making this perfect little white plastic bounce card yourself, you can save between $20 and $40 and, more importantly, make a huge improvement to the quality of your on-camera flash pictures. All you need is a sheet of white plastic (a textured white plastic will produce softer light), an Xacto knife to cut it, and some Velcro or big rubber bands to attach it to your flash.

To buy the plastic you need, find a hobby store that supplies raw materials for model trains. Head to the little spinning rack that has all the different size sheets of plastic that are used for making model buildings and such, and start spinning. You're looking for a white sheet of plastic that's approximately $\frac{1}{16}$-inch thick and is smooth on at least one side (preferably both). Buy a couple sheets (most bags have two sheets of plastic in them) and head home; you're almost done! If you don't have a decent knife, the hobby store will have plenty of different Xacto and hobby knives to choose from.

After tirelessly researching the width of shirt pockets, I've determined the average dress shirt pocket is about $3\frac{1}{2}$ inches wide, so your bounce card needs to be just a smidge under $3\frac{1}{2}$ inches wide (sorry all you metric users . . . I'm actually wondering whether a metric shirt has the same width pocket . . . hmm) and approximately 6 inches long. How you taper the end down depends more on your particular flash than anything, but if you're totally stuck, going about $2\frac{1}{2}$ inches across the bottom with about a $1\frac{1}{2}$-inch taper ought to work pretty well. Attach a couple pieces of Velcro to your new card and to your flash, and you're livin' the dream. Make sure to use the soft side of the Velcro on the card so if you place it in your pocket, it won't catch or stick to any clothing.

When you're using it, you can adjust the pitch to get 100 percent of the light to bounce if you're outdoors or in a ceilingless place, or you can make the bounce card parallel to the flash if you want some of your light to pass on up to the ceiling. I've used this style of bounce card for many years. You can also use this bounce card in addition to the OmniBounce (see the section "Adding lighting modifiers for on-camera flashes") to increase the effective size of the flash (an extra little bit of light will get thrown out the front and sides).

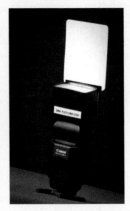

Lighting Common Events in Less-than-Ideal Conditions

You don't always have the pleasure of being able to control the lighting conditions when you set out to make your pictures. In many cases, you have to handle the existing lighting conditions without being able to change a thing.

Here are some tips and suggestions to make the best of a couple popular scenarios that you may find yourself in.

Plays, recitals, and other spotlight events

I work with a crazy and fantastic individual who spends every waking minute of most days either directing or acting in community theater. Photographing these shows is fun, and the community actors (who aren't getting paid) couldn't be more appreciative of my pictures.

The challenge of shooting any kind of lit stage event, whether it's a local community production or a high-end show on an international tour, is the lighting. Often the lighting changes rapidly and dramatically. Yet these very challenges can actually lead you to some fantastic imagery.

Arrive early so you can stake out a position that's close enough to allow you to capture dramatic expressions, but far enough back that you can capture the entire stage in one shot. I almost always set up to use a 70 to 200mm, f/2.8 lens and shoot it either wide open or pretty darn close. This lets me use a high shutter speed so I don't get any blurring of the actors. Shooting at 640 or 800 ISO does the trick in these situations, and produces relativity clean files.

Theatrical lights are all 3,200-degree Kelvin bulbs, a perfect tungsten setting for your camera. Don't worry about performing a custom white balance, because that negates all the efforts of the director to color the lighting with gels. If a night scene is lit with blue gels to simulate nighttime, you don't want to neutralize it with a custom white balance; you want your images to reflect the blue color of the actual scene. Setting the camera to the proper color balance for the lights without the gels ensures that you capture all the color of the show as it really appears.

The actors will be lit from above, sometimes from below, and sometimes even by the (very bright) spotlights that follow them around the stage from the back of the auditorium or theater. This is terrific, because your actors will have great detail and ample lighting for your exposures. The challenge comes in with whatever the actor is standing in front of. Nine times out of ten, it's something that isn't lit as brightly, which is the situation in Figure 14-4. If you simply point your camera at the scene and you're set to a metering mode that takes the entire scene into consideration and calculates an average, the camera will try to expose for the darker background. This will make the actor you're photographing completely blown out. In most cases, the difference is too much to repair in postproduction.

200mm, 1/60, f/4, 640

Figure 14-4: Using the spot meter and recomposing for the picture gives the proper exposure in this tricky scene.

A camera's spot meter reads only the center 5 percent of the frame when it sets the exposure. For this to work properly, you need to make sure the actor's head is smack dab in the middle of the frame when you take the meter reading; after the camera has taken a meter reading and the exposure settings are locked, you can then recompose your shot and take the picture. Note that you'll need to meter and recompose for every image unless you're using the manual exposure setting, where you set the exposure values and the camera can't change them. So if you don't fill the frame with your actor's noggin each time, the exposure won't be correct.

Don't wait till the curtains open to get your camera out of the bag or off your shoulder. More often than not, a more memorable image is waiting for you before the curtains open or after the final bow. In Figure 14-5, I captured a truly memorable picture during the band's warmup. I remembered to perform a custom white balance in this mix of light sources. A quick pic of a pocket-sized gray card gave this natural-light photo an almost perfect color balance without needing any postproduction to get the skin tones where they should be. Again, don't be afraid to move the ISO to 800, 1200, or even 1600 if that's what you need to get a sharp, well-exposed image.

200mm, f/2.8 lens, 1/60 sec., f/2.8, 800

Figure 14-5: A nearly perfect color balance in seconds in a tricky location (the school gym), made possible by performing a custom white balance.

Indoor sports

When you're shooting fast-moving action, the challenge is getting enough light to stop the action. Most indoor sporting facilities for kids are poorly lit. It's not on purpose; it's a "value engineering" step, and that's okay because we're not playing major league ball here. But if you have the opportunity to shoot for a major league club, it's a trip — the entire bullpen is lit to the exact same brightness and direction as daylight at high noon. How easy does that make things?

Consider how fast your subject is moving, and what colors are around her. For example, in volleyball and basketball, the action moves quite fast; horseback riding and jumping are even harder because of the dark dirt floor and poor lighting. With wrestling in particular, the athletes aren't moving around much, so you can shoot with slower shutter speeds and get decent results.

Sports that take place on a light-colored and super-shiny reflective floor are easier to shoot because the floor actually acts as a reflector and bounces light back up to your little Jane or Jordon. You'll find the exposures are a good ½ to 1 full stop brighter in these conditions than with dark matte or dirt floors.

Because the action you'll shoot on the floor will include stands, walls, and other stuff in the background, I encourage you to meter the playing area before the game, and set the exposure manually into the camera. Ideally, if you have an incident meter (see Chapter 5), take a reading at each end and in the center before the game starts. Hopefully the readings will be within a stop of each other, and you'll be able to get a decent average exposure with your camera set to one of the higher ISOs. Don't be afraid to crank it clear up to 1600, 3200, or even farther if necessary on a modern DSLR camera. Your goal is to shoot with a shutter speed of 1/250 second. Your aperture will most likely be close to wide open, which is okay if you have a fast lens with a maximum aperture of f/2.8. If the lens has a maximum aperture of f/5.6 or smaller, then you may have to push the ISO even higher. If you're going to do a lot of shooting in low-light situations, you really need to invest in some fast glass like a 70–200mm, f/2.8. lens.

As long as you achieve the proper exposure, the noise or digital grain is less noticeable than if you underexpose the image. An underexposed image lacks both the contrast and overall color fidelity that are desperately needed, especially when photographing in darker lighting conditions. Underexposed images will contain just as much noise as properly exposed images, only the vibrance of the properly exposed images will eclipse the noise greatly, making it less noticeable.

I like to sit on the floor or in the first row of seats at court level so I'm looking up into the eyes of my loved one. Using a telephoto lens, I patiently follow him or the ball around the court, taking pictures when things look good in the finder. Being familiar with the game helps considerably, because it allows me to anticipate when the team will drive to the basket or move the ball. In Figure 14-6, Sam brings the ball down court in a dark and poorly lit court at the YMCA. While the image is grainy, you're drawn to the action and his eyes. If I had underexposed the image, I would have lost detail in his eyes, and the noise in the shot would be much more noticeable.

200mm, 1/200 sec., f/2.8, 3200

Figure 14-6: Properly exposing this shot forces the viewer to see the detail in the shot and not the amount of noise the higher ISO will give you.

Outdoor sports

When you shoot outdoor sports, you're working with either a single bright light source on a bright and clear day or a very large, diffused light source on a cloudy day, depending on weather conditions. You'll always create a more pleasing picture with the sun backlighting the subject, so if the day is sunny, position yourself at the end of the field that allows you to backlight the players. Doing so will keep your subjects' eyes from squinting and their faces more natural-looking. The backlit players will also pop off the background, whereas otherwise, they'll tend to blend in. On a cloudy day, you can shoot from anywhere; the clouds provide a nice, even, soft lighting. A wide f-stop results in a shallow depth of field and a blurry background, which also makes players seem to pop off the background.

Regardless of the weather, I encourage you to use the manual settings on your camera after you determine the proper exposure. Panning with the action changes the background, and subsequently your exposure, if you don't set your camera manually. Your lighting will vary from a little dark to a little bright and everything in between. An incident or hand meter is best, but the camera can do a good job too. If you use the camera's meter, I encourage you to get your exposure from the grass rather than the players. Grass is ironically close in tonality to a gray card.

 Don't forget the standard exposure compensation is 1 stop from normal daylight exposure. A quick recap: If you shoot with an ISO of 250, you can simply set your shutter speed to 1/250 second and your lens to f/16 for normal, sunlit pictures. If you can backlight your subject, you need to open up 1½ stops to compensate for the darker, shadowed side of your subject. This will give you a new exposure of 1/250 at f/8½ — 1½ stops from the standard daylight exposure.

If you own an incident meter (see Chapter 5), take a quick exposure reading by holding the sphere that looks like half a ping-pong ball to emulate the face of your subject in the direction your subject's face is pointing. This is the best way to determine your exposure, because it keeps the camera's meter from being fooled by any overly bright or dark backgrounds.

In Figure 14-7 you see the goalie's hands and arms being lit with the hard sunlight, but with the sun at his back, his face is smooth and squint-free. Also paying attention to your background, trying to keep it free of other spectators, trashcans, and lawn chairs will help your subject pop off the background as it does here.

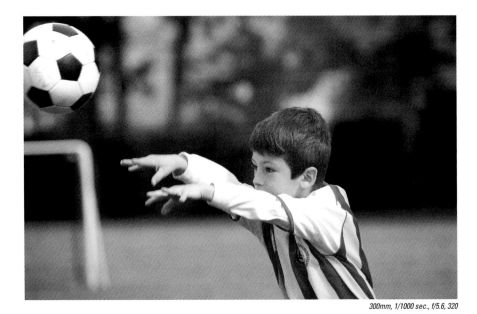

300mm, 1/1000 sec., f/5.6, 320

Figure 14-7: Using a wider aperture, f/5.4 in this case, helps everything fall out of focus so your eye is drawn to your subject.

Holiday lights

Call me a dork, but I never get tired of holiday light shots. To me, this is Americana at its best. I have a detailed record of my family and the Charlie Brown trees that we shared the holidays with. I can't help but do the same thing with my own family, although the kids seem to enjoy it less than I did — maybe I'm only remembering the good parts.

Here's the foolproof method for ensuring perfect exposures around a Christmas tree. Grab both your tripod and your flash. If you use a bracket, get it. Better yet, set up the flash in a light stand with an umbrella to diffuse the light. You want to set up a *drag shutter shot,* meaning that you hook up the flash and umbrella, and get set for the proper exposure. Say you set the flash to half power, and your meter or test exposures indicate you should be shooting at f/8 at ISO 400. If you make the shot now, the umbrella will provide nice, soft light on the faces of your family or friends, and you'll see some of the tree behind them. But because you're shooting at a faster shutter speed, the little twinkling lights that you individually tested won't really show. This is where the drag shutter technique comes in.

Darken the room you're in so the only light on your subjects' faces is the umbrella flash. Keep any bright lights like the overhead off of them. Then set your shutter speed for 1/8 second, and see how it looks. If the Christmas tree lights still aren't showing enough, try 1/4 or 1/2 second. Keep backing the shutter speed down until you get a balance between the front flash and the Christmas lights that you like.

Figure 14-8 was shot with a single flash into a small 12-inch soft box with all the room lights off to let the lights from the decorated tree burn in. A longer lens also helps isolate the boys and keeps the tree soft and blurry in the background.

70mm, 1/10 sec., f/5.6, 640

Figure 14-8: The drag shutter effect used to capture the lights behind the children.

If you leave the overhead lights on, depending on how bright they are, the faces in your photo may become blurry because the longer exposure allows the ambient light to expose the kids' faces in addition to the flash unit. You don't have to be in the dark, but you don't want to be in really bright conditions either.

How to ensure your memories will be around for generations to come

Back when shooting film was the norm, you'd shoot a roll or two of film and drop it off with your local photofinisher. An hour or a week later, you'd pick up your pictures, flip through them, relish your creative genius, and put a couple in an album, one on the fridge or your desk, and the rest in a drawer or a shoebox. This was what would later become a cherished archive of your family life. In my 42 years of life, I've seen three fights over boxes such as these (sorry, Mom and Uncle Chuck), and they aren't pretty!

But at least in this scenario there's a box of pictures and/or negatives to fight over. Ready for a scarier scenario? In this one, everyone is shooting digital (insert dramatic pause here). Really, everyone is shooting digital now. I'm a professional photographer, and I have to admit, I'm not archiving my digital files as diligently as I should be. Photographers everywhere rejoiced when the price of media cards came down enough to allow them to keep a couple gigs' worth of images on the camera. Say you download all your photos to a laptop for a year or so before it gets stolen or crashes. You now have a year's worth of family history that's gone for good. You may have burned CDs and DVDs before the crash, but the sad truth is that the lifespan of a CD or DVD is about ten years. Film fades over time and may get scratched or even ripped. But you can still see an image that's faded, scratched, or ripped. If one thing goes even the least bit wrong with a digital file, the file won't open and is gone forever.

So how do you combat this conundrum technology has created for us? You treat your digital files just like film files and print them. Print them early and often. Don't replace the shoebox in the attic with a hard drive just yet. The time will be upon us sooner than later that family memories stored as Xs and Os will be just as safe as a properly washed photographic negative, but it's not here just yet. Keep the cherished family album alive, and print your birthday, holiday, and vacation photos to put in it. Anyone, anywhere, regardless of technical competence or computer savvy, can look at a family photo and smile. Great grandpa just isn't going to open up a photo-editing program to check out a Christmas card — he just isn't!

Painting with Light

*P*ainting with light is a fascinating technique that can entertain children and solve complex problems for a professional photographer. The concept is pretty straightforward: You simply open up the shutter and use a light source to illuminate what you want to highlight in a dark scene. You can also turn the light to the camera and write your name, outline your best friend (or a tree, or anything else that strikes your fancy), and otherwise bring mayhem to an ordinary scene.

Shedding Light on the Concept

When you paint with light, you move a light source (a strobe light, say, or a glow stick — heck, even a regular household flashlight) through a dark scene that you shoot with a very long exposure. Because the shutter is open for a couple of minutes while you "paint," you have time to ensure you get enough light or exposure on your subject or the scene that you're photographing. You can use the technique in a variety of creative and functional situations, from simply using a flashlight to illuminate an evening scene in your back yard to dispatching entire teams with strobes, flashlights, and lanterns to light the Pile Gate in the city of Dubrovnik, Croatia — which is exactly what the faculty and students of Rochester Institute of Technology's photography department did to create Figure 15-1.

Image courtesy of RIT Big Shot (www.rit.edu/bigshot)

Figure 15-1: Pile Gate in the city of Dubrovnik, Croatia, is bathed in the light of hundreds of photographers and locals.

The following sections introduce three methods commonly used to paint with light.

Using light as a paintbrush

The traditional way to use this technique is to think about the end of your flashlight as a pen or marker that lets you write and draw in almost cartoon-like fashion within your frame. By moving your light through a scene with the camera's shutter open, you leave a visible light trail in the frame. It's a simple thing to do, as shown in Figure 15-2.

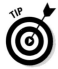

The options for painting with light are just about endless and getting cooler each day. With the number of LED flashlights and personal safety lights available, the possibilities for creativity are limitless. I've even picked up some very high-power, small, LED flashlights that have "painting with light" written all over them. Following are some ideas to get you started, but feel free to experiment with anything you find that emits light:

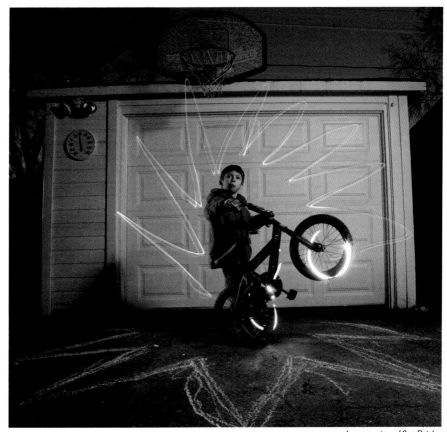

Image courtesy of Sam Fletcher
24mm, 30 sec., f/10, 400

Figure 15-2: So easy even a 9-year-old can do it. Here, Sam Fletcher "paints" his little brother.

✔ You can turn off the flashlight while you're taking the picture to stop the light at a particular point. Turning it back on will restart your light trail.

✔ For a dotted line, try a blinking light, like the LED taillight for a bike. The faster you move it through the scene, the farther apart the dots will appear in your image.

✔ When you use a flashlight, you can add different colors to your lines by covering the business end of your flashlight with colored gels that you get from a camera or theater supply store, or you can use colored tissue paper. (Nothing fancy, just the kind you use inside gift boxes.) Tissue paper doesn't just color your light, it diffuses it, giving you a bigger pen, marker, or paintbrush. Cover your light in red tissue before drawing the flames on your car shot, for example. Check out the "Creating stories with color" section for more about adding color to your painted images.

The digital disadvantage

One disadvantage of digital photography is that the longer you keep the shutter open, the more noise builds up in your scene. Discolored pixels show up in your shadow areas and other dark parts of the scene. You don't have this problem when you shoot with film; you can keep the shutter open all night if you want to without increasing the noise or grain.

Using light as a marker or paintbrush also works well in the studio. Robert Vreeland made the image in Figure 15-3 by using camping-style glow sticks and flashlights to augment and add drama to his tabletop shots. Robert sparsely lit his scene with studio strobes; then after the strobes fired, he kept the shutter open while he created light trails with a glow stick.

Image courtesy of Robert Vreeland

Figure 15-3: Glow sticks and flashlights serve as paintbrushes when you paint with light.

Creating a dramatic light in the dark

Photographers also paint with light by using a flashlight as a portable light source that bathes the subject. In Figure 15-4, you see how Hollywood Steadicam Operator Eric Fletcher paints his car in the middle of a nearly pitch-black desert.

Image courtesy of Eric Fletcher
10mm, 30 sec., f/3.5, 6400

Figure 15-4: In the middle of a perfectly dark desert, Eric Fletcher gives his car a fresh paint job.

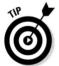

Keep the flashlight's reflector out of the shot; otherwise, you get a light stripe like you get when you use a flashlight as a paintbrush. To make sure you don't get a line when you don't want one, wrap Black Wrap, Rosco Cine Foil, or just some dark cardstock or construction paper into a snoot around your light to ensure the lens doesn't catch the front of the flashlight. Roll the material into a cylinder that the flashlight can fit into. A snoot is a very effective way to control the width of your light.

To try this technique, you want to underexpose or darken down the image so you can come back in and brighten the scene where you see fit. Set your exposure a stop or more lower than the meter recommends. You want your lighting to tell the story. (Flip ahead to "Setting your exposure for maximum effect" for help.)

With your flashlight snooted down a bit, open the shutter and begin to shine the light at the parts of the scene you want to be illuminated. Walk away from the camera and get closer to your subject as you move the flashlight around to paint your subject. Painting in gentle circles by moving in this way creates pleasing pools of light. If you paint in longer brush strokes, your lighting can cover larger spaces easier and more naturally. Use longer strokes for the side of a building, for example, and then use pools of light to light the plants and foliage around it.

You can control the type of light you use with some simple techniques. Cover the tip of your light with diffusion material, spun glass, or even tissue paper if you want a larger and softer light source. Eric wanted to soften the light for his desert paint job and ended up placing a (clean) white sock over the end of the flashlight to spread and soften the light. I've seen photographers place powerful battery-powered light sources, similar to "pizza delivery" lights inside small, soft boxes before painting a scene. A soft box makes your light source bigger and enables you to cover larger spaces with a smoother and more even light. (Chapter 4 tells you more about soft boxes.) Keep in mind that you lose approximately half the power or effective wattage of your light when you use a diffusion material.

Be aware that as you increase the ISO or the amount of time the shutter is open, noise builds up in the image in the form of grain or pixels that are most noticeable in the darker shadow portions of the shot. In the case of Figure 15-4 you can see the noise in dimly lit areas.

Painting with a portable flash

To use this technique, make sure the camera is firmly on the tripod, and then simply open the lens and repeatedly fire or pop a small, portable flash unit to light a space. You can even light a huge space that would normally take a truckload of lights. You can use a small, hot-shoe flash unit or a larger, battery-powered, portable flash unit. This technique keeps you free from light stands and cables while enabling you to light your space with only a small flash unit. It's an exciting way to paint with light and, if done well, creates a photograph that doesn't look artificially lit.

The photo of the art deco Brookfield Water Pumping Station (see Figure 15-5) was made by a group of students led by John Karl Brevick. The student photographers surrounded the building, each with only a small Canon flash unit. Once the shutter was open, each photographer triggered their flash a predetermined number of times. How many times each of the flashes popped determined the exposure for that area. From two to eight full-power pops from a Canon 430EX strobe was all this image took. You can see purposeful and deliberate management of tonality across the building. If the entire building was the same level of brightness, it wouldn't look as robust and natural as it does.

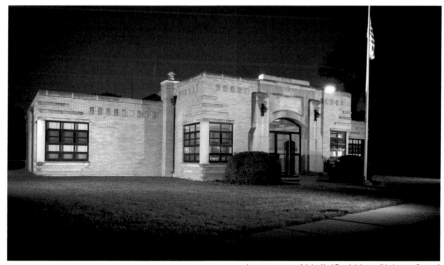

Image courtesy of John Karl Brevick (www.jkbphotografix.com)
24mm, 30 sec., f/4.5, 400

Figure 15-5: The art deco water pumping station in Brookfield, Illinois, gets the full-flash treatment.

Follow the instructions in the section "Setting your exposure for maximum effect" to set your exposure a stop or more lower than the meter recommends. Because you're using a lower-powered portable flash, you need your f-stop to be on the lower side. You want to set the camera so that the image starts out at least three stops underexposed for this technique. If your meter tells you to shoot at f/2.8, for example, you need the f-stop to be set at f/8. Set the camera's ISO to a lower number — between 200 and 400 is a good starting point — and see what kind of exposure your meter gives you at this setting.

Either set your flash to the auto setting that lets the flash measure the light itself, or use the flash in manual mode. I recommend the manual mode, in which case you set the flash to half or ¾ power. (If it's set on full power, it takes too long to recycle and may give you only a couple of pops during your 30-second exposure.)

If you own a larger external power pack (see Chapter 4), this is the place to use it. If you don't own one and really like this approach, you may want to start saving for one — it will be repaid tenfold.

Open the shutter and walk around (and even through) your scene, popping your flash by pushing the test button. Start by pointing the flash at your subject from 10 to 12 feet away; this should give you a balance between good coverage or spread of light and a good amount of power or light falling on the subject.

Taking a "Painted" Shot

Before you set out to use these techniques, you need to have a solid idea of what you're shooting or why you're making the image. Make sure that your picture stands on its own before adding your light painting. The light painting should enhance an already good image, making it great. If you start with a ho-hum or mediocre image, the painted image ends up looking gimmicky.

Seeking dark locations

Regardless of which technique you choose to work with and the subject you decide to shoot, you need darkness to create an effective "painted" photograph.

Brightly lit urban nighttime scenes won't work if you're planning an image that involves elaborately painting with light. Head to rural and country settings, especially when you're starting out. Doing so gives you time to experiment and work with your painting times and techniques. If you're shooting structures and buildings, don't forget to see whether any internal night lights or safety lights are visible through the windows to the camera. Although you can reduce or remove them later, you're better off being thorough when you set up your shot than getting back to your computer and seeing a giant exit sign through a window. Usually, you can move the camera just a tad to get rid of unwanted lights.

Environmental lights that are beyond your control are a limiting factor in your exposure. In John Karl's shot of the pumping station (refer to Figure 15-5), the flag was lit by some large floodlights that were on a timer and couldn't be turned off. To work around those lights, he set his exposure to 30 seconds. Any longer, and the flag would have been completely blown out and unfixable in postproduction. He had enough people to pop the handheld strobes the proper number of times to get the exposure he wanted, but if he had been working alone to make this image, he wouldn't have been able to light the entire building before the flag was totally blown out.

Take another look at Figure 15-4. That photograph had a different limiting factor: Pitch-black desert gave the photographer all the time in the world to paint the car with his flashlight, but he wanted the stars to be visible in the final image. The sky is real, and the entire image was done in-camera without any postproduction tricks, in a single exposure. Shooting in the desert enabled Eric to get clean and rich color in the nighttime sky without any of the reddish light pollution you pick up in densely populated urban areas. He based both his exposure and ISO settings on what he needed to get the stars to read, then went in with his high-powered LED flashlight and painted the car and the ground around it until he got what he wanted.

Setting your exposure for maximum effect

When you set out to draw in your image, first you need to set your exposure so you get maximum effect. That means underexposing just a tad. Follow these steps to determine your (under)exposure:

1. **Set your camera on a tripod and frame your scene as you like.**

2. **Using your camera in manual mode, take a look at what the meter tells you is the proper exposure when the camera is set to 30 seconds.**

 If you're shooting digitally, you can take some test exposures to see how it looks.

3. **Stop down the lens.**

 If the meter tells you to shoot for 30 seconds at f/8, set your aperture to f/8½ or f/11. You don't want to make the shot too dark; stopping down 1 stop (or even just ½ stop) enables you to see everything in your shot and ensures that your writing doesn't get lost in the scene.

4. **Set your ISO around 200 to 400 as a starting point to keep the amount of digital noise down.**

 The higher you set your camera's sensitivity, the more noise you add to your final shot.

When you're set and ready to go, open the shutter and take off like a crazy person! If you're shooting a picture of your car, for example, draw around the shape of your car and outline the wheels, and then see how you did. Then try to add some flames from the exhaust pipes!

Determining exposure by number of pops or time

For some reason people are intimidated when it comes to using a strobe unit instead of a flashlight for this technique. Determining your flash exposure is much easier than most people think, and in the digital age it couldn't be easier — just consult the histogram (see Chapter 5) while shooting. In Chapter 4, I tell you about using guide numbers as a reference to determine just how powerful your flash unit is.

The guide number indicates the power of the unit in terms of f-stop at 10 feet with an ISO of 100. So a Canon 580EXII with a guide number of 191 tells you that setting your camera to an ISO of 100 and the flash at full power in a white room 10 feet from your subject gives you an f-stop of f/19, or a split stop between f/16 and f/22.

The other key component to keep in mind is this: When you double the distance between the flash and the subject, the power will be exactly one quarter of what it was before. So if your Canon unit actually tested at f/16 at 10 feet, when you go to 20 feet with the flash, you'll get an f-stop of 8.

The same concept applies (albeit in the opposite direction) if you push the strobe in to 5 feet. The power (or output) doubles, giving you an f-stop of f/32.

To get started with your first nighttime painting-with-flash test, follow these instructions:

1. **Set the camera's**

 • **Speed to ISO 200**

 • **Shutter speed to 30 seconds**

 • **Lens to f/8**

 Chapter 3 takes you through the finer points of camera settings.

2. **Make an exposure without a flash.**

 If the shot is too bright, try 30 seconds at f/5.6. Still too bright? Find a new location that is darker.

 If it looks good (but a little dark) you're perfect!

 If your location is too dark from the get-go, don't pack up; instead, go straight to Step 3 and start your first exposure from there.

3. **Set your flash to manual control and half power.**

4. **Take a shot, popping the flash twice during the 30-second exposure.**

5. **Check out your shot. If it looks pretty good, keep shooting, experiment, and play a little. If it looks dark, try the following fixes in this order:**

 1. **Double your pops to four per exposure** or two pops in two different locations, lighting up two different parts of the scene.

 2. **Set your ISO to 400** and try again.

 3. **Set your flash to full power.** Chances are it won't recycle fast enough to pop four times though, unless you have an external battery.

 4. **Open the lens to f/4,** but be careful with your focus — your depth of field will be reduced.

If you pop the flash twice, you also double the power, so if you're at 10 feet and you pop the unit twice, you should now have f/22; to get to f/32 you must double it again, so you have to fire the unit four times. Another stop of light on your subject requires eight pops of the flash, and so on.

The pumping station image was shot at an ISO of 400 at f/5.6 (refer to Figure 15-5). Using a wide-angle lens prevented the flash from getting too close to the subject. Also keep in mind that when a manufacturer rates its units, it seems like it's done in a small white room, because it wants the units to appear as powerful as possible. You should always test your own equipment as you use it in your own situations, instead of relying on the manufacturer's numbers.

Placing your light source for different effects

After you're comfortable painting with light, you can up the ante. Instead of just being happy with lighting up a scene, take a careful look at how your light reveals and illuminates your subject. Even small changes in the position of your light can vastly change the appearance of the final image.

The very best thing that digital photography did was to free photographers from worrying about the cost of film and processing. You're now free to experiment in the field, see instant results, and make adjustments while you shoot instead of trying to fix problems in postproduction. Relying on post-production creates more headaches after the fact than getting the shot right while shooting.

Survey your subject before you start. Whether it's a car, a building, or just the jungle gym in your back yard, walk around it with your flashlight or strobe unit and carefully study how your light looks when you illuminate your subject. Take test shots with the light in various positions as you move in a half circle around your subject so that you can see how it looks lit from the front, sides, and even edges when lit from behind or overhead. Let your curiosity run wild; doing so only improves your final product.

When lighting spaces and buildings, before you even get your camera out of its bag, determine what you're attempting to do with the image. Is this Grandma's house in the woods or is it a haunted house? Your camera angle and your lighting let viewers know. Table 15-1 gives you a taste of the differences.

Table 15-1	Lighting for Two Opposite Effects		
Grandma's House	**Lighting Choices**	**Haunted House**	**Lighting Choices**
Sweet, warm place, loved by all	Warm lighting that reminds us of a wonderful, warm sunset. Bathe the outside in this light.	A scary, dark, and unwelcoming place	This is the time to use the widest angle lens you have, get on the ground, and look up at the house so you get as much distortion as possible. Use very little light, and make it dark blue in color.
Small, well-cared-for home	Pick an angle that shows the entire house without distortion. Use a normal or short telephoto lens and even lighting all around the house to show her attention to detail.	Not sure of the activity going on inside	Either no light at all in the windows or possibly a silhouette in the front window.
Always good food and smells coming from the kitchen	Hmm, can't make a picture smell, but you can light the inside of the house with an extra warm light, even shining light through a window into the yard to show warmth coming from within.	Unkempt and questionable surroundings	Using your snooted light with a blue gel, light up the broken glass in the front walk and the empty trashcan lying on its side.

Creating Depth through Painted Lighting

One of the fastest ways to add professionalism to your image is to keep the light source away from the front of the camera. By building your lighting in the areas where it would naturally fall, you make your images stronger.

When you see a picture made with an on-camera flash, you can't help but be underwhelmed by the flat and lifeless lighting.

The next time you're in the grocery story or a bookstore, take a peek at *Architectural Digest,* even if it's just the cover. The lighting in those images draws your eye into the scene.

Imagine your scene as a house: The kitchen is always the center of attention at a party; the living room is a quiet, peaceful place; the entry hall or mud-room merely transitions you from the outside world to the inside world.

Visualize the scene you're photographing in a similar fashion. The entry hall or mudroom is the vignette that directs your eye from the edge of the frame to the center of interest. The "kitchen" is the very reason you are taking the picture. It's the point of focus and excitement. This is what you're lighting; the rest of the frame supports it. You may light it from several angles or create a soft lighting ratio that will allow your viewers' eyes to move around and make discoveries on their own. Just as with the kitchen, this is where viewers end up mingling. Don't forget to light the living room as well; offer the eye a break from the contrast and visual excitement without taking away from the focal point of your image.

If you're lighting a structure or other large space, you may want to go Jackie Chan–style on your scene — dress in all black clothes and ninja your way through the scene, dispensing light at will. This technique is particularly helpful if you're shooting a large space with a small strobe. Moving yourself (and your flash unit) in, out, and all around your scene enables you to better sculpt the light on your subject and to get the flash closer to your subject; you get more power and a better exposure from your flash. If you try this approach, take care not to stand between the lens and the area you're light-ing, or you'll end up with a silhouette of your body in the shot.

Protect the front of your light source from being seen by the lens, because it will leave a bright line that you'll need to remove later.

Emulating natural light versus creating stylized lighting

If you look at the image of the pumping station (refer to Figure 15-5), it looks, well, lit, but in a photographic way. Light has been applied to the exterior walls, as you would expect a photographer to do. John Karl could have gone one step further and emulated the streetlights or perhaps the moon as you would expect a Hollywood production to do, but the point of this image was the application of light to define the building. So as it is intended, it's quite successful.

Figure 15-6 is an image by Chicago photographer Britton Black. His unique and stylized images begin with a dramatic subject — in this case a classic Model A Ford. By shooting before the sky is completely dark he can keep some deep blue color in the sky. When he sets out to create the image, he works with a bright LED flashlight and a couple of strobes to provide a foundation for the image. You can see these strobes under the car and lighting up the trees and grass in the background. The rest of the image was "painted" with a high-power flash light.

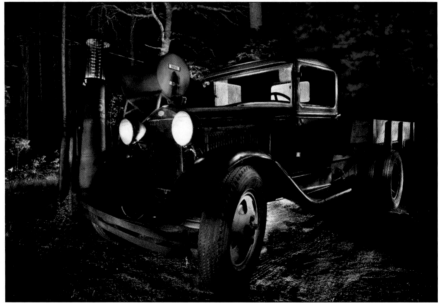

Image courtesy of Britton Black (www.brittonblack.com)

Figure 15-6: Combining a bit of color in the sky with Britton Black's dramatic treatment makes for an amazing image.

Creating stories with color

As you begin to create scenes and stories with your "painted" shots, don't forget how the colors can change the mood of an image. Pictures with reds, yellows, and oranges make the viewer think of positive, loving emotions and warmth, whereas blue adds a cold and unwelcome feeling or mood to an image.

Think about placing a blue gel over your strobe and lighting the exterior of your house or building. As you ninja around lighting the exterior of your scene, keep the blue gel on and light the walkway, trees, bushes — in short, everything outside the house. Then change the gel to a warm one, a full CTO

(convert to orange) gel, and light the inside walls that are visible from the outside. Light through the windows into the grass or snow with your orange gel still attached. This gives a warm, window-shaped pattern in the ground, making the home seem like a warm and friendly place to be. You can even use a second sheet of the gel and place your strobe close to the floor to emulate a lit fireplace inside the house.

Now imagine this: Employ the reverse strategy, bathing the outside with warm, afternoon-looking light and lighting the inside of the house with blue light. What does it look like now? You've just created a dark and evil-looking house out of what was a warm and happy home moments before.

Figure 15-7 shows a hallway – quant, warm, and inviting in every way. But how much of the effect is because of the thoughtful brush strokes of light that photographer Britton Black added with his unique approach? If his lighting was flat and non-directional, the shot would look and feel like a hospital or an uninviting institutional setting. If the light was cold and blue in color, it too wouldn't look as inviting as this shot. But this photo is warm and wonderful and makes me think of my grandma's house. I can smell her famous baklava rising in the oven! Cool, eh?

Image courtesy of Britton Black (www.brittonblack.com)

Figure 15-7: Creating a loving interior, Britton Black paints the interior of this home with warm colors.

Painting at night: A tale of two colors

The two images that follow are identical, a perfect match, the same in every way. . . .

Hmm, that doesn't sound right, does it? Here's a breakdown of how the shots were taken. First, I set up a tripod across the street from the house being photographed. I mounted a 24mm–70mm lens to the camera, adjusted the zoom to just a smidge under 35mm, and mounted an electronic cable release to the camera. Then, with a battery pack attached to my belt and my flash in hand, I proceeded to meander through the night, popping my flash in a methodical manner. I took two pops at the tree in the foreground; four pops at the bushes in front (one over each bush); and one pop from each side of the house, pointing up toward the middle of the roofline. That's it for the outside. Inside, I popped the flash four more times: three times through different windows and once into the ceiling of the room to fill the room with light. Pretty simple: 12 pops, with the flash set to half power.

I did this for each of the following two exposures. Yet the images look completely different, so what changed? It isn't hard to figure out that the second figure is blue on the outside, whereas the first figure is normal to warm on the outside. Here's the secret: Using a dollar's worth of gel fastened with Velcro over the flash, I painted with either warm or cool light.

While the process remained pretty straightforward for each shot, the feeling and emotion of each shot is completely different. The second figure makes the outside look cold, uninviting, and even evil, whereas the warm light coming from the inside is inviting — it almost makes you feel like you've just pulled up to grandma's house.

On the other hand, by reversing the gels and adding the warm light to the outside of the house and the cool blue light to the inside, the house looks like a warm and wonderful place to spread out on the couch and watch TV. I'm particularly fond of the exterior lighting on the first figure because it almost has the feeling of a home that has had garden or accent lighting added to it.

Both of the shots are benefitted by the city glow in the sky behind the house. If the sky had gone completely black, they would have had a different feel to them: The warm exterior would lose some of its appeal, and the cool, blue exterior would have an added layer of darkness and mystery to it.

Pretty amazing how two 3-x-2-inch strips of plastic can drastically change the look and feel of an image.

Both photos: 34mm, 129 sec., f/16, 400

16

Correcting and Embellishing Lighting Postproduction

Going out and capturing fantastic images is only part of digital photography; the next step is postproduction — or as I like to think of it, playing in the digital darkroom. Anyone with a home computer, a software package or two, and a printer can now take images from the camera and edit, adjust, and — if needed — fix them.

The fact that you can use software to fix your images doesn't mean you should rush the actual photography or get lazy while out shooting. A couple of extra minutes on location getting it right in the camera can save countless hours in front of the computer later. Instead of thinking "I can fix that in Photoshop," try to capture the image as best as you can in the camera.

Image-editing software like Adobe Photoshop, Lightroom, or even Apple's iPhoto enables you to adjust the exposure of your image. It can even simulate traditional darkroom tools like dodge and burn for adjusting the exposure in parts of your images. It can also help with the composition by allowing you to crop unwanted elements.

This chapter begins by telling you how to calibrate your monitor so what you see is what you get, and gives you the lowdown on a handful of popular image-editing programs. Then I tell you how to use these programs to improve exposure, fix an image that looks flat, and add special effects.

Leveling the Playing Field: A Strong Case for Calibration

Calibrating your computer monitor brings you happiness and joy, and makes the sun shine and the birds sing. Okay, maybe it doesn't do all of that, but it does fix that frustration you feel when your images just don't look right coming out of the printer, on the Internet, or even in e-mail. You no longer have to think, "Well, it looked great on my screen, but when I printed my photo, it looked terrible."

Calibration ensures that the colors and contrast you see on your computer give you an accurate view of your images. If they don't, all the adjustments you make in postproduction won't do what you want them to do. Imagine that you go out and take a great sunset photo full of reds and oranges, but when you look at it on your uncalibrated monitor, the image looks very dark. You adjust the exposure of your image accordingly, and print it. The print seems to be *over*exposed, so what went wrong? The monitor you used wasn't calibrated properly, so it made everything look too dark. The solution is to calibrate.

Although calibration used to be a somewhat complex process, it's now a straightforward procedure. Both Apple and Windows operating systems have a built-in monitor calibrator, which is fine if you want to watch movies on your computer. But it isn't precise enough if you want accurate results for photography.

The better way to calibrate your monitor is to buy a calibration system that includes software and hardware. The hardware is called a *spectrophotometer;* it plugs in to your computer and reads the colors on your monitor and reports them to the software. The software compares what the monitor displays to the actual numeric values of the colors and makes adjustments accordingly, so that you see a more accurate representation of colors on your monitor.

If you want to go a step further, you can also calibrate your printer and scanner, but the most important part is to make sure your screen is calibrated.

I like the ColorMunki system made by X-Rite. It's a very robust system that can handle everything from capture to output and uses simple (real) language like "Match my monitor to my prints" instead of complex nomenclature. It's easy for students and old farts like me alike to get perfectly controlled and calibrated color every time. Figure 16-1 shows the ColorMunki set up on an iMac in the middle of its calibration procedure in one of our classrooms.

Running Through Your Software Choices

Just about every digital camera on the market today comes with some sort of image-editing software that allows you to edit and adjust your images. This software could be a full-blown image-editing suite including programs that import, sort, edit, and output your images, or it could be a stripped-down version of a commercial software package like Photoshop Elements. The one thing that these programs have going for them is that they're included with the camera, so there's no extra cost, and they usually provide the basic image-editing controls.

Figure 16-1: The ColorMunki's spectrophotometer in position on a monitor during its calibration process.

However, a great many image-editing programs exist for those looking for a program that includes the basics and then some. The following list covers a few of the best known and most widely used image-editing programs.

- ✔ **Adobe Photoshop** was released by Adobe more than 20 years ago, and photo-editing on the computer has never been the same. Photoshop is actually three separate programs: a media browser called Bridge, a Raw image file adjustment program called Adobe Camera Raw (ACR), and Photoshop itself, a pixel-level image editor. Photoshop can do just about anything you can imagine, but it comes with a steep learning curve and an equally steep price tag.

- ✔ **Adobe Photoshop Lightroom** was created to help photographers with digital workflow and postproduction. It combines image sorting with the power of Adobe Camera Raw and adds modules that can easily create slideshows, Web galleries, and prints. Lightroom was first released as a public beta in January 2006, and its designers have always taken photographers' feedback into consideration. Lightroom lets you import, sort, organize, edit, and output professional results all in one program — and for a reasonable price. This is a fantastic piece of software!

✔ **Aperture** was created by Apple as an image-editing and postproduction tool for professional photographers. It lets you import, sort, and publish your images easily. The only downside to Aperture is that it runs only on Apple computers, so it isn't an option for anyone running a Windows operating system. One really nice feature of Aperture is that it enables you to sort your images like you would on an old-fashioned light table.

✔ **Photoshop Elements** is Adobe's amateur version of its flagship software, Photoshop. The great part about Photoshop Elements is that it benefits from the same powerful editing features you find in the full, professional version of Adobe Photoshop. Photoshop Elements lets you download your images from the camera and view them in a media browser, where the images can be tagged with keywords, ratings, and labels for easier searching and retrieval later. Photoshop Elements also functions as a good introduction to what Adobe Photoshop can do without requiring you to spend the big bucks Adobe Photoshop commands.

✔ **iPhoto** comes preinstalled on every Apple computer, and although it's aimed for the beginner, iPhoto has a great set of powerful tools that allow you to sort and edit your images in a very intuitive way. One real plus is that you can easily export images from iPhoto for a variety of uses, including e-mail and specialty products printed by Apple and shipped right to your doorstep, such as calendars and cards. Images stored in iPhoto are also easily loaded onto other Apple devices like the iPod, iPhone, and iPad so that you can take your photos with you to share with others.

Correcting Exposure Problems in Postproduction

Sometimes you get a great photograph and capture the moment just perfectly, except that the exposure is slightly off. When your photo is a little too dark or a little too light, photo-editing software allows you to adjust the exposure in postproduction.

Comparing under- and overexposures

An underexposed image (one that's too dark) is a better starting point than an overexposed image (one that's too bright). That's because when an image is too light, the bright parts (especially the areas that look pure white) have no image data in them. This means that when you try to correct the exposure, those parts of the image will never show any detail. When you start with an image that's too dark and you want to make it a little lighter, the dark areas contain data that facilitate lightening your images to get a better exposure. Even though fixing the images in postproduction is possible, it's always

better to try to get the image right in the camera so you only have to make small adjustments later.

In an underexposed image, not enough light has reached the sensor, and the image is too dark (see Figure 16-2). When you look at an underexposed image, the whole image will be too dark, and the areas that were supposed to be dark will be closer to totally black. When you adjust an image that's underexposed, you can make the areas that are too dark lighter, and you can recover the details that are hidden in the dark areas.

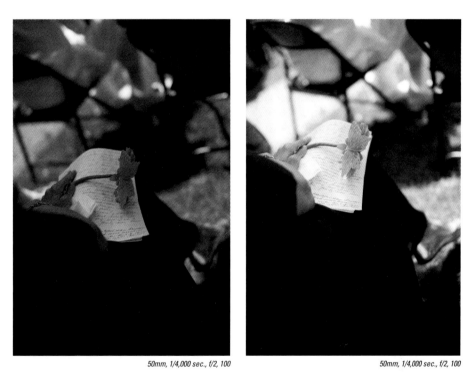

50mm, 1/4,000 sec., f/2, 100 *50mm, 1/4,000 sec., f/2, 100*

Figure 16-2: An underexposed image on the left and the corrected version on the right.

In an overexposed image, the highlights or very brightest parts of the shot look completely white and don't show any detail. When you adjust the exposure to a reasonable level, the parts that have been overexposed still have no detail. Figure 16-3 shows an overexposed image on the top and a corrected version on the bottom. Looking carefully at the pants in the corrected version on the right, you can see where there's just white without any detail whatsoever. The version on the left is what came out of the camera before attempting to correct the file.

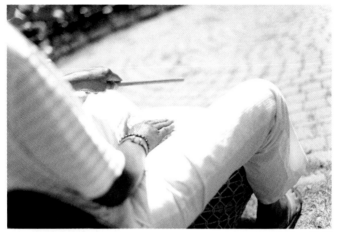

50mm, 1/125 sec., f/8, 100

50mm, 1/500 sec., f/8, 100

Figure 16-3: An overexposed image on the top and the corrected version on the bottom that's lacking detail in the subject's leg where the image was "blown out."

Using the exposure control for whole-image corrections

The easiest way to make an adjustment to the exposure when doing any post-production is to use the aptly named "exposure" control. This control shifts the entire scene and makes it brighter or darker, just as changing the exposure on the camera when shooting the photo would have done. The exposure adjustment is a broad tool that adjusts the whole image to make it lighter or darker.

Just slide the exposure slider to the right to lighten an underexposed image; slide the control to the left to darken an overexposed image. It really is as simple as that. But keep in mind that this works best when making small adjustments — it won't fix really bright or really dark images.

If your image still needs help, try using the level controls described in the following section. They enable you to adjust specific parts of your image and create a better-looking and better-exposed photo.

Making specific adjustments with the levels control

Most image-editing software packages include a "levels" control that enables you to adjust highlights (bright parts), midtones, and shadow points (dark parts) individually for greater control over your whole image. Figure 16-4 shows you this control in Photoshop. Each of the three sliders controls a different area of tonality. The white one is for the highlights, the middle gray one is for (you guessed it) the middle gray tones, and the solid black one is for the black tones in the image.

The following steps help you get the best results when editing your images:

1. **Open your image in Photoshop (or whatever editing software you're using).**

2. **Click on the Levels control.**

3. **To adjust the dark areas, slide the left control over toward the right until the image looks right.**

4. **To adjust the bright areas of your image, use the rightmost control and slide it left until the bright part looks good to you.**

5. **Using the control in the middle, adjust the overall look of the image by tweaking the mid-tones.**

Figure 16-4: Three sliders (triangles) under the histogram control brights, midtones, and shadows.

If the overall look of your image is a little too dark, slide the control to the right; if the image looks a little light, slide the control to the left.

In Figure 16-4, simply grabbing the third slider on the right, which represents the brightest part of the image, and pulling it until it is under the farthest

right side of the histogram properly adjusts the white level of the photograph. Keep in mind that it's very unlikely that there will be much pure white in any image, because pure white has no detail at all.

When you've adjusted the exposure of your images, the histogram reflects the adjusted image (see Chapter 5 for more on reading histograms), and you may see gaps like the ones in Figure 16-5. These gaps are places where your image lacks information, and they can result in banding when you print or view your images. You'll notice this banding in areas with smooth gradations, like the sky shown in Figure 16-6. This is a great case for getting the exposure right when you shoot and for shooting Raw files.

Figure 16-5: Gaps in a histogram show missing information in an image.

24mm, 1/80 sec., f/4, 100

Figure 16-6: An adjustment in this JPEG file led to banding in the blue sky.

Using Postproduction Tools to Enliven Flat Images

At times, your images can look a little flat, meaning that they lack any real contrast — the blacks look dark gray, and the whites look light gray. A number of factors can lead to low-contrast images, including flat lighting, overcast days, and even the camera's sensor. Have no fear, you have options — especially if you shot the image in the Raw mode, giving you the greatest amount of image information to work with. But even if you're working with JPEG files, all is not lost. (See Chapter 3 for more info on choosing a file format.)

I show you the steps for correcting a flat image by using Adobe Photoshop CS5, but you can use these steps with any editing program that has a levels control:

1. **Open your image in Photoshop.**

2. **Open the Adjustments palette.**

3. **Click on the Levels adjustment.**

 You see a histogram of your image with three arrows beneath it. They are, from left to right, the black point, the gray point, and the white point.

4. **Evaluate your image and the histogram.**

 If you have areas that should be very dark and a gap at the left end of the histogram, click on the black arrow under the left side of the histogram and start to slide it to the right. As it moves, watch the colors in your image; the darker areas should be getting darker.

 If the lightest parts of your image seem to be a little dull and the histogram shows a gap on the right side, start to slide the white arrow toward the left until the light parts look right.

5. **Adjust the gray slider depending on your taste.**

6. **To complete the look, use the Vibrance adjustment palette to increase the Vibrance and Saturation until the image looks right to you.**

 See Figure 16-7 for a before-and-after example of the effect these adjustments have.

 Use these controls sparingly; a little can go a long way.

Both photos: 50mm, 1/30 sec., f/1.4, 400

Figure 16-7: The same file after having the vibrance and saturation levels adjusted.

If you were taking photos way back in the film world (I'm being sarcastic here), especially if you shot color slide film, then you probably recall the

stacks of filters that you'd carry to make overall color changes to your pictures. Photoshop has incorporated these exact filter combinations and gone one step further to call them by the same name. Now you can warm and cool colors in your photos in six easy steps:

1. **Open your image in Photoshop.**

2. **Duplicate the background layer by choosing Duplicate Layer from the Layer menu or pressing the Apple and J keys at the same time.**

3. **Make sure the new layer is the active one by clicking it.**

4. **Then click the Image menu at the top of the screen and select the Adjustments menu.**

5. **In the Adjustments menu select the Photo Filter option, and then select a warming or cooling filter from the drop-down menu.**

6. **Once you've selected your filter, adjust the Density to your liking, which makes the effect of the filter strong or subtle.**

 If you want the same effect as placing the actual glass filter over the lens, then move the slider to 100% (to the right).

Adding Effects in Postproduction

Photo-editing tools can manipulate and change just about every aspect of your image and can help create just about any effect you can think of. The editing and manipulation possibilities are endless. Here, I show you a few of my favorite tricks, tools, and filters so that you can jump in and get started, but this is just a springboard for your own exploration. Lens flare, noise or film grain, edge glow, and vignette are some of the ways that you can add something special to your images.

All the following instructions are from Photoshop CS5, but most of these can be done in other photo-editing software programs as well.

Adding a lens flare

Even though you probably try to keep your lens away from bright lights to avoid lens flare when you shoot, you may find adding a flare in postproduction gives more interest to heavily backlit images. Adding a lens flare gives you a halo effect. Here's how to do it:

1. **Under the Filter tab in Photoshop, find the Render menu.**

2. **Hold your mouse over the Render menu, and click on Lens Flare in the submenu.**

3. **A window opens and shows you your picture with several different lens types underneath.**

 These lenses give you different-looking lens flares.

4. **Choose a lens that matches the effect you want.**

 You don't need to use the same one that you actually shot the picture with; just pick one that gives you the look you want.

5. **Use the brightness slider to adjust the brightness and size of your flare.**

6. **Position the flare by moving it in the preview window.**

 Click and drag the flare to wherever you want it. You can adjust the flare's brightness and lens type until you click OK, and then it's rendered to your image.

The flare is most realistic when it comes from the brightest part of the frame. In Figure 16-8, the hot spot of the flare isn't even visible against the bright white sky, but the effects stream across the frame adding realism and believability to the shot.

Both photos: 35mm, 1/200 sec., f/4, 400

Figure 16-8: A postproduction lens flare adds to this image.

Bring the funk; bring the noise

Film grain or digital noise can add to the texture and feel of a shot. It can also be used to match photos taken at different times and under different conditions. If you shot a series of images using ISO 1600 with a fair amount of noise, and you want to show them along with an image taken at ISO 100 that has no noise, you can artificially add noise to the ISO 100 image so that it looks like it belongs with the others.

Try using both the film grain filter and the noise filter; each has a different feel. The noise filter seems to replicate digital noise better, whereas the film noise seems to replicate traditional film grain better.

Follow these steps to adjust an image using the noise filter:

1. **Open your image in Photoshop.**

2. **Hold your mouse over the Noise menu.**

 A submenu appears.

3. **Click the Add Noise tab in the submenu.**

 Controls for three settings — Amount, Distribution, and Monochromatic — appear.

4. **Increase the Amount until you easily see the noise, and then slowly start reducing it until you have the desired effect.**

5. **Choose Uniform or Gaussian in the Distribution setting.**

 The effect either selection provides depends on the photo you're working with. Uniform seems to give a better result for matching digital noise, but try both and see which you prefer.

6. **Check or uncheck the Monochromatic box to toggle between black-and-white or color noise.**

 You can lay black-and-white noise over a color photo, match the noise to the photo, or put color noise over a black-and-white photo. I prefer the color noise, which looks more like the digital noise produced by high ISO shots with today's cameras (see Figure 16-9).

Use the grain filter by following these steps:

1. **Open your image in Photoshop.**

2. **Under the Filter tab in Photoshop, find the Artistic menu.**

3. **Hold your mouse over the Artistic menu.**

 A submenu appears.

4. **Click the Film Grain tab in the submenu.**

 You find controls for three settings:

 - **Grain** adds overall grit to the image that actually looks like the grain you'd find if you used high-speed film. The maximum amount is 20; I generally stay around 5.

 - **Highlight Area** enables you to add grain to a portion of the shot. I generally keep this slider around the 8 or 12, but the way you use it depends on your personal taste and the image you're working on.

 - **Intensity** controls how bright the effect is.

5. **Starting with the Grain control and then using Highlight Area and finally Intensity, adjust the sliders until you get the result you want; see Figure 16-10.**

Keep in mind that these effects have a profoundly different outcome depending on the image you use, so play with several images to get a feel for the effects. I always find it best to experiment with an image that I'm very familiar with, so I can really study the changes that the filter brings to the image.

Making edges glow

The glowing edges filter flips an image into a groovy inverse with brightly colored edges. The filter finds contrasty edges in your image

35mm, 1/200 sec., f/4, 400

Figure 16-9: Postproduction digital noise.

35mm, 1/200 sec., f/4, 400

Figure 16-10: Postproduction film grain, which looks blotchier and darker than the color noise filter.

and makes them instantly look like something Andy Warhol would simply despise.

Follow these steps to use the glowing edges filter:

1. **Open your image in Photoshop.**

2. **Under the Filter tab in Photoshop, find the Stylize menu.**

3. **Hold your mouse over the Stylize menu, and click on the Glowing Edges tab in the submenu.**

 You see a control with three settings: Edge Width, Edge Brightness, and Smoothness.

4. **Adjust the controls to get the effect you want.**

 While the width and brightness are really a matter of personal taste, I encourage you to keep the smoothness up past 10. The slider goes to 15, and the closer to 15 you get, the less detail you have in the image so the glowing edges are most prominent. See Figure 16-11.

35mm, 1/200 sec., f/4, 400

Figure 16-11: A T-shirt-worthy glowing edges effect.

Using the vignette filter to darken or lighten the edges of your image

The vignette effect is a way to lighten or darken the outside edges of an image to draw the viewer's eye to the subject. The effect can be subtle or very obvious, depending on how much you lighten or darken the edges. I used the vignette filter to varying degrees on nine out of ten images in this book.

You don't want to overdo this effect, however. In Figure 16-12, the vignette filter is overdone because there's no detail in the sky. The bottom of the frame looks great, but the top looks odd.

If you use Adobe Lightroom, you find the Vignette filter in the Develop tab. Photoshop doesn't have a vignette filter, so here's a quick way to do the same thing using layers:

1. **Open your image in Photoshop.**

2. **Duplicate the background layer by choosing Duplicate Layer from the Layer menu.**

3. **Make sure the new layer is the active one by clicking it.**

4. **Change the layer mode depending on the effect you want.**

 For a lighter border, change the mode to Screen; for a darker border, change the mode to Multiply. When you take this step, the whole image becomes either lighter or darker. Don't worry; the following steps knock out the middle part, leaving a lighter or darker edge.

35mm, 1/200 sec., f/4, 400

Figure 16-12: Darkening the edges of a shot with a postproduction vignette

5. **Pick the Rectangular Marquee tool from the Tools menu.**

 If you don't like the rectangular look, you can always use the Elliptical Marquee tool, which you find by holding the mouse pointer over the Rectangular Marquee tool in the Tools palette until the fly-out menu appears.

6. **Set the Feather setting for the Marquee tool.**

 You find the Feather setting in the tool option bar on the top of the screen. The Feather setting determines how hard the edges of the transition are from the middle to the outside. I use a 200-pixel setting for big images and a 100-pixel setting for smaller images.

7. **Make a selection in the middle of your image with the Rectangular Marquee tool.**

 The edge effect will appear outside your selection.

8. **Press the Delete key.**

 Doing so knocks out your selection so that you get a lighter (or darker) edge effect.

If the effect isn't as strong as you'd like, go to the Layers menu and duplicate the effect layer. If the effect is too strong, you can adjust the opacity of the layer from 100 percent down at the top of the layer palette.

Controlling Huge Differences in Contrast

Controlling contrast is one of the paramount concerns of the photographer. This is the very reason you carry a reflector with you or need extra lights when shooting an interior. Contrast also provides cues for emotion — can you imagine Vincent Price with a perfectly smooth 1:2 or 1:1 lighting ratio? Heck no, contrasty lighting is what helps him look so scary. A complete lack of contrast is what keeps Barbara Walters from looking too scary as well. Lots of soft light keeps her looking . . . well . . . like Barbara Walters.

In recent years, a technique has emerged that lets the photographer control the contrast in certain situations. It's a nifty little trick that can be used both as a timesaver and as a creative element, depending on how heavy-handed you are at the helm.

It's called *HDR* and stands for High Dynamic Range photography. The concept is pretty brilliant actually; you shoot a pretty big range of exposures, which is also called a *bracket,* that goes from dark to light. So you may shoot a scene at the right exposure and then shoot a range or bracket from 3 stops underexposed to 3 stops overexposed for a total of seven pictures. You can actually use any number of over- and underexposed shots as long as you have the same number on each side of the good or "on" exposure. This gives you a "perfect" exposure for just about every tonality in your scene, from a bright, bright sky to the deepest, darkest shadow in the shot. You'll most likely have one shot with great detail of each area.

When you get home, you then place all of these shots into one folder and activate the super-scruncher 3000. What you actually do is pretty darn close . . . if you're using Photoshop, you simply use the Merge to HDR function in the Automate menu and sit back while Photoshop samples each exposure and combines all the files into one file. You'll get detail in the sky and detail in the deepest, darkest shadow. Once that's done, a slider lets you determine where you would like to sample the images for control over the final image. If you're intrigued by this process and its potential, a software package that can do this *much* better and gives you more control is Photomatix, which is made by a company called HDRsoft. The Photomatix software is available as a standalone package or as a plug-in that works with Photoshop, Lightroom, and Aperture.

Processing the same image for shadow and highlight detail

The previous chapter goes into detail about how to turn a bracket, or a wide range of exposures of the same subject, into a robust file with detail ranging from deep into the shadows to highlights that are equally rich in detail. But what if you're looking at an image you made and are wishing that you'd thought to shoot a bracket because, in hindsight, it's a perfect candidate for an HDR image?

As long as you shot the image as a Raw file, an approach exists that might give you a worthwhile result. Know that it won't replace having the amount of detail that you would by shooting the range in the first place, but it's not a bad runnerup.

By having the added information that you gain with the higher bit depth of the Raw file, you can process out your original Raw file several times to maximize the amount of detail. Say what? Okay, when you shoot Raw, the file needs to be converted before you can use it. If you're using Aperture or Lightroom, this happens in the background, and you really aren't aware that it's going on. But if you're using Photoshop, this is the window your file opens up in on its way to Photoshop. You're given options for exposure, amount of fill (which is really your gray channel adjustment), amount of recovery, saturation, vibrance, and so on. You're also given different options for how large or small you'd like the image to be when you open it.

Here's the trick: By using these Raw controls, you're controlling the image where the greatest amount of information or data exists. You can process out the file several different ways. Process the file the first time to maximize the amount of detail in the highlight area of your picture. Secondly, output a version with solid midtones and general detail without worrying about shadow detail or detail in the highlights. Lastly, output a third version of the file that looks deep into the shadow area and pulls as much detail as possible from the darker parts of your shot. With these three files outputted and in a folder, head to the Photomatix software. Let the software sample detail from across all three files to maximize detail across the entire tonal range for a better, more robust final product.

Keep in mind this will only work if you have a well-exposed RAW file to start with. The final result won't be as good as if you had shot a solid bracket in the first place, but this approach remains a viable option.

Figures 16-13 and 16-14 provide an example from a former student, Nick Provost. Nick began experimenting with HDR early on in his studies and used it in two very different ways. The first is what I call a functional approach. By using HDR, he can build up and control with perfection the exposure in the shadow area while keeping perfect control over the highlight area of the scene. Figure 16-13 shows the darkest image that provided the detail in the highlight portion of the image; the middle exposure, which would be the "on" exposure if HDR were not going to be applied to this image; and the bright image that only provided detail in the darker portions of the trees. While the final image is robust in tonality, the viewer isn't aware that any additional software or techniques are at play.

Figure 16-13: The diverse files that made up the final image.

Images courtesy of Nick Provost

Figure 16-14: The wonderfully exposed image.

The second approach that can be taken with HDR is a creative one. By controlling how much or how little of the tonality is used in the final image, you can create surreal-looking land and cityscapes. The image in Figure 16-15 of the underpinnings of Wacker Drive is a prime example of pushing an HDR exposure well beyond its functional aspect and deep into a creative approach to the technique.

If you're interested in exploring this as a creative tool, you must be using the Photomatix software, because it provides more options and considerably more functionality than simply using Photoshop.

Figure 16-15: Pushing well into using HDR as a creative tool.

Part V
The Part of Tens

The 5th Wave — By Rich Tennant

"Quick-get into position! I want to capture this light."

In this part . . .

These chapters give you nuggets of wisdom fit for a variety of lighting situations. They guide you through avoiding rookie mistakes and point out the questions to ask before you shoot.

Avoiding Ten Rookie Lighting Mistakes

Rookies make mistakes. (Frankly, so do professionals.) But mistakes are undervalued: Without mistakes you can't move forward, and that's as true for photography as it is for math or tennis.

Of course, you can always learn from the mistakes others have made. Here are ten mistakes that rookies often commit, along with ways to avoid or correct them.

Getting Hung Up on Gear

Many photographers worry about their camera gear and believe they need the latest and greatest camera, lens, flash, and lighting tools to get great photographs. Not true: Having top-of-the-line gear and lighting may be nice, but understanding exactly how your gear works and how to get the best images with what you have are much more important.

Read the manual that came with your camera and practice, practice, practice. You should be able to change the shutter speed and aperture without taking your eye away from the viewfinder. Your fingers should be able to find all the controls and know what they do so that you don't waste time trying to figure out what to change when you're actually out shooting. The sun won't stop moving across the sky as you try to remember which dial changes the shutter speed and which one changes the aperture.

So practice with your gear, and don't worry that the newer version may have more pixels, a different meter, or even a better focusing system, because that's not the camera that you have.

New flashes and strobe lights are released all the time. They range in price from a few hundred to many thousands of dollars, but you don't need to spend a lot when starting out. Look for lights within your budget. Buy lights that allow you to control the intensity of the output and to easily attach lighting modifiers.

Start with one light and one modifier, and learn how to use them correctly. Build your lighting kit as you build up your techniques.

Buying good used equipment, as long as it comes from a reputable dealer with a warranty, is a great option, especially if it's something you aren't going to use all the time.

Relying Blindly on Your Light Meter

Setting up the world's greatest portrait or finding a stunning landscape doesn't guarantee you a successful image. Figuring out the proper exposure for the lighting conditions and scene you're working with is critical.

The light meter in your camera is a great tool, but it can be fooled and end up giving you mixed results.

Your camera's light meter measures the brightness of the light being reflected off of everything in your scene. Then it averages those readings and gives you camera settings. But the camera settings it suggests are designed to render the whole scene as 18-percent gray. This works well for a lot of photos, but if you have a large area of light or dark, the light meter tries to average those areas into your image, and you end up with an underexposed or overexposed image. Chapter 5 tells you more about metering.

Know when to trust the light meter and when you may need to purposely over- or underexpose an image. For example, a bride in a flowing white dress brings a lot of light to an image, so the settings the camera gives you will underexpose the image. You can either change the metering mode to spot meter, which takes into account only a small portion of the overall light — specifically the light on the critical area of the image — or you can purposely overexpose the image slightly.

This is why an incident meter is a professional's best friend — it doesn't get tripped up by the color or tonality of your subject. It only reads the amount of light falling on a subject.

Overusing Full Power on Your Flash or Strobe

You can adjust flash units and studio strobes so that they aren't always firing on full power. Many rookies forget that they don't always have to use full power — and often don't want to. Figure 17-1 shows a portrait lit with just an umbrella off to the right-hand side of the image. In the first shot the strobe was set to full power, which seems to make sense; it's already a bright room and you're bouncing the light into an umbrella, but a flash at full power can make for an overlit, artificial-looking portrait. The second shot is a much more pleasing version. The only difference is I reduced the flash output to half the power.

Both photos: 85mm, 1/125 sec., f/5.6, 400

Figure 17-1: Cutting the flash from full (left) to half power (right) makes for a more pleasing and natural image.

When the flash on your camera is firing at full power, it takes much longer to get ready to fire a second time. By turning down the power on your flash, you can cut the recycle time between flashes and take more photos without having to wait as long between shots. An easy way to do this is to increase the ISO setting so that the sensor doesn't need as much light to make a proper exposure. Not only is this a good idea from a practical, battery-saving point of view, but it also allows you more artistic control over your images.

If you want to use a shallow aperture, one that lets in a lot of light, you may need to turn down the power of the flash so that the image isn't overexposed.

Leaving the Flash on the Camera

The on-camera flash doesn't provide a very flattering light. It blasts right at the subject at the same angle as the lens, making your subject look as if she's being interrogated in prison or getting a passport photo taken.

The best way to avoid this look is to get the flash off the camera, or to at least bounce or diffuse it to create a softer, more flattering light. Rotate the flash head upward and over the head of your subject and let the light spill down on her, or aim the light at a nearby surface to bounce the light back at her.

You can buy a sync cord that enables you to simply move the flash a foot or two off the camera, giving dramatically better results. Just slide the flash in the sync cord's hot shoe, and then slide the other end of the sync cord into the camera's hot shoe. When you press the shutter release button, the flash fires just as if it were still on the camera, but you can position it at a better angle.

Many camera systems have a built-in way to trigger external flash units; spend some time with your camera and flash manuals to familiarize yourself with these options.

Using Too Few — Or Too Many — Lights

Lighting is not a one-size-fits-all proposition but one that depends on the particulars of any scene you shoot. You can light some scenes with just a few lights, whereas others need a whole lot more. Practiced photographers take the time to figure out the difference. Rookies often try to use one light to illuminate a whole room or use all their lights to illuminate a tiny scene.

Take your time and build up the lights until the scene looks right. Start with the main light in your scene, and slowly add lights until everything looks the way you want it to. When you start slow and build the lighting, you can see how the additional lights change the scene as you add them. You get a better sense of how lights improve or detract from the scene when you build than when you start with all the lights on at the same time, and you learn as you're doing it.

Rushing through the Process

One key difference between pros and the rest of the world is that professionals take their time to get the best results. After a while, they seem to be able to do everything really fast, but that's because of the thousands of hours of practice they've had. Rookies tend to rush through things to get to the end.

Slow down. Take a moment to look at your composition and see whether it really is the best it can be. Will moving left or right, up or down, or changing the angle improve or detract from the image? Should you be shooting in portrait orientation or landscape? When you're sure you have the image set up exactly the way you want it, take a deep breath and press the shutter release button. Then look around again and see what changes you can make.

Check the LCD on the back of the camera to get feedback about what you just shot before walking away or changing the lights. Even though the screen is small and can be difficult to see detail on, it lets you know whether you're close to getting what you want. Find out how to read a histogram, and check it to determine whether any areas in your image are too dark or too light. Keep taking shots until you get the one you want. And then take a few more to find out what else you can do with the scene. If you're using a shallow depth of field, enlarge the image to 100 percent to check for critical focus and make sure that the area you wanted in focus indeed is in focus.

Shooting High-Contrast Scenes

Your eyes can see more than your camera can capture, which makes dealing with contrast a little extra tricky. Rookies often take photos in which the contrast between the lightest areas and the darkest areas is too high.

When a scene includes very bright and very dark areas, your camera just can't capture all the detail in both. You have to decide whether you want to capture the details in the bright areas or the details in the shadows — or whether you can change the light. If none of these solutions is right for your shot, find another one and save yourself the disappointment. Or you can experiment and shoot it anyway; bracket wildly and re-evaluate later, seeing what photographic surprise awaits you.

Check out Figure 17-2. If you choose to expose for the details in the brightest area, then those in the darkest area will turn solid black (or very close to it); if you decide to expose for the darkest areas, then the bright areas will lose all detail and turn solid white (or close to it). The third option is to adjust the light, and the easiest way to do that is to expose for the brightest areas and then add light to the darkest. You can do this by using a flash or strobe as shown in Figure 17-2, or by using a reflector to add light where you need it most. Keep in mind that you don't need a lot of light because

these areas are the darkest parts of the image, but adding just enough to reduce the overall high contrast enables you to get details in the dark and the light areas of your image.

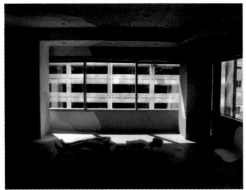

28mm, 1/100 sec., f/5.6, 400

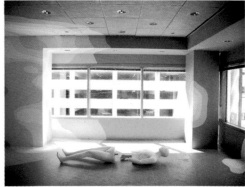

28mm, 1/60 sec., f/2.8, 400

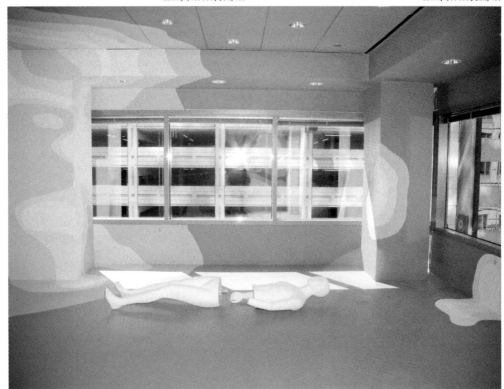

28mm, 1/100 sec., f/5.6, 400

Figure 17-2: I brought the contrast between the interior and exterior together by using a flash on the camera to light the interior and using the camera exposure to properly expose the parking garage in the exterior.

The third option is to adjust the light, and the easiest way to do that is to expose for the brightest areas and then add light to the darkest. You can do this by using a flash or strobe, or by using a reflector to add light where you need it most. Keep in mind that you don't need a lot of light, because these areas are the darkest parts of the image. But adding just enough to reduce the overall high contrast enables you to get details in the dark and the light areas of your image.

Failing to Try New Things

Many famous photographers never would have captured their iconic images had they not pushed the boundaries and tried new things. Joe McNally never would have gotten the image of Fiona Apple dressed in armor in a New York subway car by playing it safe. By definition, rookies are unsure of their skills, but failing to experiment with subjects, techniques, lighting ideas, and so on may not only keep you from making mistakes but also keep you from becoming a better photographer.

One of the greatest things you can do, — and the one that most people *don't* do — is to go into a situation and ask questions about the possibilities. Consider what happens if you move a light from one side of your subject to another, or if you close the curtain in the room where you're shooting. How does a reflector or soft box make your subject look different? Would more light help tell the story you want to tell?

Don't forget the basics, but do experiment a little and try something new, especially after you get the shot you hoped for. Sometimes the shot you didn't know about is even better.

Expecting to Fix All Ills in Photoshop

Many times you hear photographers say, "Don't worry; I'll fix it in Photoshop." Adobe Photoshop and other postproduction image-editing software packages can fix a lot of problems — that's why the programs exist in the first place — but capturing an image properly in the camera is always better.

Some Photoshop wizards out there can fix just about everything, but doing so usually takes more time than fixing it in the camera.

If you count on fixing everything later, you don't think about the image as you shoot it and may sell your scenes short. Sure, sometimes you do have to fix images later, but if you keep these to a minimum, you can be out shooting instead of sitting in front of the computer all day fixing images.

Not Planning Ahead

One thing that tends to separate the professionals from the rookies is that the pros have a plan before they head out to shoot photographs. No matter what type of photography you do, a plan is a good idea:

- ✔ Have a list of shots you want to try along with the gear needed for each one.
- ✔ Try to estimate a rough timeline for the whole shoot so that you can get all the shots you want.
- ✔ Scout ahead for shooting locations and scenes.

For some types of photography, a plan is obviously important. If you're shooting a wedding, for example, you need to know where and when the bride and groom are going to be and where and when you can photograph them. Without a plan, you'd always be trying to catch up or waiting for an opportunity that may never arise. Landscape photographers need to be at their locations at certain times of the day — or even certain times of the year — to get the best light. When it comes to shooting in the studio, you need to know how you intend to pose your subject and roughly where the lights will be before you even start to shoot.

In other words, you need a plan.

Having said that, don't be afraid of abandoning your plan if cooler things present themselves. Just remember to have fun.

Ten Aspects of Light to Consider Before You Shoot

In This Chapter

▶ Figuring out what kind of light you're dealing with

▶ Bringing situation, equipment, and knowledge together

▶ Improving your images by taking stock of lighting before you shoot

*Y*ou have a lot to keep in mind when you get ready to take a photograph. (But don't worry: As you gain experience, some of the aspects of photography that confound you early on become second nature.) Time that you spend planning for and thinking through your shot is never wasted. This chapter alerts you to ten considerations about light that help you get the best possible results.

Where's the Light Coming From?

Light has to come from somewhere, and whether it's coming from the sun or the flash on your camera, the first question you need to address before you shoot is which direction the light is coming from. The direction of the light determines where the shadows are, which elements are visible in your image, and which elements are hidden in those shadows.

Here are some of the situations you're likely to run into:

- ✔ **Frontlighting** means that light strikes your subject directly from the front, as if the light was coming from the camera. You get this kind of light when you use a flash on the camera or pose your subjects looking directly into the sun. Frontlighting isn't very flattering; it causes your subjects to look washed out and bland. It causes people to squint and blink a lot. Whenever possible, move your subjects or your light source so that the light comes from slightly off center.

- ✔ **Backlighting** occurs when your subject is lit from behind. Unless you add some light to help balance the photograph, backlighting results in a silhouette. Using a little fill flash or reflector to add light to the subject helps even out backlight.

- ✔ **Sidelighting** lets shadows fall across the image, helping to define the shape and texture of the subject. If the light seems too extreme, try to position your subject and the light so that the angle falls more between frontlighting and sidelighting.

- ✔ **Overhead lighting** comes from above like the noonday sun. It can make your subject look very plain, with little shadow and little depth. Use a fill flash or reflector to add some extra light to the front of the subject.

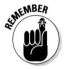

None of these types of lighting is inherently bad, but to get the results you want in an image, sometimes you need to move your subject so the light strikes it differently or take the photograph at a different time of day.

How Bright Is the Light?

The brightness or intensity of light is one of the factors that you use to determine which camera settings are right for your shot. If the light isn't very bright, you need a slower shutter speed or a wider aperture, and you may have to increase the ISO as well. If the light is very bright, you have to use a faster shutter speed or a smaller aperture and reduce the ISO if you can. (Chapter 3 tells you more about setting your camera.)

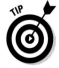

When you encounter a big difference between the light illuminating your subject and the light in the background, make sure you expose the image for the subject and not the background. Otherwise, your photos end up under- or overexposed.

Rarely can you control the intensity of available light — that is, light you didn't bring to the scene. You can't adjust the intensity of the sun, for example. You

can use reflectors and diffusers to modify the sunlight, but you can't actually change its brightness.

When you work with your own lights, you can easily adjust the light intensity. Makes shooting in a studio sound awfully appealing, doesn't it? You miss out on the magic hour (see Chapter 8), but you do get to feel like you're the god of light.

Is the Light Hard or Soft?

Hard light comes from a source that is small in comparison to the subject. It casts hard-edged shadows and can create high contrast. Soft light comes from a source that is large in comparison to the subject. Soft light seems to wrap itself around the subject with soft-edged shadows that produce much less contrast.

You use hard and soft lights to create very different looks. If you want your image to have deep, well-defined shadows like the ones you see at midday, a small, bright light will do the trick. You can make this kind of light with a flash without any diffusers or light modifiers. If you want soft light instead, you need to use a diffuser up close to create the largest, softest light source. The light from this setup creates a very soft shadow and a gradual change from shadow to nonshadow areas.

How Far Away Is the Light?

Depending on how far away a light is, it may seem bigger or smaller than it really is. The size it seems (its apparent size) is the one that you need to pay attention to.

The bigger the light source, the softer the light, and the smaller the light source, the harder the light.

Larger light sources that are very far away from your subject become small light sources. The best example of this is the sun. Everyone knows that the sun is a very large light source, but because it's so far away, it becomes a small light source — just look at the shadows created by the noonday sun.

As the light gets closer to the subject, it becomes more powerful. So if you're using a light at full power and move it in closer, you have to reduce its intensity or change your camera settings accordingly.

What Color Is the Light?

Light has a color that can affect the look and feel of your images. Sometimes this color is easy to see, like the warm reds and oranges of a sunset or a subject lit by candlelight; other times it's harder to see because your eyes adjust to the light and believe that it's white.

Photographers measure the color temperature of light by using a Kelvin scale that runs from very red (low numbers) to very blue (high numbers). Chapter 2 tells you more about light's colors and the Kelvin scale.

To get the most accurate representation of the scene in your photographs, you need to tell the camera what color the light is so that the white parts come out white. You do this by setting the white balance on the camera. Make sure that the white balance is set to the type of light you're shooting under, or you'll get some pretty severe colorcasts. Chapter 5 gives you the lowdown on performing a custom white balance.

The color of light can be affected by any surface the light bounces off. Because light picks up the color as it's reflected, make sure you take any colored surfaces into account when photographing — especially when you set up your own lights.

Would a Gel Improve the Image?

You use gels over your lights for two main reasons: to add some creative color and to make the flash light match other lights in your scene. Because lights have different colors, when you use a flash along with other lights, you want the light produced by the flash to match the other lights. Otherwise, the subject takes on the color of the light, and that color is very difficult to get rid of later.

Fluorescent lights tend to be a little green, so to match their color when using a flash, a light green gel over the front of the flash works well. When it comes to matching incandescent or tungsten bulbs, you need to make the light from your flash a little warmer by using an orange filter. These are usually called color temperature orange (CTO) filters and come in various strengths.

The light from the flash is close to daylight. Therefore, when you shoot outdoors in the middle of the day, you don't need a gel, but if you shoot in the early morning or late evening, a CTO gel can match your flash to the warm light from the sunrise or sunset.

Do I Need to Reflect Light into My Scene?

One quick way to add light to a scene is to reflect some of the ambient light where you want it. Doing so can help even out the lighting and make a better image. Many sizes and styles of reflectors are available, and each has its plusses and minuses. Bigger reflectors create bigger lights but are harder to handle and usually require an extra helping hand so that you can get them aimed right. Smaller reflectors create a smaller light but are easier to handle, and some can even be used single- handedly. Be careful on windy days!

The color of the reflector changes the color of the light, so if you want to make sure the light doesn't end up with a colorcast, use a neutral white reflector. The bigger the reflector, the softer the light but the harder it is to take with you.

Look for surfaces already in or near your scene and see whether they reflect the light.

Does This Scene Call for a Fill Flash?

Fill flash, or using the flash on your camera to add just a little light and fill in the shadows, is a very easy and popular way to shoot under difficult lighting. (I tell you about it in Chapter 8.) The idea is to have most of the scene lit by the natural light but to use the flash to tone down the shadows — especially on a person's face. Many wedding and event photographers use a flash outside when photographing people to get this effect. Usually the flash has a diffuser on it to increase the size of the light source, and the intensity is turned down so that just a little light is used.

A quick and dirty way to use fill flash is to do the following: Add a diffusion dome to your flash, and then decrease the flash output (reduce the intensity) by 1 stop and take a test shot. If the light from the flash is obvious in the photo, decrease the output some more; if the shadows are still too dark, increase the output and try again.

Does the Light Need to be Diffused?

Anything that isn't solid and gets between the light and your subject diffuses the light. The more opaque the material, the less light it allows through.

Diffusing light reduces its intensity and creates a bigger light source. When you put a diffuser in front of a light, the diffuser becomes the light source, usually spreading the light evenly across a much bigger surface.

Clouds, for example, work to diffuse sunlight. They block part of the sunlight and, in doing so, become the light source. Gone are the harsh shadows and very small, bright light source; instead you have a very large, soft light source. This effect is why taking photos on a cloudy day often works better than photographing on a very bright, sunny day.

Many different diffusers are available for photographers, from giant soft boxes and umbrellas for studio lights to smaller plastic domes that go over flash units. They all do the same thing — turn a harsh, small light source into a bigger, softer one.

Am I in Control of My Gear?

Whether your lighting gear is a single flash or a studio full of strobes, you need to know what your lighting gear can and can't do in every circumstance.

When you use you own lights to illuminate the scene, you can control the direction of the light and the brightness, along with the distance the light is from the subject and even the color of the light. When you use your lights in combination with the available light, you need to match the light so that the available light and the flash look natural together.

I could give you a hundred other examples of the ways that understanding your lights improves your images. But why keep reading? Get out and practice. You can always come back to these pages when situations get vexing.

Shoot lots — it's the best way to learn!

Index

• *G* •

Apple & Macs

iPad For Dummies
978-0-470-58027-1

iPhone For Dummies,
4th Edition
978-0-470-87870-5

MacBook For Dummies, 3rd
Edition
978-0-470-76918-8

Mac OS X Snow Leopard For
Dummies
978-0-470-43543-4

Business

Bookkeeping For Dummies
978-0-7645-9848-7

Job Interviews
For Dummies,
3rd Edition
978-0-470-17748-8

Resumes For Dummies,
5th Edition
978-0-470-08037-5

Starting an
Online Business
For Dummies,
6th Edition
978-0-470-60210-2

Stock Investing
For Dummies,
3rd Edition
978-0-470-40114-9

Successful
Time Management
For Dummies
978-0-470-29034-7

Computer Hardware

BlackBerry
For Dummies,
4th Edition
978-0-470-60700-8

Computers For Seniors
For Dummies,
2nd Edition
978-0-470-53483-0

PCs For Dummies, Windows
7 Edition
978-0-470-46542-4

Laptops For Dummies,
4th Edition
978-0-470-57829-2

Cooking & Entertaining

Cooking Basics
For Dummies,
3rd Edition
978-0-7645-7206-7

Wine For Dummies,
4th Edition
978-0-470-04579-4

Diet & Nutrition

Dieting For Dummies,
2nd Edition
978-0-7645-4149-0

Nutrition For Dummies,
4th Edition
978-0-471-79868-2

Weight Training
For Dummies,
3rd Edition
978-0-471-76845-6

Digital Photography

Digital SLR Cameras &
Photography For Dummies,
3rd Edition
978-0-470-46606-3

Photoshop Elements 8
For Dummies
978-0-470-52967-6

Gardening

Gardening Basics
For Dummies
978-0-470-03749-2

Organic Gardening
For Dummies,
2nd Edition
978-0-470-43067-5

Green/Sustainable

Raising Chickens
For Dummies
978-0-470-46544-8

Green Cleaning
For Dummies
978-0-470-39106-8

Health

Diabetes For Dummies,
3rd Edition
978-0-470-27086-8

Food Allergies
For Dummies
978-0-470-09584-3

Living Gluten-Free
For Dummies,
2nd Edition
978-0-470-58589-4

Hobbies/General

Chess For Dummies,
2nd Edition
978-0-7645-8404-6

Drawing
Cartoons & Comics
For Dummies
978-0-470-42683-8

Knitting For Dummies,
2nd Edition
978-0-470-28747-7

Organizing
For Dummies
978-0-7645-5300-4

Su Doku For Dummies
978-0-470-01892-7

Home Improvement

Home Maintenance
For Dummies,
2nd Edition
978-0-470-43063-7

Home Theater
For Dummies,
3rd Edition
978-0-470-41189-6

Living the
Country Lifestyle
All-in-One
For Dummies
978-0-470-43061-3

Solar Power Your Home
For Dummies,
2nd Edition
978-0-470-59678-4

Internet

Blogging For Dummies,
3rd Edition
978-0-470-61996-4

eBay For Dummies,
6th Edition
978-0-470-49741-8

Facebook For Dummies, 3rd
Edition
978-0-470-87804-0

Web Marketing
For Dummies,
2nd Edition
978-0-470-37181-7

WordPress
For Dummies,
3rd Edition
978-0-470-59274-8

Language & Foreign Language

French For Dummies
978-0-7645-5193-2

Italian Phrases
For Dummies
978-0-7645-7203-6

Spanish For Dummies,
2nd Edition
978-0-470-87855-2

Spanish For Dummies,
Audio Set
978-0-470-09585-0

Math & Science

Algebra I For Dummies,
2nd Edition
978-0-470-55964-2

Biology For Dummies,
2nd Edition
978-0-470-59875-7

Calculus For Dummies
978-0-7645-2498-1

Chemistry For Dummies
978-0-7645-5430-8

Microsoft Office

Excel 2010 For Dummies
978-0-470-48953-6

Office 2010 All-in-One
For Dummies
978-0-470-49748-7

Office 2010 For Dummies,
Book + DVD Bundle
978-0-470-62698-6

Word 2010 For Dummies
978-0-470-48772-3

Music

Guitar For Dummies,
2nd Edition
978-0-7645-9904-0

iPod & iTunes
For Dummies,
8th Edition
978-0-470-87871-2

Piano Exercises
For Dummies
978-0-470-38765-8

Parenting & Education

Parenting For Dummies,
2nd Edition
978-0-7645-5418-6

Type 1 Diabetes
For Dummies
978-0-470-17811-9

Pets

Cats For Dummies,
2nd Edition
978-0-7645-5275-5

Dog Training For Dummies,
3rd Edition
978-0-470-60029-0

Puppies For Dummies,
2nd Edition
978-0-470-03717-1

Religion & Inspiration

The Bible For Dummies
978-0-7645-5296-0

Catholicism For Dummies
978-0-7645-5391-2

Women in the Bible
For Dummies
978-0-7645-8475-6

Self-Help & Relationship

Anger Management
For Dummies
978-0-470-03715-7

Overcoming Anxiety
For Dummies,
2nd Edition
978-0-470-57441-6

Sports

Baseball
For Dummies,
3rd Edition
978-0-7645-7537-2

Basketball
For Dummies,
2nd Edition
978-0-7645-5248-9

Golf For Dummies,
3rd Edition
978-0-471-76871-5

Web Development

Web Design
All-in-One
For Dummies
978-0-470-41796-6

Web Sites
Do-It-Yourself
For Dummies,
2nd Edition
978-0-470-56520-9

Windows 7

Windows 7
For Dummies
978-0-470-49743-2

Windows 7
For Dummies,
Book + DVD Bundle
978-0-470-52398-8

Windows 7 All-in-One
For Dummies
978-0-470-48763-1